Why Photographs Work

George Barr

Why Photographs Work

52 Great Images:
Who Made Them,
What Makes Them Special
and Why

rockynook

George Barr (www.georgebarr.com)

Editor: Joan Dixon
Copyeditor: Judy Flynn
Layout and Type: Petra Strauch, just-in-print@gmx.de
Cover design: Helmut Kraus, www.exclam.de
Printed in Korea

ISBN 978-1-933952-70-3

1st Edition (1st Reprint, January 2011)
© 2011 by George Barr
Rocky Nook Inc.
26 West Mission Street Ste 3
Santa Barbara, CA 93101

www.rockynook.com

Library of Congress Cataloging-in-Publication Data

Barr, George, 1949-
 Why photographs work : 52 great images--who made them, what makes them special and why / George Barr. -- 1st ed.
 p. cm.
 ISBN 978-1-933952-70-3 (soft cover : alk. paper)
 1. Composition (Photography) 2. Photographers. 3. Photographs. I. Title.
 TR179.B373 2011
 770--dc22
 2010028849

Distributed by O'Reilly Media
1005 Gravenstein Highway North
Sebastopol, CA 95472

DEDICATION

This book is dedicated to the wonderful photographers
who not only donated their images to the making of the book,
but also patiently wrote for and worked with me as the text for the book was developed.
We went through many rounds of editing, creating a storm of emails back and forth,
and interrupting their very busy schedules—in places like Afghanistan, Africa, Bulgaria,
and other locations around the world.

First and foremost though, I have to thank the photographers
for creating the wonderful images for us to enjoy,
and which make the book even possible.

Cheers people, beaucoup thanks,

George

Table of Contents

Introduction

Why this book, why now, and perhaps most importantly why me? Who is (and who isn't) the book designed for? How did I select the images and is there a strategy to the book?

I wrote this book for me, as if I could go back in time to when I was starting out as a serious photographer. This is the book I wish had been available then, to explain great photographs, to point out what works and how these images are planned and composed, how tones should be printed, how subjects explored. Not coincidentally, these are the same issues that help someone who already enjoys photographs learn to appreciate them more, and to open themselves to more genres of photography.

Looking At Photographs by John Sarkowski (Bulfinch, 1999) was an important book in my self-education. It is still available and still very worthwhile to read. It does, however, have a couple of shortcomings. It has no color photography, and as a curator and historian of photography, Sarkowski brings to the book a bias toward talking about processes as much as images—useful perhaps for a student of photography, and even a collector, but not as important to someone who simply wants to make or enjoy photographs.

With digital imaging vastly expanding the interest in photography, more people than ever are taking photography seriously. While much of the book is in color, there is still a need to show the power, the subtlety, and the beauty of black-and-white photography to a new crowd whose cameras shoot color by default. There are many "how-to" books and even "how I did it" books. But there are not many books available that discuss why photographs work from a practical rather than theoretical or philosophical point of view.

I'm the one writing the book both because I can and because I feel the need. I can because of the success of my previous two books—the publisher is willing to run with this idea. I can because I have experience writing about photography in clear, relaxed, and comfortable terms—terms that the average person can relate to. I won't claim there is no art-speak in this book, but I do assure you that you won't need an art degree to understand, appreciate, and take advantage of it.

This book is for any photographer who wants to make beautiful photographs. And it is for anyone—photographer or viewer—who wants to understand why some photographs stand out from all the others. It can certainly be of value to students of photography, but probably not by those specifically studying photography criticism, where art theory and history, philosophy and culture become more important than whether the photograph is beautiful or powerful or meaningful.

In choosing photographs for this book I used as my own source books (I have more than 100 books of photographs in my personal collection), magazines (hundreds of issues of those magazines which celebrate wonderful images), the Internet, and my own life experiences meeting other photographers and hearing their suggestions of still more photographers to consider. As such, it is unashamedly biased toward Canadian and North American photographers simply because I am more familiar with them.

I have tried to push past my own comfort zone in photographic subject and style, being inherently a photographer of fairly conservative tastes. After all, I am a middle aged white guy from Canada. We're known for our niceness, not our pushing the envelop of modern tastes. (OK, we wear weird hats called touques, but I don't think that counts.) I want to open

readers to new ideas of photographs that are not "traditional" or "straight".

My own tastes are firmly based in the highest image quality; that concept does not trump craftsmanship; that being radical is not an end in itself but rather a tool to express ideas that are difficult to express in more traditional techniques. I'm an experienced photographer, with high standards for both my own images and the photographs of others. I have had some success being published and in selling my photographs and it is with this background I chose the images for the book.

This book is about great photographs rather than great photographers. Some of the images I have chosen are by relatively unknown or even less experienced photographers. Some of the photographers are famous, others are not. Some of the photographers have literally thousands of strong images and many books to their names, while others have only made a handful of great images but are poised to make many more.

I have made an effort to search out international photographers and there are some, but not as many as I would like. Women photographers are not equally represented simply because I know fewer women photographers. Some of the photographers were completely new to me, and discovering their work has been a delight, while others are long time friends of mine.

The book is about photography as art. Many common genres of photography are either sparsely represented or entirely absent. You will find no sports photography, and almost nothing of reportage. Each of those subjects has certainly been responsible for many great photographs, but in those images, the subject and the story predominate over the image as art, and quite frankly I don't feel qualified to comment on them.

Enjoy this book as a collection of 52 wonderful photographs. Some you may well know already, but I trust there are enough new images to surprise and delight you. Feel free to flip through the book to simply enjoy the images, but sooner or later, do read about each image, about what I think makes each work, about what the photographer was thinking in making the image, about who the photographer is and how they came to see the way they see.

George Barr, Calgary
July, 2010

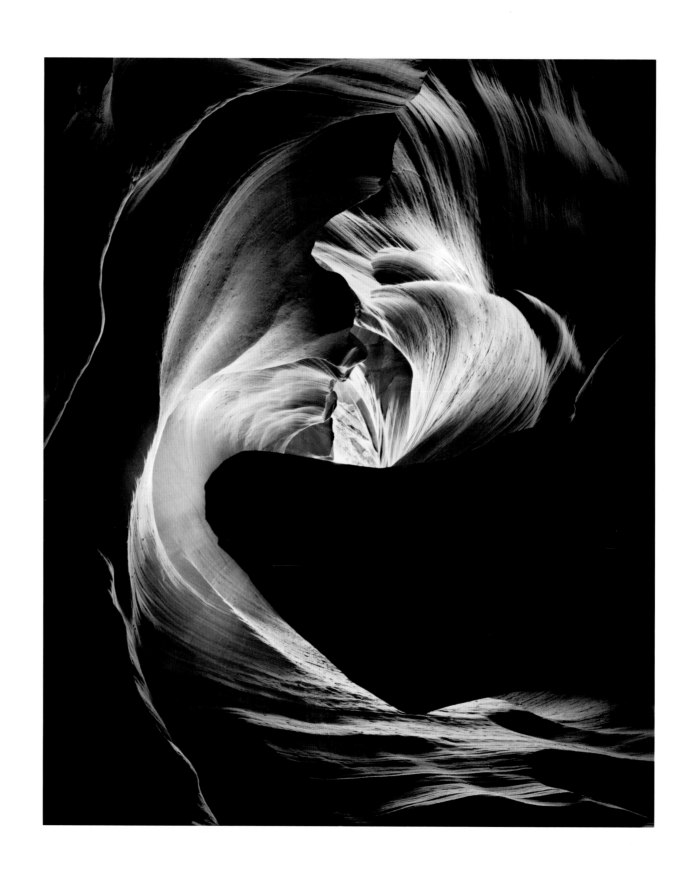

Circular Chimney
1980

GEORGE'S ANALYSIS I have been a fan of Bruce Barnbaum's work for more than 25 years, seeing it first in exhibition and purchasing one of his Antelope Canyon images (page 88 of *Visual Symphony*). I purchased his book and fell in love with his cathedral photographs. I have attended a couple of Bruce's workshops, most recently in 2007 in Nova Scotia. A highlight of that trip was being able to see more of his original prints not behind glass, and seeing some of his recent work.

Although it would be easy to label Bruce as an Ansel Adams acolyte, in fact, Bruce has his own vision that has developed over the years. That said, Bruce asked me especially if I would write about his all-time favorite image, made 30 years ago in 1980. Bruce was the first to seriously photograph Antelope Canyon, and its popularity since, not to mention the downright crowded conditions, bothers Bruce more than a little.

Unlike many photographers who tackle Antelope Canyon, Bruce approached the subject more in the way of raw material from which he could compose an image that reflected his thoughts and feelings on being there (see his description of making the image). It would be more accurate to describe this photograph as one *using* Antelope Canyon than *of* the canyon.

The concept of "from the subject" rather than "of the subject" has been around since the beginning of photography and, in fact, in art in general long before that. It has nothing to do with whether one "manipulates" photographs and has everything to do with how one sees the subject. The color work of the late Ernst Haas is about as different from Bruce's work as you can get, yet they both interpret the subject rather than simply recording it.

Unlike my approach to most of the photographs in this book, I was already aware of how Bruce felt about the image before writing my essay on what makes the photograph work. Fortunately, I do love the image (even if it wasn't the one that I purchased), and writing about its strengths has been a pleasure.

If the best you can say about a photograph is that it is superbly composed, then the image has failed. Composition is merely a tool, a means to an end, a way of emphasizing, clarifying, and illuminating that which the photographer wants to tell us. Bruce has used his powerful sense of composition to help create the "otherworldliness" of this photograph, to create the relationship between the dark center of the image and the surrounding "celestial" forms.

Black-and-white photography is about contrasts and tonality. Beautifully made prints have a richness of tone that belies their two-dimensional origin. They invite the viewer to touch and even reach into the print, stroking or grasping the forms. This is what I feel like doing when viewing this photograph.

With what has already been described, we would have an admirable photograph; but what is it that takes an image from admirable to wonderful? Bruce has his own explanation for why he thinks that might have happened, but my interpretation is that the added element is that of mystery. Sure it's a mystery to figure out what direction the camera is pointing, but I mean more than that. In conversation, Bruce told of how difficult it was to record any detail in the central finger of rock, but I think it is that almost solidly black shape that creates the mystery. Is it a window into elsewhere? Does it sit in front of or behind the other structures? The remainder of the photograph seems to wrap around this structure. In most photographs, the center of interest is the part that is best lit, but here we have the negative, the center of interest is in essence nothing.

It is not immediately obvious that the light areas are sloping away from the camera. It is easy to interpret them as equidistant. Only on closer inspection is it apparent that this is the chimney he refers to in the title. This duality of possible interpretation adds interest to an image. Bruce has given us a puzzle to solve. The curved lines of light stone wrapping around the central "knuckle" remind me of interlocked hands.

Repetition is always a powerful tool, and here there is excellent use of repeated curved lines, starting from the outside of the print and working inward. In the upper-left corner we have four distinct curves and even a short segment of a fifth right in the corner. The lines and edges get tighter until we reach that central dark shape. We have the same idea of repetition in the other corners of the print, yet each corner is dramatically different for all that, adding to the interest.

Some images are like a cartoon—well seen, quick punch line, you get it, react, and leave. Other images have to be gradually understood. Some of the best photographs can capture your attention like a good cartoon and hold your interest like the most sophisticated symphony, offering layers of meaning, from interesting subject to wonderful tonalities and beautiful composition, and then on to deeper layers of emotional reaction and interpretations and associations.

THE PHOTOGRAPHER'S PERSPECTIVE Due to my lifelong interest in forces, which led to two degrees in mathematics and physics, my first impression of Antelope Canyon was one of a cosmic or subatomic force field, not an eroded sandstone canyon. Everything seemed to be swirling around me. It was an overwhelming feeling.

Knowing that forces have no direction—there is no up, down, left, or right—I immediately knew that I wanted to convey the metaphorical feeling of forces rather than the realistic view of a canyon. In other words, I decided to use the canyon as subject matter to say something that meant so much to me. I chose to avoid the canyon floor or anything that could give an indication of scale.

I was faced with an enormous technical challenge: This was by far the most contrasty scene I had ever encountered. Rather than doing the usual thing of exposing the shadows in Zone 4, high enough to get adequate detail, I immediately went to an unusual first-time approach of placing the highlight just below Zone 15 (recognizing that film has such an enormous brightness range), getting as much as I could below that. I then compacted the brightness range in developing the negative. Thus, this image actually represents a reduction in contrast from the scene I encountered.

One can see the image as that of our own spiral galaxy—the Milky Way—swirling around the super-massive black hole at its center. Any of a number of other interpretations could be equally valid, since abstraction allows a wide range of interpretations. This was the first photograph I made in a slit canyon, and it led to two decades of studies in these decidedly unearthly locales. They strike me as the most extraordinary places I have ever photographed, and I am delighted and privileged to have opened up this subject to photographic exploration. It had never been studied previously. Throughout all the years of photographing in these canyons, my initial impressions have never changed; they remain metaphorical force fields to me.

BIOGRAPHY I was born in 1943 and live with my wife in Washington state. Having received a Master's Degree in mathematics, in 1970 I abruptly switched from the sciences to the world of art/photography. I've never had any regrets. In addition to producing photographs, I was almost immediately attracted to teaching photography, first teaching weekend workshops for the Sierra Club in the Los Angeles area, and then developing my own workshop program in 1975. Art and teaching has been my career ever since.

Teaching and photographing have taken me around the world, to a large variety of interesting locales in North America,

from Nova Scotia to Mexico City, Europe, Australia, and South America.

I have combined that with a lifetime of environmentalism in a world that degrades the environment daily, wondering throughout the past 40 years if humanity will ever wake up to the inevitable fact that we're undermining our own existence on the only planet we will ever have as our base.

The photographers who have influenced me are Ansel Adams, Brett Weston (the greatest influence of all), and Jay Dusard.

I write regularly for *Photo Technique* magazine and have been featured in most of the serious photographic magazines over the years. My books include *Visual Symphony* (University of New Mexico Press, 1988, out of print but available used), *Tone Poems 1* (Photographic Arts Editions, 2002), *Tone Poems 2* (Photographic Arts Editions, 2005), and *The Art of Photography: An Approach to Personal Expression* (Rocky Nook, 2010).

Information about me, my workshops, and a few of my thoughts are available at www.barnbaum.com.

TECHNICAL The photograph was made with a 90mm lens on my 4×5 Linhof Technika camera, using TRI-X film. The exposure was made at f/45 for 3½ minutes. The exposed negative was developed in my extra-dilute "compensating development" process for 11½ minutes, during which I immensely reduced the inherent contrast. The print has been made on several types of enlarging papers over the years, with burning and dodging, but no bleaching.

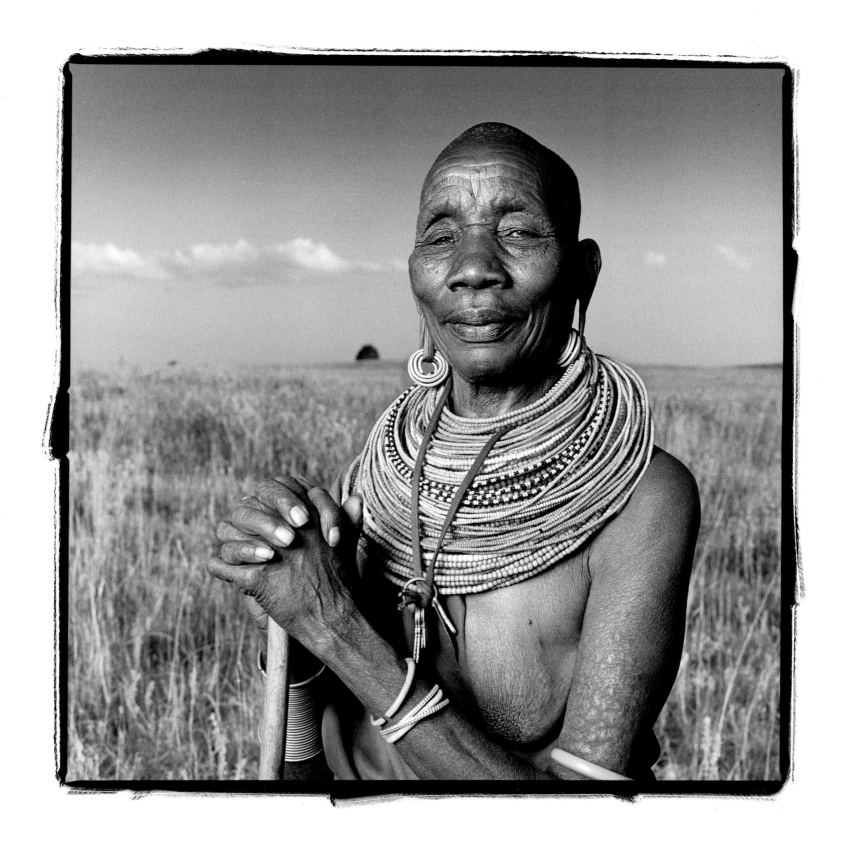

Iparo
1997

GEORGE'S ANALYSIS In this photograph of Iparo, I feel like I have met an amazing woman, even come to know her in some small way. Her face shows pride in her family, a sense of satisfaction with life (don't we assume all third-world people are less happy than ourselves?). I suspect she thinks we're the odd ones and she finds it amusing, perhaps even being sympathetic that our lives aren't as rewarding as hers. I have been privileged to see the world through her eyes, and it isn't anything like what I expected.

It has become common for enthusiast photographers from developed nations to visit the third world and photograph the "natives." Some do it better than others, but one can't help but feel that this "drop in and shoot" style of photography is somehow just a little distasteful. The idea that some odd-looking stranger from a faraway land would stop me on the street and ask me to pose in my "traditional" Calgary clothing is more than a little bothersome. That they would want me to wear a cowboy hat and boots (I don't own any) would seem positively absurd, yet that is exactly what westerners do all over the world. Some of the photographs made this way are quite excellent, but in the end are no more than a catalog of interesting faces.

Phil has managed to photograph a person, a life, an attitude, a tribe, and a culture. This is the difference that an artist with experience and commitment to both their work and the people they photograph can bring to their image making.

The background tells us a little of Iparo's circumstances, probably grassland or field. Her hands rest on the handle of an implement, so perhaps she is a farmer or manages livestock. Her hands, however, show well-cared-for nails, suggesting that she doesn't work any harder than we do deadheading our pansies or collecting the

dog droppings from our backyard gardens. Perhaps her life isn't one of suffering and misery after all. The rings of beads speak to tradition and tribal custom, possibly even wealth, the stretched ears of ritual. What about the keys round her neck — do they belong to her BMW, her home (hard to reconcile a grass thatched shack with a locking door), or to the village tractor? Are our preconceived ideas even further from the truth than we guessed?

The split color of the image helps emphasize the subject and gives the image power that might be missing from either a straight black-and-white print or a full-color one. Once again the tools and techniques have been carefully matched to the intent of the project, a means and not an end.

The folded hands suggest peace and contentment, the pose confident. The lighting brings out the character in the face without overemphasizing lines. The camera position is lower than the eyes, imbuing the subject with respect.

Viewing this photograph makes me want to sit down with this woman, to learn more of and from her, to hear of her insights into life and living.

THE PHOTOGRAPHER'S PERSPECTIVE In 1997 I was working in the Samburu territory of Northern Kenya when I was introduced to Iparo. She was the mother of my guide, Abdullahi. Abdullahi was in his early 40s and had 11 brothers and sisters. He also introduced me to his youngest brother, Laquoi, who had just turned 23. When Iparo told me she was 85, I started doing the math—this couldn't be! I looked at Abdullahi in disbelief as he translated his mother's words. "She gave birth when she was 61?" I asked. He said, "Yes, she's a strong woman." Abdullahi also told me that her husband had just died and that she had recently been chased from her home by the violent cattle raids that periodically occur in their territory.

Watching her as she relayed her story, which was punctuated with a lot of animated arm movements and laughter, I began to get a sense of her strength and mental flexibility. Here was an elderly woman who had just gone through some extremely difficult life experiences yet had the demeanor of someone half her age. I thought to myself, "What does she know that I don't?"

I asked to do her portrait outside in the hot sun against the flat, dry landscape. She was an easy subject. She stood straight as an arrow and looked directly into the lens. There was absolutely no self-consciousness. All her strength of character came through. I just stood there in total admiration as I clicked the shutter.

BIOGRAPHY It was the late 1960s and I was living in the Haight-Ashbury district of San Francisco and attending the School of Dentistry at UCSF. I was given a work-study job with an epidemiologist who was writing a paper on the spread of hepatitis in the Haight. It was my job to interview the hippies on the street about their IV drug use. To keep my day interesting, I would choose the most interesting looking subjects for my interviews. I eventually took out a student loan and purchased a Minolta SRT 101 and began making portraits of my interview subjects. I fell in love with the process and found myself spending hours in the community center darkroom. After graduation I put all my energy into my orthodontic practice and set my love of photography aside.

Eighteen years later I took out my old SRT 101 to record the birth of my son Dax. I didn't have a darkroom to process or print the TRI-X film I had shot, so I checked into a nearby community college to use their darkroom. I had to take a course to get darkroom privileges, so I ended up in a portrait class with an amazing photographer and inspirational teacher named Ron Zak. My love for photography was rekindled, and within a year and a half I had sold my dental practice and moved to Seattle to begin my new career as a photographer. Dax recently turned 24 and I have never looked back.

These black-and-white silver gelatin prints are selectively toned in sepia toner. They are not hand colored with oils or dyes. I print on Ilford Multigrade IV paper and tone the prints with Kodak sepia toner. The sepia toner changes each silver halide crystal in the print from black to sepia color. I prefer this method to hand coloring because, unlike oils or dyes, sepia toning is very archival. Also. this method allows the white areas, where there are no silver crystals, to remain white. I protect the areas of the print that I don't want to sepia tone with a sheet of frisket. (Low Tac Frisket can be found at any art supply store) and a liquid product call Maskoid (used by airbrush artists). After making the black and white print, I cover the part of the print I don't want to tone with the frisket and Maskoid leaving the areas I want to tone exposed. I then immerse the print in the toner and the chemical transformation that produces the sepia color takes place—just in the areas of the print not covered by the frisket.

For 20 years now I have been living with and documenting the indigenous and tribal cultures of the world, attempting to create a relationship between the viewer and the subject, through both the images and the stories of the people photographed. I joined and started working with Amnesty International. I founded "Bridges To Understanding," an online classroom program to connect youth worldwide. Mentors help students create photostories of their lives. I have hosted programs for *Discovery* and *National Geographic* and continue to travel and photograph.

I have been influenced by Ron Zak, Richard Avedon, Edward Curtis, Robert Mapplethorpe, and Irving Penn.

The following books containing my works have been published: *Tibetan Portrait: The Power Of Compassion, Enduring Spirit* (Rizolli, April 1996), *The Gift* (Interplast, Dec. 2000), and *Women Empowered* (Rizolli, Feb. 2007).

My website is www.Philborges.com.

TECHNICAL The photograph was made with a Hasselblad on Tri-X Film, with supplementary lighting via Lumedyn portable studio light. The image was selectively toned as follows:

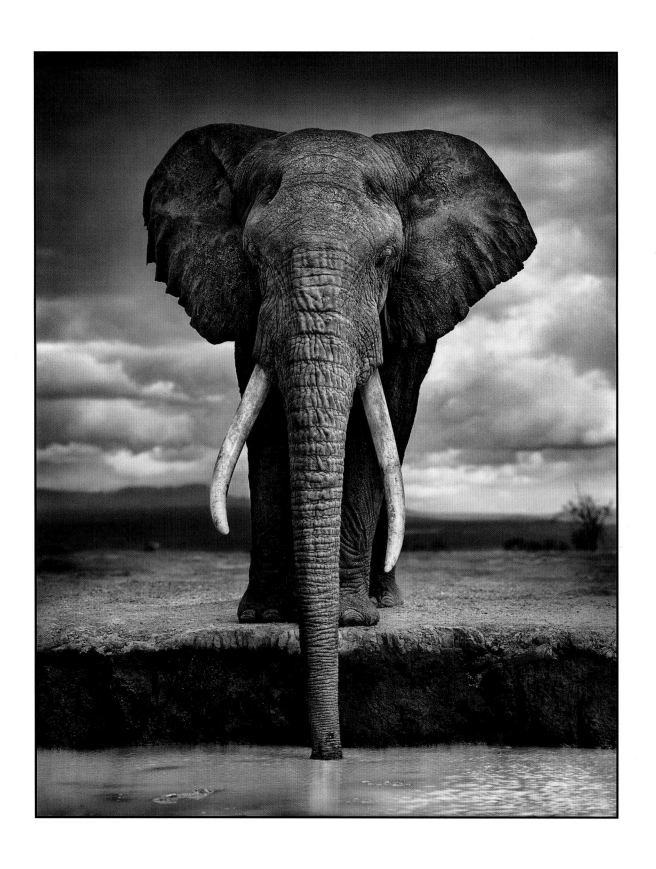

NICK BRANDT

Elephant Drinking
2007

GEORGE'S ANALYSIS With many ties to classical formal portraiture, Nick Brandt brings us a unique view of African wildlife. Gone are the tight head and shoulders, extreme telephoto color images we are used to seeing. Here we see the animal's environment and its interaction with that environment.

On the one hand, this animal is clearly of Africa, and yet there is a sense that the portrait could have been a staged image in a studio. The portrait lighting and the darkened edges suggest indoor, artificial lighting—perhaps implying that these animals are soon to exist only in urban displays. On the other hand, there is dignity in the portrait, a magnificence to the beast. The water clearly shows this was not some studio work, contradicting the other clues.

The lighting is perfection, showing the rugged texture of the elephant while maintaining tonal gradations in the ears. The light is stronger from our right, soft enough to show detail in the shadowed bank while also recording highlights on the tusks.

The pose is almost square on, but with sufficient asymmetry to suggest a naturalness—one hind leg showing, the left tusk lower than the right, the lower edges of the ears uneven, the highlight on the water on our right, and something in the water on the left. There is only one middle-distance bush in an otherwise simple background.

The dark tones are of a depth that has strength to them while retaining plenty of texture, both in the right foreleg and the bank. There is clearly vignetting around the head of the elephant, just as in traditional portraits. The image might have been made 100 years ago.

The concept that this is a wildlife portrait, shot from close range, with nothing more than a shallow pond or stream to separate the photographer from this wild animal in its own environment gives pause for thought. Nick discounts the danger to himself in the situation. The incongruities of the image on top of the excellent tonalities are more than a little disturbing. They raise questions and cause uncomfortable thoughts: indoors or out, new or old, stuffed or live, a happy future or not, to be admired or pitied? That is a lot for a single photograph to engender.

THE PHOTOGRAPHER'S PERSPECTIVE

I photograph animals in the exact same way I would a human being. I regard every animal as a sentient creature as equally worthy of life as us, and that informs how and what I frame every time I look through the viewfinder.

It's also one of the reasons I don't use a telephoto lens. I prefer to get close to the animals and shoot them in the same way, with the same lens, one would usually shoot a portrait of a person. You wouldn't take a portrait of a human being from a hundred feet away and expect to capture their spirit or personality; you'd move in close. Also, by avoiding telephoto lenses, I see as much of the sky and landscape as possible. I want to frame the animals within the context of their environment, their world.

Sometimes I return to the same animal that has drawn my eye day after day, stretching into weeks, as I attempt (but often fail) to get the right shot. However, in the case of this image, I had only a few seconds to shoot a few frames when we came across this particular elephant one late afternoon at a small, temporary watering hole.

On the contact sheet, I was drawn to this particular frame because it almost seems as if it was shot on a soundstage, with the set blending into the scenic backdrop of sky, and the elephant in a spotlit pool of light. (As a director, I had built sets that looked just like this).

There are not many bull elephants left in East Africa with tusks this size. Eight years ago I saw elephants with tusks down to the ground. Sadly, I recently discovered that this beautiful elephant, aged 45, was murdered by poachers in October 2009 in response to the growing demand for ivory from China.

In the last few years, the demand for ivory in China has exploded once again. Ivory sold for around $400 a kilo in 2005; today it sells for around $6,000 a kilo. Estimates are now put at around 30,000 elephants being killed every year, which is something like 10 percent of Africa's elephant population. The majority of this seems to be financed by Chinese business cartels. Urgent action is needed now, just as occurred during the dark days of the 1970s and 1980s before the ivory ban was brought in. Now, unlike then, there is less land, more people, and a far greater level of organization to the killing and destruction.

In this regard, the somber quality of the image makes it the obvious choice for the cover of my book titled *A Shadow Falls*. As Peter Singer wrote at the end of his introduction to the book, "The shadow that falls across the land is our own."

BIOGRAPHY Originally a painter, I first switched to film because I wanted my images to move and to be put to music, as music affects me more than any other art form. Then in 1995, I was directing a music video for Michael Jackson called "Earth Song," which I had scripted to deal with the various ways in which man was destroying the planet. The destruction of Africa's wildlife was a natural part of that, and I chose Tanzania to film the African section. I found myself entranced by the animals and the landscape, in all the clichéd ways that most people generally are. Meanwhile, I was more and more desperate to combine my passionate love of animals and what they mean to me, with my need to create visually. I saw a way to do that here in East Africa. And so finally, in 2000, I happily switched careers to photography. So my love of animals came first, with photography merely the chosen method to capture that. At the moment, it's all I want to photograph for the rest of my life.

No single photographer particularly influenced me, but early Edward Steichen is what captivates me the most.

My photographs have been published in *On This Earth* (Chronicle Books, 2005), *A Shadow Falls* (Abrams Books, 2009), and *On This Earth, A Shadow Falls* (Big Life Editions, 2010), which combines the best photos from the first two books.

You can also see the work at www.nickbrandt.com.

TECHNICAL This photograph was taken on a Pentax 67II with T-MAX100 film. The photograph exists in a limited edition of eight 56" × 73" archival pigment prints, as well as smaller sizes.

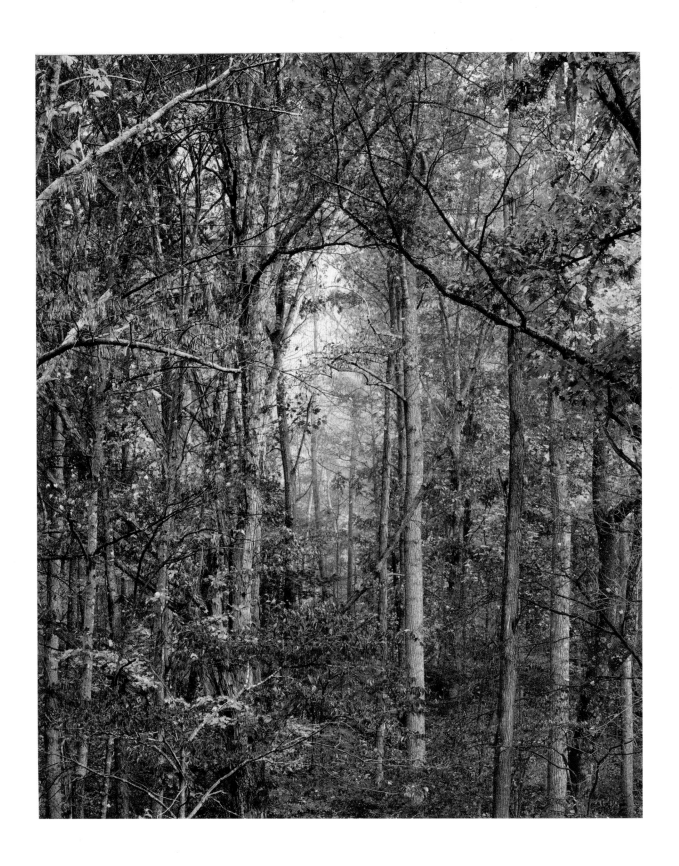

Glowing Autumn Forest
2000

GEORGE'S ANALYSIS The usual fall color photograph relies on drama rather than subtlety, saturation instead of pastels—the images are rarely moody or atmospheric, yet mood and atmosphere is exactly what Christopher Burkett has photographed.

The obvious center of interest is the fall colors, but in fact I think the real center is the misty trees in the distance. Everything else, even the brighter leaves, is the framing, the introduction, and the counterfoil to the subtle tones in the distance.

The pink glow and the pastels of the distant trees make it look like there is magic in the air. Anything is possible. Is this where unicorns come from?

Although at first glance we have a jumble of colors, careful perusal of the image reveals some order. The various branches and the gap in the nearby bigger trees all act to present the distant mist to us. Notice the alternating pattern of diagonal branches above the mist, the steeples that Christopher sees forming a cathedral. The green leaves are nicely distributed down both sides near the top, in the center of the top of the image, and again at center bottom.

Although we might describe the light in the foreground as flat, notice that the left side of each tree is dark, separating the trees without making them appear harsh.

Photographed with an 8x10 camera and recording exquisite detail, this photograph really achieves its full glory in large-sized prints, impractical for the book, but something for us to look forward to seeing. Even seeing it on-screen and being able to zoom in, the trees open up, spaces between become more prominent, and the mist more obvious. Individual leaves take on shape and varied tone.

Photographing such a complex subject with literally hundreds of elements is challenging. It is necessary to bring some sort of order to the chaos. Master photographers do so through repetitive patterns, connections made across the image, and through the use of framing objects and changes in tone to help us make sense of the complexity. The reward in doing so successfully is an image that can be understood at a basic level at a glance yet rewards the repeat visitor with new discoveries on each viewing.

THE PHOTOGRAPHER'S PERSPECTIVE

Ruth and I had camped at Sherando Woods in Virginia, which is a beautiful area managed by the U.S. Forest Service. We awoke early one morning to find the scene set for a potentially worthwhile photograph. There was no wind and the forest was arrayed in brilliant hues from the huge variety of hardwood trees in the peak of their autumn colors.

We carried two-way radios with us so we could communicate as I walked among the trees and forest looking for a photograph. The fog was on the lake but also filtering through the trees, and the sun was above the horizon but had not yet struck the steep mountain valley where we were. All was quiet, and I knew there must be an image somewhere if I could but see it.

As I moved slowly, carefully and quietly looking and contemplating the untold thousands of potential images around me, suddenly all of the elements came together in precisely one spot. The three-dimensional forest elements aligned in a particular way to form the image that you see here. The forest fog was lit from behind the scene from the sunlight striking the mountainside and reflecting off the distant colored leaves. Yet the foreground trees remained clear and free of fog. I knew the scene would disappear in only a few moments and called Ruth on the radio to bring the equipment to where I was located.

Moving quickly as a team, in just a minute or two we set up the 8x10 camera. I carefully focused the camera as Ruth adjusted the f-stops on the lens, allowing me to check my focus and maximize the depth of field, which was crucial for the image to be successful. I held my breath, hoping the wind would not pick up nor the glowing fog dissipate. I was able to make one exposure, which was slightly less than one second, and then quickly changed the film holder and made a backup exposure just to be safe. But even in the short time it took to make a second exposure, the image had significantly changed and only the first image has the luminosity and drama that convey the feeling and inspiration that I felt.

Of all of my photographs, perhaps this one embodies in one single image what I've been trying to accomplish in over 30 years of photographic work.

To me, this image has a cathedral-like quality, filled with light and peace, and it's a reminder of God's grace that fills the world and touches and enlivens every soul.

BIOGRAPHY I was born in 1951 and was reared in the Pacific Northwest. In 1975, while I was a brother in a Christian order, I became interested in photography as a means of expressing the grace, light, and beauty I saw present in the world of nature. Over the next 20 years, I gradually perfected my craft so that photography could be the means through which I could express my innermost feelings and inspiration. Today I work almost exclusively with color 8x10 transparencies.

In 1979, I left the brotherhood to pursue photography and married my wife, Ruth. I learned the offset printing process and ran four-color printing presses and laser scanners to create detailed color separations. These years of experience in the printing trade helped develop my fine discernment of color and gave me a deep understanding of the principles of color and tone reproduction.

Most of my time is spent in the darkroom, carefully making my prints by hand, which allows about one month each year to travel and photograph. I have also taught several workshops sponsored through the Friends of Photography and Anderson Ranch Arts Center.

My influences are Ansel Adams, Ernst Haas, and numerous color landscape painters.

My website is located at www.christopherburkett.com.

TECHNICAL I use a Calumet 8×10 camera and color transparency film. I personally make all my Cibachrome (Ilfochrome) exhibition prints by hand, using sophisticated and unique masking techniques. I start with 6×6 cm or 8" × 10" transparencies and make prints up to 40" × 50" in size.

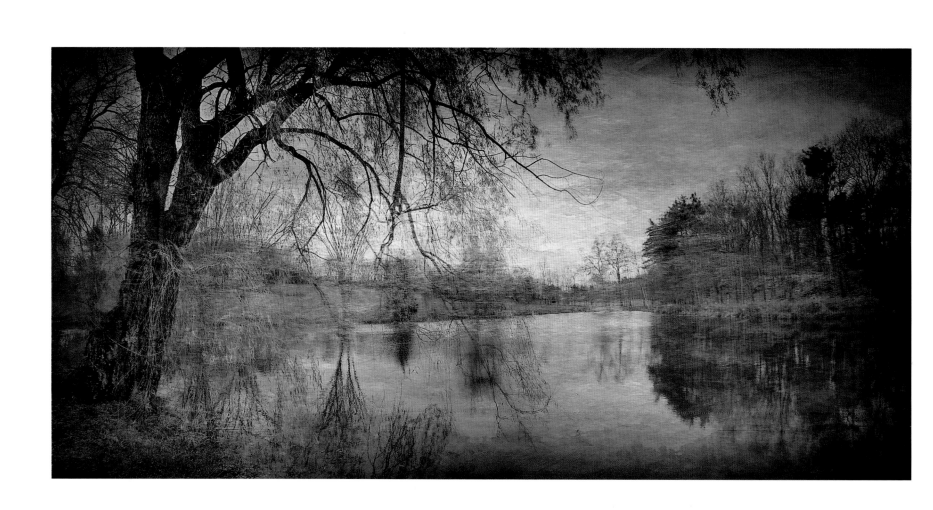

DAN BURKHOLDER

Tree and Pond in Fall
2009

GEORGE'S ANALYSIS Dan Burkholder has a reputation as both fine art photographer and innovator. He'd done a series of interesting images of the damage from Hurricane Katrina, which I had seen published. I knew he sometimes uses alternative processes (digital or otherwise) to create his images. He published a book on the making of digital negatives. Going to his website, I was greeted by his latest project—photographs taken with his iPhone, with image editing also on the iPhone. Normally I'd greet an idea like this with considerable skepticism, but these images were beautiful, looking like old master landscape paintings.

Although this photograph is a rather ordinary rural composition, it is the color and texture that make this image. The vignetting (darkening of the edges) contributes to the antique look of the scene, as if the image has darkened over many years with layers of varnish hiding the image along the edges and warming the colors.

The strength of the photograph is in the handling of color and in the overall presentation. Unlike simple photographic tinting in which typically large areas are colored with a single wash, here we have changes in color on a very small scale, as if these were brush strokes from a palette of generous proportions, exactly as a skilled painter would use, while at the same time entirely avoiding the look of fake paintings. The subject is something that most of us can relate to: rural, pond, late fall, low sun, peaceful, still, a refuge from the city. The presentation reminds us of our youth, grandparents, neighbors, or a day away.

Dan has stitched together several images, but with the iPhone's automatic exposure and less than perfect stitching, we see ghosting, as if some of the elements were not entirely there. Given the painterly presentation, this deviation from reality seems entirely appropriate, giving the image a sense of movement as

well. Dan shows very skilled use of his tools and a thorough knowledge of their limitations. Moreover, he knows how to work around their limitations and most importantly (and separating the artist from the worker) he knows how to take advantage of these limitations to make something wonderful.

The concept of using a cell phone to make serious photographs, images with artistic merit, is analogous to photographers using Polaroid SX-70 to make images and then manipulating them at a cafe table within minutes (for an example, see Elizabeth Opalenik's photograph in this book). Galleries have long accepted those as legitimate art, so why not cell-phone work?

Really, the difference between an image captured on a cell phone and one taken with the best and most expensive digital equipment is mostly about the number of pixels and about how spontaneous and relaxed one can be in making the image. When multiple photographs are used to stitch the final image, size is no longer limited by the equipment. Dan tells me prints up to two feet square have been made full of detail.

THE PHOTOGRAPHER'S PERSPECTIVE It was the fall of 2009 and I'd just returned home from an out-of-state teaching trip. I'm always glad to return to the *shire* of Palenville, New York, with its waterfalls, woods, and backdrop of the Catskill Mountains. On this day, I was particularly happy to relax with a motorcycle ride through the local countryside.

I'm never without a camera. Decades ago I heard Jerry Uelsmann describe how the very act of having a camera with you makes you more aware of your surroundings. That advice made so much sense that I'm practically neurotic about having one camera or another with me at all times. Heck, I've been known to turn around and go home to fetch one on those rare occasions I've forgotten.

Discovering a new country road was the first delight, but spying the classic composition of the tree and pond really turned my head. As a photographer, I'm always on the lookout for beauty and/or visual intrigue; if either (or more likely a combination of both) captures my eye, you can bet I'll try to get the image on a sensor. It seems that I'm finally developing good before-shutter editing sense. That is, I'm getting better at feeling the potential for a good photograph rather than just clicking away. It's funny that this skill comes so far into my career, when image capture is so much easier and cheaper than when I started making photographs.

As one who rarely shoots in sunlight, I found that the early evening light with the glow of sunset framed the tree and pond perfectly. An iPhone was used to capture a series of images that I stitched together at the scene. As one who counts his time with the medium in many decades, I can't help but be amazed (and amused) that the creative process can now find me leaning against a Ducati in the countryside combining a series of images in the palm of my hand. Photography is a brilliant engine that powers just such amazing journeys.

BIOGRAPHY My seminal moment of artistic and career commitment came in 1975 when I put a fist through my apartment wall. Though violently expressed, it was suddenly clear that if I didn't make a serious run at photography, I'd wake up at 75 with a giant heap of regret. That didn't feel like a formula for a contented old age. Brooks Institute of Photography was the antidote, and two degrees later I had the raw materials to tackle the technical aspects of my chosen medium; the artistic facets would come via other explorations.

Like so many artists, my wife Jill and I find that our income pie chart comprised print sales, teaching income, publishing (both our own efforts and writing for others), and a bit of stock photography sales. In 2007 we moved to Palenville, New York, where we have an amazingly beautiful environment for living along with a much more attractive setting for workshop students who come to study with us in our studio.

I was one of the pioneer adopters of digital technology in making fine prints, starting in the early 1990s, from digital negatives for platinum printing to the iPhone today. I can't wait to see what happens next in the world of photography.

My influences are Jerry Uelsmann (who never takes himself too seriously), John Sexton (whose mastery of tonality has always been an inspiration), and Tom Millea (an artist and friend whose insights and perception continue to inspire me 25 years after first meeting him).

In addition to the images and articles that have been included in numerous publications internationally, I have published the following books: *Making Digital Negatives for Contact Printing* (Bladed Iris Press, 1995; 2nd Edition, 1999), *The Color of Loss: An Intimate Portrait of New Orleans after Katrina* (University of Texas Press, 2008).

You can see my work at www.DanBurkholder.com and www.iPhoneArtistry.com. My email address is info@DanBurkholder.com.

him that indeed the ability to work on images right there at the scene was part of the joy, Sean commented that this approach was similar to plein air painting in which the artist takes easel and canvas into the environment rather than working from memory (or photos) back in the studio.

As I always tell my students, "There is no virtue to difficulty," so the final four percent of image tweaking (color correction, final sharpening, etc.) is done on a "real" computer with Photoshop. This image is printed on an Epson 9900 using beautiful Museo Max paper. The colors from this combination are second to none. I should add that, as much as I love Epson printers, I despise Epson software. Imageprint (a third party, RIP software by ColorByte) is the printing solution, saving me tons of ink, paper, and time.

Though one could dig into the iPhone JPEG metadata for shutter speed and ISO (they are both adjusted automatically by the iPhone to create a proper exposure), there's not much point since the photographer really has no input in that technical regard anyway.

TECHNICAL　For this image, I shot a mosaic of images with an Apple iPhone. I say "mosaic" because a single shot could capture neither the scope of the scene nor the tonality I wanted in the final print. Stitching on the iPhone (yes, on the iPhone, not in Photoshop) was the solution. Overlapping the 19 images provided both a wide-angle perspective and, thanks to the varied exposures in the to-be-stitched series, a quasi HDR effect that helped preserve velvety shadows and milky highlight detail.

Fellow photographer and friend Sean Duggan asked if I actually processed my iPhone captures in the field. When I told

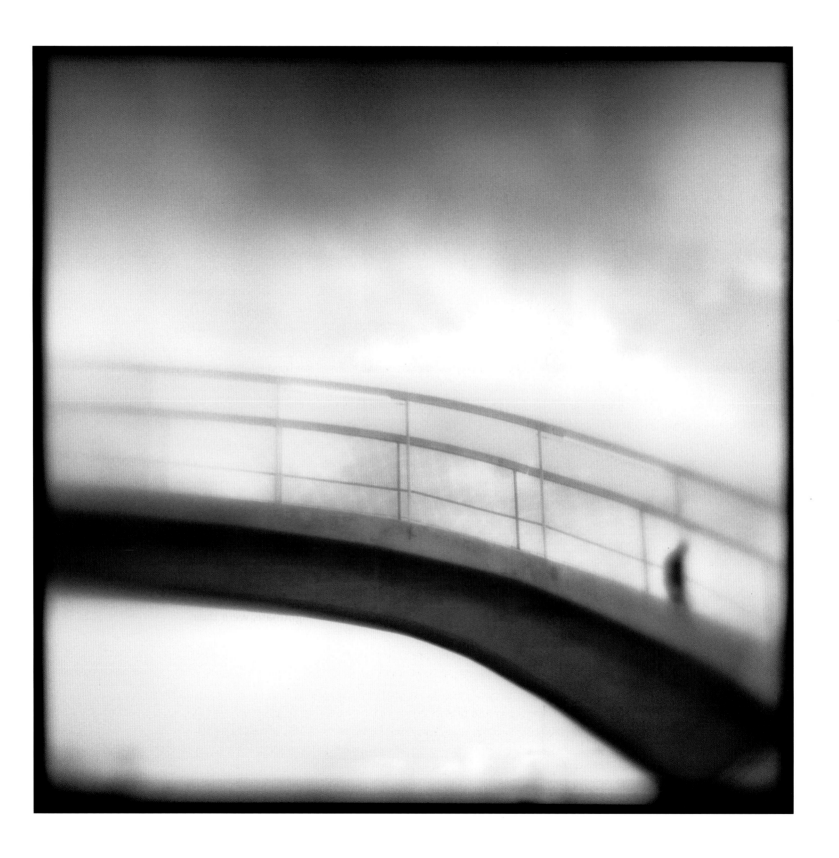

Bridge To Nowhere
2006

GEORGE'S ANALYSIS Magazines are full of highly detailed images, sharply rendered and usually with little room for the viewer to interpret what they are seeing. The concept of blurring an image is hardly new, and with Holga cameras and Lensbaby lenses, blurred images are actually becoming quite common. What is apparent is that of those images, a tiny percent really make effective use of the tools, and none look quite like Susan Burnstine's image.

In rendering the subject in soft, flared, mostly blurred tones, everything surplus to the message has been eliminated. We see a person nearing the end of their journey across the bridge. There is only enough information to identify it as a bridge and a person and no more. The subject could be anyone; the bridge located anywhere.

This allows us great flexibility to interpret this image in a myriad of ways. That Susan titles the series *On Waking Dreams* shows that she is thinking in terms of "not quite real." One could even interpret this image as a nightmare, were their thought processes inclined that way.

Is this a man or a woman? Where are they going? Their back seems humped—weary or sad? The tonalities are anything but cheerful; therefore few would interpret this as someone off to a great party.

We are completely free to take on the persona of the bridge crosser. Suddenly this is us at the end of our journey: The sadness is ours, the burden personal.

While I am not normally a fan of fake or even real film carrier borders for an image, or the bubbles and streaks from a supposed Polaroid, or heaven forbid, film numbers and sprocket holes, I do like the simple black border, ill defined and asymmetrical in this photograph. It does nothing to distract from the image and, on the

contrary, frames it nicely. The soft focus image allows for some lovely tonalities, which give the image a wistful sense rather than outright tragedy.

That the figure isn't the sharp part of the image adds to the sense of moving on, perhaps the best already behind us. The sky is foreboding, yet not so dramatic as to spoil the subtleties of the image. Perhaps it's raining and that's why the figure is slumped—but we don't know. I have a sense that the increased blurring of the left side of the bridge implies that one cannot go back, memories of the past dissolving.

You may well be thinking that my interpretation of the image is total nonsense, but that's just the point; you will interpret the image through your eyes and your experience, your biases and your mood of the moment. The photographer is facilitating that opportunity, with some nudges based on how the image was framed, what was made sharp and what was blurred, and how the tones were printed.

I strongly recommend you check out Susan's other images from the same series to see how she has used her tools to create a variety of moods, stories, and interpretations.

While we normally think of photographs as informing, illustrating, and explaining, sometimes they are reflective, showing us ourselves, giving voice to our feelings, aspirations, thoughts, worries and regrets, and our memories and dreams.

THE PHOTOGRAPHER'S PERSPECTIVE *Bridge To Nowhere* is part of my *On Waking Dreams* series, which is the first installment in the trilogy *Within Shadows*. This body of work explores the fleeting moments between dreaming and waking—the blurred seconds in which imagination and reality collide.

This image was shot in 2006, midpoint in the series *On Waking Dreams*. The images in this first part of the trilogy focus on my own dreams, which I journal as I wake, then shoot that very same day. To create the images, I recall a significant metaphor, contemplative moment, or pathway into the

unknown from a dream the night before. I then capture the fading memory on film using details from my own imaginings to tap into the collective unconscious.

What is particularly remarkable about *Bridge To Nowhere* is that the final image is the exact vision I awoke with—not a metaphor or an interpretation. And it was captured only an hour after waking. The location where this was shot is a 30-minute drive from my home. So basically, I got out of bed, grabbed three of my cameras, put my dog Blue in the car, and drove (virtually half asleep) to Santa Monica. A large part of my process is that I remain in somewhat of a dream state when shooting, so my best advice is never to be a passenger in my car when I go out to shoot in the morning.

The actual shooting of this image was tricky, since I photographed it with one of my 21 homemade cameras and lenses that can be wildly unpredictable and technically challenging. The cameras are primarily made out of plastic, vintage camera parts and random household objects. They have one to three shutter speeds, and the single element lenses are molded out of plastic and rubber. Learning to overcome their extensive limitations has forced me to rely on instinct and intuition—the same tools that are key for attempting to interpret dreams. One final piece of trivia is that because each camera has a distinctive sound or trait, I name them all after famous musicians. The camera used to shoot this image is named Johnny Cash.

BIOGRAPHY I am a fine art and commercial photographer, originally from Chicago and now based in Los Angeles. I am represented in galleries across the world, regularly teach workshops, and write for several photography magazines, including a monthly column for *Black & White Photography* magazine (UK).

My love of photography began at the age of eight when my mother gave me a vintage camera to play with. I was instantly hooked. I then studied photography in a four-year program in

high school, worked for a top commercial and occasion photographer in Chicago, then left to pursue a few different careers in the entertainment field for 10 years.

Photography reemerged in my life in the mid-'90s when I became a commercial photographer once again. Then in 1999, my mother's sudden death initiated a number of major life-changing events, including debilitating nightmares that re-emerged from my childhood.

As a child, I suffered vivid nightmares that stayed with me for days. Often, I would walk around not sure if I was dreaming or awake, as the lines between the two remained blurred. In order to deal with the traumatic effects from these nightmares, my mother taught me to draw and paint my nightmares. The practice proved effective, so when the nightmares returned in 1999, I decided to make sense of it all by trying to capture my dreams on film.

For years, I tried various conventional cameras, but the results did not satisfy. In 2003, a friend gave me a toy camera as a way to keep my creative juices flowing, but after a few months, I became bored by the lack of challenge. I then started modifying toy cameras to have close–up lenses, telephotos, and so on, but that failed to sustain for more than a few months. After molding my own homemade lens out of plastic, I tried it on a toy camera and was struck with the idea to build my own cameras as a means to being able to visualize and communicate my dreams from the previous night on film. The results were interesting, but the camera was limited. Following a discussion with my late father, Philip, he inspired me to build my own lenses and cameras when he reminded me of his personal credo, "If it doesn't work make your own."

In March 2005 I built my first homemade lens, thus beginning my path of making over 20 handmade cameras and lenses out of plastic, vintage camera parts, and random household objects. These rudimentary cameras are frequently unpredictable, but the results continue to challenge and inspire.

In the body of work *Within Shadows,* I would awake, write my dream down in a journal, and then go out the same day to capture my visions on film. There's no previsualization involved in terms of setting up a shot. Serendipity, instinct, and chance are an essential part of the process. The first successful image in this body of work was shot in June 2005 *(In Passage)* and the last was completed in March 2009.

In January 2007, a chance meeting with photographer Dave Anderson at Photo LA led to an introduction to Susan Spiritus, who subsequently became my first gallery representative that very same day. I am now represented at seven galleries worldwide, and I regularly teach classes and workshops across the country for organizations such as PhotoNola and Texas Photographic Society. I am also a frequent reviewer and juror for festivals and contests.

I am influenced by the impressionist painters more than any other art form as that's what I immersed myself in as a child. Once I became a serious photographer, various pictorialists had a strong influence on my work: Stieglitz, Steichen... but work such as Sally Mann's later series such as *Deep South, What Remains,* and *Proud Flesh;* and James Fee's imagery speak to me the most.

My work has appeared in *B&W Magazine, Photo District News (PDN), Rangefinder, ARTWORKS Magazine, SHOTS Magazine, Black & White Photography* (UK), *CameraArts, Professional Photographer, Photo Magazine Romania,* and *Kamera & Bild.*

You can see my work at my website, www.susanburnstine.com.

TECHNICAL I shot this image with a homemade camera.

Pillow of Sickness
2009

GEORGE'S ANALYSIS Several of the photographers with whom I was familiar and who signed on early for this book recommended the work of Brigitte Carnochan. Contributor recommendations have been a wonderful tool to introduce me to other great photographers, to broaden my horizons, and to push me to consider work previously a tad outside my comfort zone.

On her website, Brigitte has hand-painted flowers and nudes, montages of historical images that form a story, and most recently, a series she calls *Floating World*. These images are layers and blends of figures and botanicals. The images are in soft, monochrome brown tones, reminiscent of platinum prints.

I selected this photograph for the marvelous tonalities of the roses and the soft tones of skin, in a simple yet powerful composition. I feel I could cup the image in my hands, caressing the delicacy of the flower on one side, the softness of skin on the other.

The flowers face forward, while the figure turns her back and hides her face. We don't know if this is simply a pose, but I like to think that she is asleep, dreaming of the flowers. Perhaps the flowers are literal, but they could indirectly refer to her flowering sexuality.

I had not fully understood Brigitte's concept behind making this photograph until I contacted her, learning that these are her interpretations of translated Japanese poems. Now that I know the origin of the photographs, it still doesn't limit my interpretation in any significant way, but it does help me understand how Brigitte conceived of the photographs.

The pose frames the dark hair, revealing the breast beautifully against the dark background. I love the feet, the line of light defining the edge of the foot. The feet

and cloth on the right match the lower petals on the left, linking the two halves of the photograph.

The tonality of the two elements is amazing—very little tonal variation from the lightest to darkest petal, yet each petal beautifully separate. The figure is wrapped in the same soft lighting, the curves, lines, and forms of the body subtle yet defined.

Where normally students are taught to avoid dividing images down the middle, here it makes perfect sense to divide the image into two equal parts, forcing the viewer into considering the similarities and differences, the connections and implications of the two halves. There is also a triangle, its peak the model's wrist, the left side made from the forearm and two roses, the base from the loose petals and the model's feet, and the right side from the model's back. This ties both sides together. This concept of separate but together is a potent compositional design.

The soft brown tones of the image do suggest some sort of woodcut or lithograph even though no such process could portray the fine detail and delicate shadings of the photograph. It isn't hard to imagine this as some sort of Asian artwork. Brigitte explains that the calligraphy tells us the name of the original poet.

The kanji calligraphy has a beauty to it, with color muted and size not dominating. The characters give us the poet's name and at the same time declare homage to the traditions of Far Eastern art going back thousands of years. That I can't read the characters is irrelevant.

THE PHOTOGRAPHER'S PERSPECTIVE While rummaging through a used bookstore in Princeton, New Jersey, I discovered a volume of poems translated in 1977 by Kenneth Rexroth and Ikuko Atsumi. The poems were by Japanese women from the seventh through the twentieth centuries and represent all the major styles during this period—from the classical to contemporary schools. I was immediately drawn to the poems, and as I read them—so allusive and rich in imagery—I knew that I wanted to make their photographic equivalents. I wanted to make my own versions of the poems that could accompany my images. With the help of translators Hitomi Sigiura and Frederick Kotas for the literal meanings of the originals, I created my own poetic English translations. Not only has the process of translating the poems made the experience of first imagining and then creating the layered images richer, it has brought me full circle, since I started my early adult life not only as a teacher of English literature but in writing and publishing poetry.

The Floating World refers to the conception of a world as evanescent, impermanent, of fleeting beauty and divorced from the responsibilities of the mundane, everyday world. For the poets in this volume (whose names are calligraphed on each image), that world centered on love—longing for love and the beloved, mourning lost love, and pondering its mystery. The beauty of the natural world—its flowers, landscape, the moon, and the changing seasons—serves as the primary metaphor.

The white roses I meant to braid in my hair
have all fallen
around my pillow of sickness.
 Yamakawa Tomiko (1879–1909)

Working in Photoshop to build the original photograph into a textured, multivalent image that alludes to but does not illustrate each of the poems has taken me on a journey of discoveries through serendipity as well as intuition and forethought. I like to think that were the poets alive to see the images I've associated with each of their poems, they would approve—perhaps even enjoy my interpretations added to their own.

BIOGRAPHY As a six-year-old, I came from Germany to the United States in 1947, where I fell in love with ballet and the idea of being a dancer. Instead of making a career of dance, however, I became a high school teacher, and later university teacher, of English with a love of gardening. Around 1996, my longstanding interest in photography culminated in a decision to make another career of photography. My interest in dance and gardening rather naturally coalesced in my primary photographic subject matters: the formal beauty of bodies and flowers.

I think we increasingly need beauty in our lives. Beauty is a word that makes people in the art world queasy. It's maddening, really, that those who dictate what is in and what is out can so arrogantly dismiss beauty—trivialize or even denigrate it. My own goal in photography is to create a beauty in my images compelling enough to establish its own legitimacy—whether beauty as a concept is in or out of fashion. Fashions come and go, beauty stays. There is so much ugliness in the world that we need to remember that the arts have the power of the beautiful.

I look frequently for inspiration at the images of the pictorialist school and of earlier women photographers like Imogen Cunningham, Laura Gilpin, Consuelo Kanaga, Ruth Bernhard, and Tina Modotti, as well as Edward Weston, Paul Strand, Robert Mapplethorpe, and contemporaries like Graciela Iturbide, Josephine Sacabo, Paul Caponigro, and Cy DeCosse.

My photographs have been published in *Color Magazine*, *Zoom*, *LensWork*, and *Silvershotz*. They also appear in *Imagining Then*, a limited edition portfolio of ten matted images and letterpress text published in November 2008 (available from Gallery291.net and vervefinearts.com), *Bella Figura: Painted Photographs by Brigitte Carnochan* (Modernbook Editions, 2006), and *The Shining Path*, a limited edition monograph of 11 images and text published by 21st Publications in May 2006 (sold out at 21st but available from me).

You can see my work at www.brigittecarnochan.com and www.imaginingthen.com.

TECHNICAL I work with a variety of cameras—4x5, medium format, 35mm—both film and digital. Since I knew from the beginning that I'd be layering the images in this series in Photoshop, most of the photographs were made with a Canon EOS 5D. I tend to learn techniques in Photoshop as I need them and avoid dazzling tricks that draw attention to themselves as Photoshop effects. In addition to the two translators who have helped me by tracking down the poems in Japanese and translating them, the series has been enhanced by Richard Man's original calligraphy depicting the name of the poet, which I scan into each image. I print this series either 9 or 15 inches square on handmade, uncoated mulberry paper with an Epson 3800 printer.

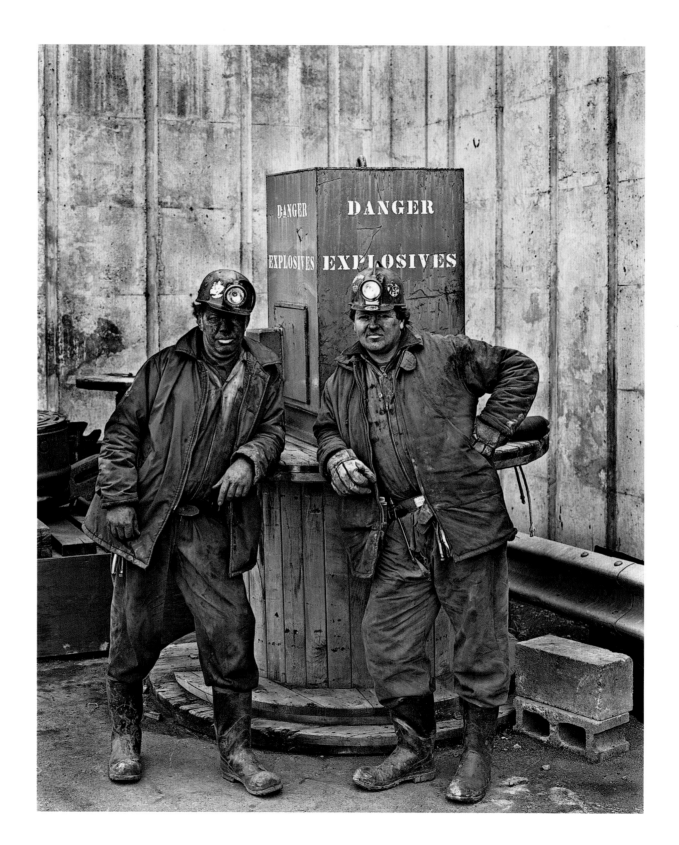

Two Cape Breton Miners
1987

GEORGE'S ANALYSIS Photographs can have value well beyond their prettiness. Lawrence Chrismas has spent years recording coal miners. He has listened to their stories, written about them, and even become an authority on the history of coal mining in Canada. Lawrence understands coal miners and they feel comfortable with him. The images make up an invaluable archive. For someone who isn't intimately familiar with the industry, these images are a window into the lives of miners.

In this photograph, we can see the wear, the brutal work, the grittiness, and the determination of the workers. We can see a fair bit of what their life must be like. Even though the portrait is taken above ground and in the light, we can feel what it must be like to work underground, reliant on your headlamp, coal dust worked into your skin, wet and filthy. Their lips are free of coal dust, licked clean and dust swallowed repeatedly. We can imagine how blackened their lungs must be after years of this type of work.

The men are backed by a concrete wall on the right, a box on the left, and the cable reel and explosives box in the middle. The men lean toward each other in comradeship and support. The hands form a diagonal line rising from left to right, ending in the hand on hip, a posture suggesting reservedness.

The dark trousers of the miner on our left stand out against the lighter part of the reel, while the lighter pants of the other miner are against the darker part of the reel. The boots, which are scuffed and worn, stand clear of the reel. With his 8x10 camera, Lawrence has captured the full range of tones in exquisite detail, from blackest face to brightest headlamp.

Any photographer would do well to consider the worth of such dedication to a single project, spanning years. Perhaps one could start by working with and recording the lives of local people, possibly a group as loosely connected as your grocery store butcher, your kid's music teacher, the local garage mechanic, and the person who trims your trees. Whether one selects a mundane group such as people you know or local actors, or go for the famous or outrageous, there is plenty of opportunity for work of considerable value.

The problem with snapshots is that they are often exactly *not* what they purport to be—natural, casual, spontaneous. The subject freezes or puts on a silly grin. They decide they are too fat, or that they should change their clothes, or they try to look impressive. Valid portraits take preparation and experience. They require an ability to relate to the subject, to make them feel comfortable. Technique has to be more than skilled; it needs to be flawless, smooth, and unobtrusive—like the superb waiter who works fast but never seems to hurry.

Photographic projects can be as short as an afternoon or as long as a lifetime. They can run uninterrupted for months or even years or be revisited occasionally as the opportunity presents. Regardless of how a photographer chooses to approach a project, the power, unity, and worth of a collection of related yet unique images is to be highly recommended and is a test of the true mettle of a serious photographer.

In a single portrait, Lawrence has opened a considerable window into the lives of miners. As part of a project of over 30 years, he has created an invaluable photographic essay.

THE PHOTOGRAPHER'S PERSPECTIVE This photograph of the two coal miners, Edison Howatson and Dennis Harrietha, was made at the Prince Colliery, Point Aconi, Nova Scotia, in 1987. These boys had just finished a shift underground in the submarine mine and were in a big hurry as they headed to the washhouse when I nabbed them for a photograph.

Most underground miners, when they reach surface, literally run from the hoist to the washhouse and would never stop for a photograph. Maybe that was to be sure they got hot water in the shower, or perhaps they were anxious to get either home to their families or to their favorite pub to wash down the coal dust. In this situation, on this day, bribery of a couple of smokes worked for me. I had already set up my old Deardorff and was waiting for some obliging coal-dust-covered miners to come along.

BIOGRAPHY I am a photographer, geologist, and mining historian. I was born in Alberta, Canada, raised in Vancouver, and I am currently a part-time resident of Cambria, a former coal mining town in the Drumheller Valley, Alberta. For nearly

30 years I have explored the culture of Canadian miners through my environmental portraits and the thoughtful stories of the their lives. I have written and published books, and co-written and produced a music CD of original mining songs about miners whom I have photographed. Through my documentation of miners, I have unintentionally become recognized as one of Canada's mining historians. I currently work as a consultant in this field to support future books and projects.

My journey toward making this portrait of Cape Breton coal miners began with a job offer in Ottawa, where I became immersed in the world of mining. My work at the Department of Mines involved visiting the old and new coal mines across Canada. At the same time, I began studying photography. After visiting some of those incredible little mining towns, I was destined to create a photography project related to coal mining.

Situated in Ottawa, Robert Bourdeau gave me feedback and motivation with respect to my landscape photographs. In 1979 I was honoured that he submitted my name to attend a photography master class at the Banff Centre. I rented a small cabin in Canmore during the class. Coincidently, during my time there, the Canmore anthracite mine shut down its mining after almost 100 years of operation, thus putting a few hundred miners out of work. One old-time miner, who was completely shocked by the closure, allowed me to photograph him and record his thoughts about life in the town and mine. This man, who had stayed in one job for 50 years and loved it, inspired me to get started in my own long-lasting project of photographing and interviewing coal miners and their families in all the coal mining towns across Canada. This rewarding experience has carried me in many different directions, including publishing 10 books related to miners. This project has been recognized as a social documentary of a vanishing industrial group in Canada.

My influences include Edward Curtis, August Sander, and Paul Stand; and recently Robert Bourdeau, Jay Dusard, and Yousuf Karsh.

Among my books, the following are currently available: *Alberta Miners ~ A Tribute* (Cambria Publishing, 1993), *Coal-Dust Grins: Portraits of Canadian Coal Miners* (Cambria Publishing, 1998), *Canmore Miners: Coal Miner Portraits and Stories* (Cambria Publishing, 2002).

My images can be seen at the following websites:
www.cambriapublishing.com
www.lawrencechrismas.com.

TECHNICAL I used an 8×10 Deardorff camera and traditional silver prints. The old Deardroff is currently in storage while I explore the digital world. Recently, I have been scanning 8×10 negatives with considerable success, and producing digital prints with "minor" manipulation in Photoshop.

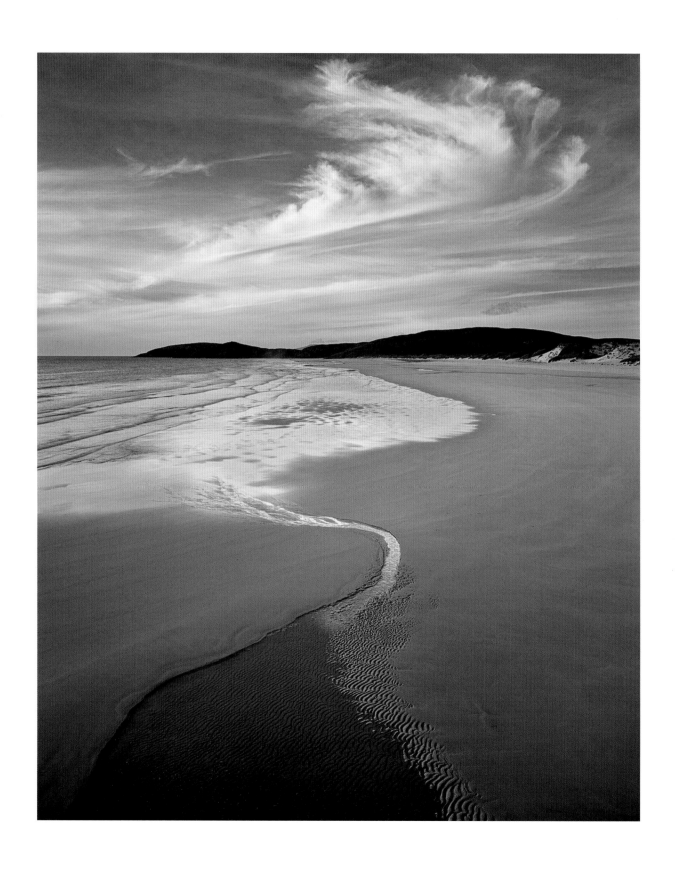

Traigh Eais Barra

2004

GEORGE'S ANALYSIS I first selected and then wrote about this photograph based on a web-sized image. I recognized its strength of composition; the coincidence of the cloud's shape, the wet sand, and foreground stream; and the lovely reflections off the water. Recently Joe Cornish sent me the full size scan from the 4×5 transparency, and the remarkable skill in recording the huge range of tones from dark, distant hills to brilliant clouds became apparent. More importantly, the wonderful gradations of tone in the sand, water, and clouds became visible, and it was possible to come back to the image time and again to find new discoveries of shapes and tones, of relationships and contrasts in small areas of the image. Hopefully, you will see some of this in the reproduction in this book, but if ever you have the opportunity to see a large print of the image, you will experience something similar to when I first saw Ansel Adams's huge prints in a gallery and discovered that in original prints there's another whole world of discovery, of richness, and of subtlety not possible in a small reproduction.

Many lesser photographers would be tempted to make this image into something bright and perky, totally destroying the mood—the feeling of the last light of the day, the wistfulness that accompanies the coming of night. Joe sent along the changes he wanted in the scanned transparency—a subtle correction of color to the whole image and minor lightening of the foreground, and that was it for editing. Virtually everything was in the seeing, the timing, and knowing his tools.

Notice how the diagonal waves on the far left are repeated at the same angle in the lower clouds on the right. The main curved cloud has the same diagonal as its base, while the cloud seems to have changed its mind and headed off to the left

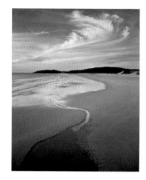

as it approaches, and a splinter group has done its own thing in heading up and to the right in an interesting array. Fascinating.

There is a very subtle pink to the lower portion of the sky, which is even more faintly seen in the sand—just a hint, no need to belabor it. Otherwise the image is almost monochrome, white to gray to blue. Only the sky holds any degree of color saturation. I'm sure the image would work in black-and-white, but pastel colors in a limited palette can be especially beautiful.

When large areas of an image have little variation in tone and no detail to break the monotony, capturing the subtle variations within that tone is critical to a successful image. Here we have the receding tide leaving faint evidence of previous higher wave lines matching the diagonal straight lines on the left and the curves of the surf in the middle. The foreground pool nicely continues the sand ripples to the right of the pond throughout its bottom. The clouds have wonderful filigree edges, and the distant hills have enough detail to be "real."

Repetition, of lines and curves, of shapes and tones, is one of the strongest compositional tools we have through careful

positioning of the camera and framing of the image. The job of the photographer is to take advantage of repeating patterns while at the same time eliminating any extraneous details that weaken the repetitions. It is vital that the photographer knows when to "hold 'em" and when to "fold 'em", as the song goes. Joe knew he had a good hand here and played it superbly.

THE PHOTOGRAPHER'S PERSPECTIVE The photo of Traigh Eais on the island of Barra was made while photographing for my book, *Scotland's Coast*. It had been fine weather all day and I was optimistic for good light later on. This west-facing bay with its low sand hills may not be particularly spectacular, but the fine white sand beach is archetypical of the Outer Hebrides. Setting sun, white sand, what could go wrong?

On a rocky bank at the south end of the beach, it was possible to gain a little height where I could see a shapely sand pool and drainage channel snaking away from my viewpoint into the calm sea. The combination of elements was promising and the sunlight was now softer. An Atlantic weather front was approaching from the west; there would be no visible sunset tonight. But there was nothing else to do in this part of the world (apart from photographing local ales at the island's main pub), so I set up my Ebony with a 90mm lens, composed, focused, and waited.

The sun was being swallowed up in cloud, and there was a cooler edge to the air. The weather front was driving some well-articulated cloud formations before it. To emphasize contrast between the blue sky and the clouds, I deployed a polarizer.

The cloud formations were now more than just interesting. It seemed impossible, but the clouds were actually taking on the same shape and proportions as my foreground elements. The sky was making the picture for me. I made an exposure, a small recompose, and then another. The cloud continued to move from west to east.

With only a ground glass screen for viewing, I had to remove the Quickload holder, open the lens and aperture, re-compose, close down the lens, return the aperture, cock the shutter, and then reinsert the film holder and film (between each exposure). In all, I managed five exposures before the cloud had moved too far away, and the composition became unbalanced. This all happened in a rush for a large format shooter. In the same amount of time, a DSLR user might have shot 100 frames comfortably enough, tweaking the camera each time.

I was amazed by the cloud, but due to the lack of sun I remained unsure whether the image would really work. I knew it had when I collected the film from the lab. Fortunately, my exposures were good. Of the five exposures, the final compositional variation was the best, with the tautest positioning and best overall proportions (well, I think so anyway). Only later did I realize that, as much as any experience I have ever had, this was a great example of "being in the right place at the right time." What are photographers if not witnesses to the facts of light? Yes, and the fantasies too.

BIOGRAPHY Born in 1958 in England, I am a working photographer, specializing in landscape. I live in North Yorkshire near a hill called Roseberry Topping, which has become something of a signature subject for me. I have a gallery in the town of Northallerton that is run and staffed by others, allowing me to continue to work on my photography. I do occasionally lead workshops and write articles, but I remain focused on photography—some commissioned, but mostly self-motivated personal projects—and books done in collaboration with friends.

I have always been involved with environmental issues, and this has continued to grow and deepen as an interest through regular encounters with the natural world. I see photography as one of many types of advocacy for nature, and one that encourages photographers themselves to engage in and connect with the landscape. I have done commissioned work for the National Trust (for 20 years) as well as other environmental agencies.

I just finished working on a book titled *Joe Cornish, a Photographer at Work,* which is a collaboration between my friend Eddie Ephraums and myself. I also just completed a commission of local landscapes images, which have been printed up to five meters wide and are hanging in a local mental health hospital.

I have contributed to *Developing Vision and Style* (Aurum Press, 2008), and *Working the Light* (Argentum, 2006).

I was the main photographer for *Urbino* (Frances Lincoln, 2003), and *Roseberry Topping,* which I published in association with the local archaeology group.

First Light (Argentum, 2002), *Scotland's Coast* (Aurum, 2005), and *Scotland's Mountains* (Aurum, 2009), are all my own work (including the text), as is *The Northumberland Coast* (Frances Lincoln, 2008).

There are so many photographers who have made a difference to me. If I had to list only three, they would be John Blakemore, Charlie Waite, and Peter Dombrovskis. Current photographers who have influenced me are Jack Dykinga, Jan Tove, Paul Wakefield, and David Ward.

My website is www.joecornish.com.

TECHNICAL *Traigh Eais* was shot with an Ebony 45SU and a 90mm lens (Rodenstock). I am pretty sure I used f/22 and a polarizer. I forget the shutter speed.

Printwise, I still have some prints made traditionally with Ilfochrome, but mostly I now do my own printing with an Epson Inkjet 7900 on archival matte fine art paper, as this better reflects my intentions.

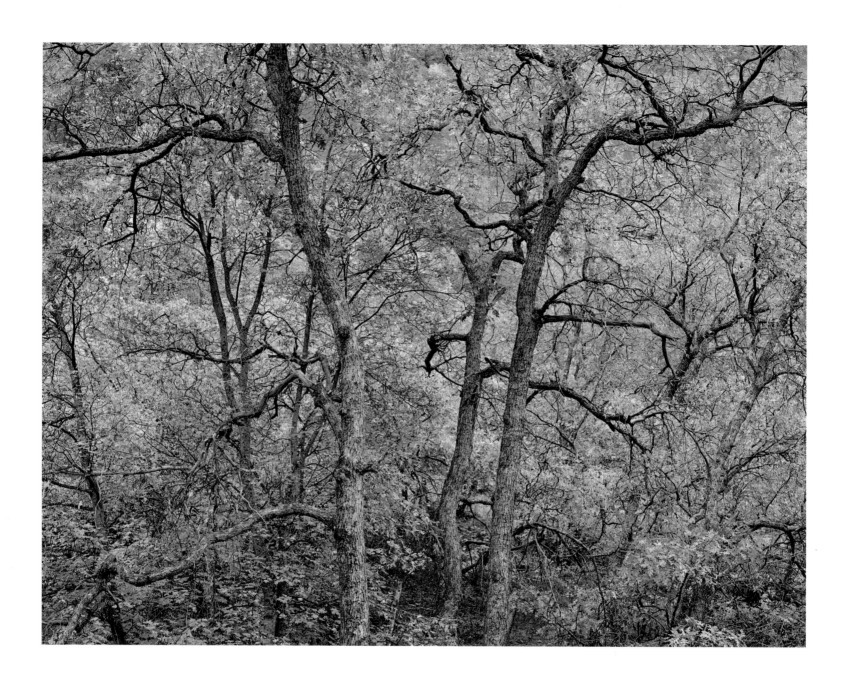

Tree Detail, Autumn, Zion Valley, Utah
1994

GEORGE'S ANALYSIS So many landscapes celebrate the dramatic, but here is a powerful image based on subtleties. It doesn't even have a horizon or a dramatic sky. There are no soaring peaks, not even a water feature. There *is* a subtle warm glow to the light, with even warmer color coming through the trees from behind in a perfect blend, without having to shout.

As your eyes wander around Charles Cramer's print, there is interest everywhere, whether it is in a glimpse of the background rock wall or some brighter fall colors, or even a patch of paler green. Absolutely nothing in this image jars or seems out of place.

The placement of the trees is perfect. I cannot imagine moving any of them. Notice the sharp bend in the middle tree that just kisses the tree next to it on the right. Alignment like that means accurate placement of the camera—to the millimeter.

There is good use of corners. In the lower left we have the branch working its way down and left. In the lower right corner there is a branch that curves back into the print, providing a frame to the rest of the scene. I really like those pale leaves on the bottom border at the right. The top right corner has the two branches, nicely going to either side of the corner. The upper left corner has the rectangle of leaves and background framed by the right-angle branches.

There is wonderful color in the leaves—green, yellow, orange, and even subtle purple. The color of the tree bark works perfectly with the rest of the image; it is warm, subdued, finely detailed.

An image like this is a perfect example of why it is not necessary to have a center of interest, something many novices feel they must achieve in their images. While a center of interest is not essential, an organization to the scene is, and despite the many branches and variety of colors in Charlie's photograph, they all tie in very nicely. Were one to have a single dramatic feature—say, a bush with flaming red leaves in one part of the image—it would take way from all that makes this image successful.

I have often commented on the power of simplicity. A complex image with a huge amount of fine detail and no large blocks of a single tone would seem to go against that guideline (I hesitate to use the term *rule*). In fact, because of the overall unifying colors, the repetitive patterns of the twisting branches, and the simple design of the image in essentially two planes—a background and the more or less equidistant trees—it is after all simple and easy to interpret.

We admire many images for the astuteness of the eye, the care in design, the use of light. Other times we fall in love with an image and our experience of the image is on another level, as is my experience with this photograph. As a photographer, you cannot dictate this experience to the viewer because it is based on their life experiences, personality, and current circumstances. Attempts to create an image to please others will usually fail; the image can seem trite or simply lack the spark that signifies great photography. You can, however, produce an image that means something to yourself and let the viewer have his or her own reaction.

THE PHOTOGRAPHER'S PERSPECTIVE This image was made at the very end of a productive trip to the southwestern U.S. back in 1994. I love the Southwest because it is much easier to find my favorite type of light—shade. With canyons, if one wall is receiving direct sun, the opposite wall is usually in shade and, as a bonus, is sometimes illuminated by bounce light from that other wall. That's what happened with this image. With shade, you can concentrate on the composition you want instead of having the sun highlight things for you.

After twelve days of intensive photography, I was ready to head home and saw these trees just as we started the drive home to California. This was found right along the road in Zion Valley, Utah. When evaluating a scene, I don't even bother to assess the scene further if the light isn't right. If the light is good, then I'll try to find a composition. These trees were in shade and had some distinctive shapes that caught my eye. After stopping, I explored the scene with my "framer," which is an 8" x 10" card with a 4" x 5" opening. This allows me to preview precisely what will show up on my ground glass, and also blocks out what won't be in the composition. Some have said that photography is more about what you don't include—and the framer allows me to see only what I want to include. It also allows me to see how the eye travels in the scene. I usually take some time to explore different framings, zooming the card in and out, and trying out horizontal versus vertical. I find that subtle changes in position will drastically change how the trunks interact. I move around until I find a composition in which I enjoy the interaction of the trees.

With trees, the background is very important, as it shouldn't detract by being too bright or too busy. Here, the canopy of leaves, along with a little bit of canyon wall peeking through, are unobtrusive, allowing one to enjoy the shapes and interplay of the tree trunks unhindered.

BIOGRAPHY After spending seven years of college studying classical piano, I visited Yosemite National Park for the first time and soon realized I wanted out of those tiny practice rooms! Realizing the similarities between interpreting music and interpreting a negative, I quickly became enamored with making prints. I started in black-and-white, but soon became interested in making color prints. That led me to the dye

transfer process—incredibly convoluted and time-consuming, but when all the planets align, capable of making wonderful prints. When Kodak ceased production of dye transfer materials in 1994, I was able to amass a stockpile of materials, which kept me going for a few years. But, in 1997, I started scanning and printing digitally using the LightJet. I now print with a big Epson 11880 ink-jet printer, which makes prints that are sharper, have greater color gamut, and last longer than Light-Jet prints. In 2006, I used my last film and switched to using a PhaseOne medium-format digital back. It's a great time to be a photographer!

I sell prints through various galleries and I also teach digital printing workshops for the Ansel Adams Gallery, John Sexton Workshops, and others. Yosemite is still one of my favorite photographic destinations, and I was selected to be an artist-in-residence there in 1987 and again in 2009. I still do music on the side but make most of my living through print sales and workshops.

My influences are Ansel Adams, Don Worth, and Eliot Porter.

I have been profiled in the magazines *PHOTO Techniques, Photovision, Outdoor Photography* (UK), and *View Camera*. I'm also included in the book *The World's Top Photographers: Landscape* (Rotovision, 2005). I was one of five photographers in the book *First Light: Five Photographers Explore Yosemite's Wilderness* (Heyday, 2009).

My website is www.charlescramer.com.

TECHNICAL Linhof Technica V 4x5 view camera, using Fuji Provia film.

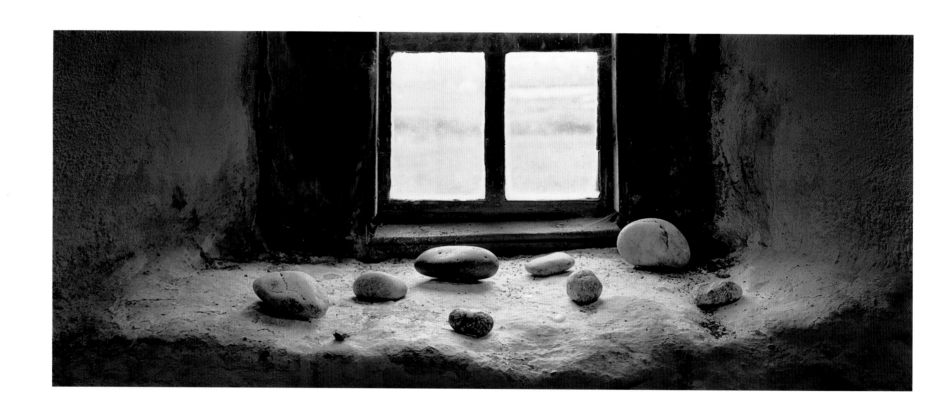

Stones in Window

2003

GEORGE'S ANALYSIS Such a simple image: an old building, a window ledge, a few stones. There are no clever tricks of composition, just a straight-on view of the window. Still, the light wrapping around the stones and pouring over the worn and rounded edge of the windowsill seems special.

We want to know why the stones are there—it seems unlikely that it is random. Some ancient rite perhaps? Might just be kids, but if so, what game are they playing? The power in an image can come from a stormy sky or late day sun, or it can come from the way it stimulates the viewer's mind.

Knowing this is an old building in Scotland, are we seeing sloppy workmanship, or more likely, 800 years of wear and tear? The construction is pretty basic. The building is not likely to be the manor house—more likely the dwelling of simple folk.

Tillman Crane prints on platinum. The process is complex and slow, yet can produce luminous prints of subjects difficult to capture on other media. Paper has to be hand coated with either platinum or palladium metals, both of which are very expensive. Exposures of prints are via UV light and enlargements are not possible (other than through making an enlarged negative). Here, the ability of platinum to capture large ranges of tone allows us hints of detail from outside the window while at the same time showing nice highlights on the sill itself and detail in the dark wood posts on either side of the window.

The rule of thirds is all very well, but centering the subject as happens here makes the image peaceful. In fact, the window isn't exactly centered, perhaps to compensate for the progression of stone size toward the right. The window has been cropped at the top, and the image shows the horizontal frame of the top of

the two lower panes of glass, holding in the very light areas of the window opening.

Although the lighting is quite soft, there is excellent texture and shaping in the walls and sill. At the same time, the soft character of the lighting helps show the roundness of the stones. The quality of the photograph is such that I want to pick up the stones and feel their coolness, their texture, their heft.

Sometimes, wonderful photographs can be quite unassuming: a simple scene, soft directional lighting, lovely shapes and textures, and just a little bit of mystery. There is something about the rightness of this photograph, which has these qualities, a sense of satisfaction, of completeness. Photographs like this are not common—the distance between unassuming and boring is not far to travel, but worlds apart in impact. Tillman has made the challenging journey to wonderful effect.

THE PHOTOGRAPHER'S PERSPECTIVE I first photographed in Scotland, thanks to an invitation to speak in 2002 at the Royal Photographic Society spring meeting. Over the next six years, I made numerous trips to further explore, and it was on a trip to Lewis and Harris that I finally went to Iona. This small island both fed my curiosity for history and religion, and provided rich images to photograph. Saint Columba established a Celtic monastic community on Iona in 563 and is credited with the spread of Christianity throughout Scotland and eventually to Europe. By the beginning of the thirteenth century, the Roman Church was in control and the Benedictine abbey church (St. Mary's Cathedral) and nunnery were built on this site. Destroyed during the Scottish Reformation, some of the buildings were restored in the twentieth century, first by the efforts of the Duke of Argyll and later completed by Lord George MacLeod and the ecumenical Iona Community in 1965.

This image was made in the small chapel building within the stonewalled cemetery. The chapel has two windows (one

on each side), a door at the west end, and a small altar at the eastern end with a gold cross above it. I spent about four hours working within the building, and the longest any visitor stayed was two or three minutes.

The chapel's uncomplicated appearance deceived most, but I found that the quiet allowed me to sit, meditate, and absorb the feeling of the place. I photographed everything within the chapel, but it was the window on the southern side that I was most drawn to. Narrow and set into the thick wall, its sides flare out as it opens into the room. My first images were of the entire window, as I tried to capture the beauty of the light flowing through this narrow opening and illuminating the walls inside. The image presented both technical and aesthetic challenges, but I liked what I was seeing on the ground glass, so I kept at it.

As I worked the photograph, I noticed the stones on the windowsill. While doing my research for this visit I had read about the practice of pilgrims bringing a stone from home and leaving it on Iona, which was believed to ensure their return to the island. Looking at the stones on the shelf, it dawned on me that these were touchstones, left by visitors on a modern-day pilgrimage.

TECHNICAL This image was shot with a KB Canham 5×12 view camera with a Nikkor 300 lens on Ilford FP4+ film, processed in Pyrocat developer. The prints are hand-coated platinum/palladium prints.

BIOGRAPHY I am a large-format photographer specializing in platinum prints. As an artist, teacher, and photojournalist, I have been professionally involved with photography for over 30 years. Beginning as a photojournalist with *the Maryville Daily Times* (Tennessee), I later worked for the State of Tennessee as a photographer before joining the resident faculty of the Maine Photographic Workshops in 1987. I earned my MFA from the University of Delaware in 1990. In 1996 I became director of the photography program at the Waterford School in Sandy, Utah, where I taught full-time and part-time until 2008. While in Utah, I organized and directed the weeklong Mammoth Camera Workshop in 1999 and 2000.

In 2001 I returned to Maine with my family after the release of my first monograph, *Tillman Crane/STRUCTURE*. I have since published three more books: *Touchstones* (2005), *Odin Stone* (2008), and *A Walk Along the Jordan* (2009), all published by Sterling and Hurst Editions, our in-house publishing arm.

I teach a variety of workshops, from the craft of large-format photography and platinum printing to destination workshops throughout Scotland and the United States. I work with cameras up to and including 12×20.

My influences are Eugene Atget, Frederick Evans, and Josef Sudek.

You can see my work at www.tillmancrane.com.

Moore Hall Interior # 1

1999

GEORGE'S ANALYSIS In Sandra C. Davis's image, *Moore Hall Interior #1,* the combination of infrared film recording foliage as light, contrasting the dark stone-work, and printed in platinum produces a photograph that celebrates light. We do not see the missing roof but can infer it from the light pouring onto the interior bushes. The delicacy of the foliage contrasts with the solidity of the building, old as it is. Platinum printing is known for its ability to record extreme brightness ranges without appearing dull. The panoramic format works perfectly in this composition. The series of arches, the strong diagonal lines extending from the two top corners to the curved wall above the central arch, and both left and right edges of the print showing dark stone work together to form a unified and strong composition. Even the platinum coating to the paper, resulting in a dark irregular border, works ideally with this composition, providing a dark base for the image to match top and sides.

The repeated shapes of the arches, including the little window, tie the photograph together, something that is challenging in long narrow images. The texture and tonalities of the walls are dramatically dark, yet with excellent detail and nicely contrasting the brilliant yet controlled highlights of the exterior.

The photograph is centered on the far wall. No rule of thirds here, and it works beautifully. Photographers learn to use rules, but as they become more experienced, they learn to break the rules, until they reach a stage in their vision in which they move past rules to a state of simply knowing what works—what is right.

Some have argued that knowing what is right is a talent, implying that you have it or you don't. What is usually implied is that the author of such comments is one of the haves. My experience is to the contrary; both within my own photography

and with the development of other photographers, I have observed that the ability to see, to create, to recognize rightness can be learned. For that matter, the same is true of painters, composers, and writers. Teachers of photography recognize that while some show remarkable skill and a good eye at the beginning of a course, by the end, it is often the hard workers who excel both technically and creatively.

To imply that it is talent that sets some photographers apart from others is also to imply that photographers are stagnant, unable to move forward, and limited by whatever amount of talent they started with. This too is wrong, although a refusal to learn and to augment whatever talent you currently have is a sure way to remain stuck. The greatest photographers strive to improve their work, to refine their vision, and to strengthen their seeing.

A number of great photographers are on record as stating that they did not learn from others, yet almost every photographer in this book refers to others (photographers or painters, and even sculptors) for both inspiration and education. If you look at the work of photographers who deny being taught or influenced by others, and further, break their work into early and late periods, it's clear that they improved over time. It isn't obvious whether that improvement happened with practice or through education, but either way, I feel certain that they had to work at getting better, and therefore, talent is not a fixed thing. Practicing the same old ideas might make you more efficient but doesn't result in better photographs, which suggests that improvement in one's images comes from external influences.

There are exceptions to everything, yet people like Brett Weston, who appeared to have strong vision from the start, must be remembered as being raised by not only Edward, but also as having been surrounded by all his artist friends and in an environment of looking at art. It is my belief that people who claim de novo talent (and actually have it) simply learned it in a subconscious manner rather than through formal education.

This photograph makes full use of the symmetry of the building while at the same time capitalizing on the differences between left and right that make the photograph interesting. Though the building itself is more or less symmetrical, the large light-toned bush to the right of the central arch of the building is offset, both exposing more of the arch and helping to avoid too much mirroring.

The location is exotic and mysterious. The decay of the stonework, the advancing greenery, and the apparent lack of a roof convey a sense of loss and abandonment.

Do photographers simply get lucky when they stumble on a scene like this? Experience suggests that many simply don't see well enough to recognize what potential there is in a scene, or they look for Led Zeppelin while walking past Bach, or they simply do not have the skill to imagine how a scene like this will translate through photographic technique into the final print. Photography is about acquiring the skills to take advantage of luck. Luck isn't that uncommon, but it doesn't announce itself with heralds and trumpets. The photographer must be receptive, alert, and aware.

THE PHOTOGRAPHER'S PERSPECTIVE *Moore Hall Interior #1* is an image from my series of photographs titled *Enduring Stones*.

As a photographer, I find myself compelled to capture images of abandoned places, to document places that were left to decay, feeling that what I find before me will never appear like this again. Time and the elements will continue to transform them. The architecture that we build, for whatever reason, represents our culture throughout history. Finding these monuments in a ruinous state makes me question what is important to us as a society, when they are left to decay. It is this sense of loss that compels me to romanticize these remains and make them appear more dreamlike than the stark reality of their certain demise.

When I make an image, I want to create a strong message. I strive to create an emotional awareness in the viewer that encourages them to take notice of the loss surrounding their everyday existence.

Europe is a treasure trove of incredible stone architecture. My goal for this excursion to Ireland was to add to my already existing Enduring Stones portfolio. When my partner and I travel, we extensively research our destinations and we leave little to chance. We purchase books, search Internet sites, and always find too much to see in our allotted time frame. Before the Ireland trip, we purchased Ordnance Survey maps and searched for castles, abbeys, and archeological symbols.

Ireland celebrates its forested areas for good reason. There are very few areas with old-growth forest, and when you find them, they tend to have public access and are treated like parks. Moore Hall grounds is one such place. The manor was built in the 1790s by the Moore family. The last person to live

there was George Augustus Moore, a famous novelist. During the Irish Civil War in 1923, the manor was burned. Some say it was burned by mistake because Moore was Catholic, but he did have some ties to the English.

When we arrived at the park on an overcast day, we found picnic tables and hiking trails. As we entered the woods we saw the abandoned roofless mansion perched in a clearing. Much to my delight, the building was not fenced off. I walked up the grand steps to the front doorway and noticed it was barred but not fenced. I peeked in. Foliage filled the interior. The three-story structure was intact with no floors. I looked into the grand foyer with a clear view of arched doorways that led into the side wings. I so wanted to step into the space and feel completely surrounded. It was the perfect mix of decay and nature taking over, a tribute to the endurance of nature over mankind's feeble attempts to tame her. I wrapped my camera strap tightly around my wrist and pushed the camera though the bars into the space and pulled it back toward my face. I framed up the shot with my face pressed against the bars. As I did this, the clouds cleared and a shaft of light streamed into the space. It was one of those shots that you think about until you develop the film.

The print is an 8" x 20" platinum palladium print contact printed from an enlarged negative.

BIOGRAPHY As I was growing up in the 1960s, my mother encouraged me to pursue my artistic tendencies. So I went to art school with a yearning to learn everything from painting to jewelry making. Intimidated by the blank canvas, I discovered gathering images through the camera lens. This art form defined my personal expression. After a 20-year career as a graphic designer, I decided to reenergize my fine art passion by studying non-silver printmaking processes. This step led to a major career change; I decided to share my passion through teaching.

I now teach alternative process and photography at The University of the Arts and Tyler School of Art, both in Philadelphia, PA. And in New Jersey, I teach at Rowan University and Mercer County College. While earning an MFA in book arts/printmaking at The University of the Arts, I published several artist books based on my unique photographs. I contributed to *A Non-Silver Manual* (Sarah Van Keuren, 1998), and have had work published in *The Book of Alternative Photographic Processes: Second Edition* by Christopher James (Delmar Cengage Learning, 2008).

Although I use modern equipment, my imagery is about capturing remembered moments from the past. Several bodies of work are in progress, each exploring history through photographing what remains from previous eras. Since I enjoy adventure and discovery, I seek out historic architecture and gardens. By capturing these places in my unique way and printing the images in various alternative processes, I transform them and create an illusory veil of dreaminess.

Early in my photography career, I was influenced by the history of the process as well as its masters. In 1980, during my second photography class, I was fortunate to see Atget's Gardens show at ICP in New York. From that day on and even now, his work has strongly influenced my work. Walker Evans and Clarence John Laughlin's photographs were also early influences on my work.

Three contemporary photographers whose work I find intriguing and inspiring are Olivia Parker, Arthur Tress, and Ruth Thorne Thomsen. The most influential photographer in my life is Sarah Van Keuren, who has been my mentor for over ten years.

My images have been exhibited nationwide and are in public, corporate, and private collections.

My work can be viewed at www.SandraCDavis.com.

TECHNICAL The image was shot in 1999 with a Noblex 35mm panoramic swing lens camera on Kodak High-Speed Infrared film. Unlike the 35mm camera's standard T-shape, the swing lens camera is very flat because the lens rotates inside a column. This shape allowed me to squeeze the camera through the bars letting my camera enter the room as my surrogate. The format of the frame makes the 35mm negative twice the length of a standard-sized shot, allowing for only 18 shots on a film roll of 36 exposures.

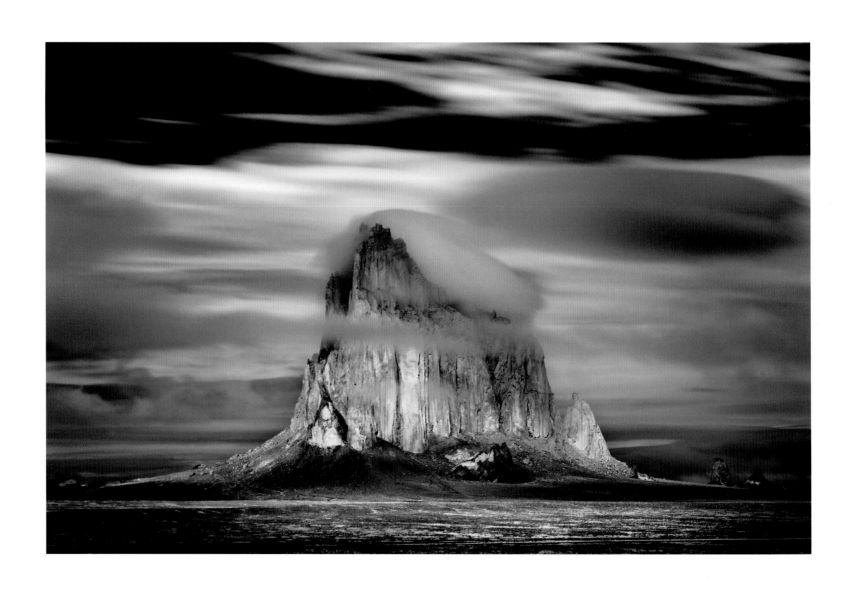

Shiprock Storm

2007

GEORGE'S ANALYSIS Like much of Mitch Dobrowner's work, this photograph speaks of magic and mystery, of wondrous light and atmosphere. Somehow the dead core of an extinct volcano has survived millions of years, only to grab and temporarily hang on to that cloud, just when the photographer happened by. We can see that there is wind in the movement of the other clouds, yet somehow this little cloud has become hung up, albeit for a moment, on this jagged peak. It even appears that a hand is reaching out from mamma cloud to baby, saying, "Come along now, no dawdling." It is almost as if the baby cloud is tired and has found a comfortable place to spend the night. Who of you has wanted to reach out and touch that cloud, to feel its softness, to pick up its moisture on your hand?

How many trips, how many hours of waiting did the photographer put in for this one magical moment? Consider the number of combined circumstances of weather and lighting that came together for this image to work.

Look at the base of the rock, with varied lighting on the slopes surrounding the pillar. There is a brilliant light at the left side of the lower pillar, while to the right of it are some nearby rocks that are almost black. On both left and right, there is a streak of light along the extended base of the pillar that superbly separates the pillar from background, while a dark area across the entire image below the rock contrasts nicely with the nearer band of light. The rocks around the pillar all play small roles, hardly standing out, so as not to distract from the real star of the show.

The streaking sky in the background speaks of movement, of hurry, and of time passing; but this rock isn't going anywhere, isn't on a deadline, and can wait many thousands of years more for who knows who to come by.

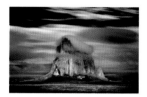

The patchy lighting is critical to the photograph, presenting the pillar, adding depth to it, building character to the rock, and separating it from the background clouds. The black streaked sky in the upper part of the photograph parallels the light and dark areas of the foreground.

Photographers often flail, trying to find something new to photograph in a world of many millions of photographers. It seemed a lost cause even before the age of digital; it is doubly so now, when every possible subject has been presented on the web. Therefore, it is far better to interpret a common scene through your own eyes, experiences, personality, and circumstances, to show the ordinary in extraordinary ways.

THE PHOTOGRAPHER'S PERSPECTIVE Landscapes are living ecosystems and environments. They existed long before and will hopefully be here way beyond the time we are here. When I'm taking photographs, time and space seem hard for me to measure. Things get quiet and seem simple again—and I obtain a respect and reverence for the world that is difficult to communicate through words. Hopefully the image presented helps communicate what is visualized during those times.

I had seen images of Shiprock before but never the image I had in my mind. Though I hadn't seen the formation in person, this immense piece of rock touched something deep inside me. Maybe it was because I knew that it is the spiritual center of the Navajo Nation, maybe it was because it is the remnant of an ancient volcano. But this combination of history and geology ignited something deep inside me. Thus I needed to travel to the Four Corners area of New Mexico to photograph it.

When I arrived in Farmington with my family, I was overwhelmed by my first distant sighting of this otherworldly formation. Over the next 10 days I woke up at ungodly hours to drive long distances in order to arrive at first light, and then

left after sundown each day in order to catch the last light—driving over rocks, in mud, snow, rain, and sand. As we arrived in late December, the weather conditions made for moody, atmospheric photographs, as well as frozen fingers and toes. I spent the first eight days driving, scouting, and sitting quietly in the area surrounding Shiprock. It also seemed like the more time I spent in the area, the more I knew that I would need to be patient—despite the cold.

The morning of the eighth day I woke up at 4:30 a.m. and got into my truck in the freezing rain with a warm cup of coffee. From Farmington, the drive to Shiprock was 50 miles one way. It was snowing, and then raining, dark, and freezing. The thermometer on my truck read between eight and twelve degrees above zero Fahrenheit. For a few minutes there I remember thinking I was nuts. As this was the fifth time in eight days that I was making this trip (during this visit), my mind kept saying, "Why are you going out again when you could have stayed with your family in a warm bed? You're an idiot. You're not going to get anything." But I felt driven, as I wanted to

capture the image I had driven 800 miles from California to get.

When I finally arrived at Shiprock that morning it was approx 5:45 a.m. The sun was just coming up and the Shiprock was behind a wall of clouds. When I finally stopped and stepped out with my camera and tripod, I sank ankle deep into cold mud. But when I looked up I knew that what was about to happen in front of me was the thing I had come all this way for.

For the next three hours I sat in front of Shiprock...not a soul around, and I felt like we had a conversation. My hope is that the image presented helps communicate what I saw and the humility I felt while photographing this amazing structure.

BIOGRAPHY Growing up on Long Island (Bethpage), New York, I felt lost in my late teens. Worried about my future direction in life, my father gave me an old Argus rangefinder to fool around with. Little did he realize what an important gesture that would turn out to be for me.

After doing some research and seeing the images of Minor White and Ansel Adams, I quickly became addicted to photography.

To make a long story short, I left home at age 21, quitting my job and leaving my friends and family to see the American Southwest for myself. In California, I eventually met my wife and together we had three children. We created our own design studio, and the tasks of running a business and raising a family took priority over photography. During that time I stopped taking pictures.

Years later, in early 2005, inspired by my wife, children, and friends, I again picked up my cameras. Today I see myself on a passionate mission to make up for years of lost time—creating images that help evoke how I see our wonderful planet.

I feel that I owe much to the great photographers of the past, especially Ansel Adams, for their dedication to the craft and for inspiring me in my late teens. Though I have never met them, their inspiration helped me determine the course my life would take. My other influences are Minor White and Nick Brandt.

You can see my work at www.mitchdobrowner.com.

TECHNICAL This image was shot December 10, 2007, with a Sony R1 camera and Carl Zeiss 24–120mm lens. I used a focal length of 100mm (approximately), shutter speed of 20 seconds, and an aperture of F6.3.

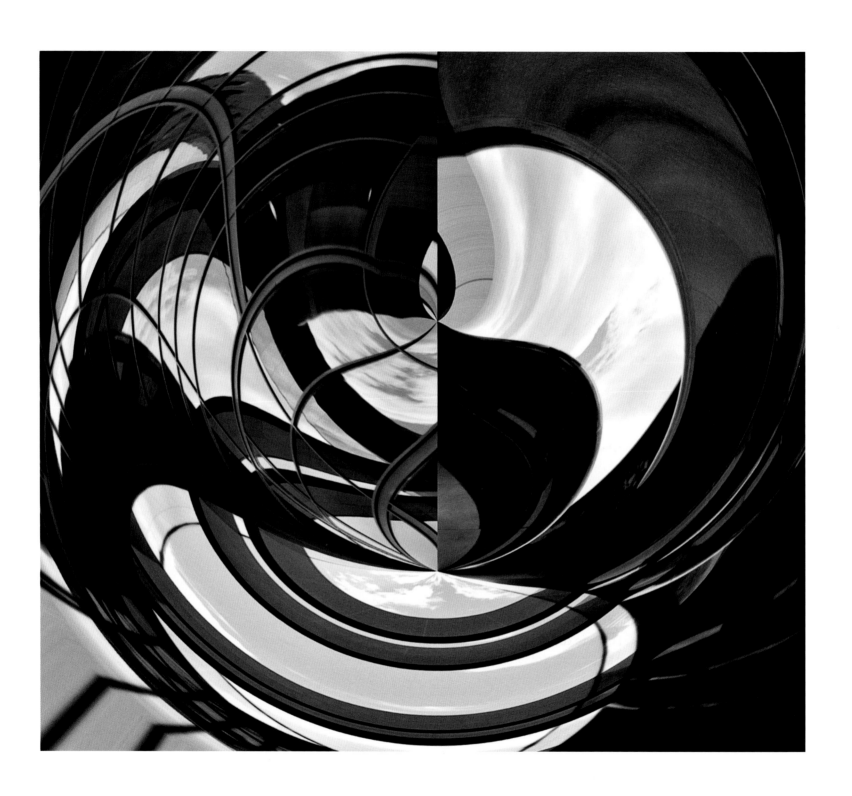

Manipulation

2006

GEORGE'S ANALYSIS I had seen Bengt Ekelberg's work on Photo.net and very much liked it. A check of the rest of his images indicated substantial depth to his work. Perhaps perversely, however, among all the excellent straight black-and-white work, I was most attracted to this image, toned and apparently manipulated. Well, this book was never intended as a catalog of people's work, and for the most part I have not gone out of my way to select representative images since the premise of the book is about photographs, not photographers.

The question then is how far can you manipulate a photograph and still call it photography? It seems many magazines are full of images that have more to do with fairy tales or nightmares than photography, but Bengt's image retains much of what it is to be a photograph, in terms of lighting and tonality, even if he has "stretched" the boundaries more than a little. Should we credit the photographer who searched harder to find the interesting image, or the person who took a more mundane photograph but manipulated it in ways that are highly creative?

I have to confess that I wanted Bengt to tell me that it was a straight photograph, some sort of chrome surface reflection, perhaps a hubcap. When he informed me that it was highly manipulated in Photoshop, I initially felt disappointed.

But this is silly. The image hasn't changed just because I understand how it was made; the lovely sweeping curves, the tonalities, and the interesting split between left and right remain the same. Perhaps we should in fact be giving more credit to imagination than to perseverance—even if instinct says otherwise.

It could be that this is a generational issue, in which people of my vintage (I'm 60) will "have issues" with manipulated images, while those under 30 will be

completely unaware of the controversy and simply accept that the road traveled is irrelevant to appreciating the destination.

I am fascinated by the division between left and right; the left detailed and complex and extending across the bottom of the image under the right, while the right side is fairly simple in design. There are two focal points from which lines radiate, and there are connections between the two. The clouded sky is recognizable, but trying to understand the source of the other elements is more than a little challenging. In his Perspective below, Bengt refers to the image being a mistake that he then took further. There is an honorable tradition of doing exactly this in all of the arts, from music to painting to photography.

Note how the corners of the image are handled. In both upper left and right, we have lines curving around the corners, though the two are quite different. At bottom left we have dark lines on a light background aiming into the corner, and on the bottom right we have three short curved lines nicely dividing up the dark space that otherwise could be too much. Thus, all the corners have lines—a connection, yet they are entirely different. There are a number of images in the book that use this technique of offering a connection on one plane while presenting almost opposites at another level; something to look for in viewing and composing photographs.

Lines extend across the center division, harmonizing the composition and creating several "S" bend curves. The complexity of the left means small areas of solid tone, while on the right there are fewer but much larger areas of light tone or dark tone exclusively. The sky is visible on both sides, furthering the connection. At the same time, we have reversal of tones near the center divider, dark on one side, light on the other, and alternating—a sophisticated composition offering multiple levels and much to enjoy over a long period.

THE PHOTOGRAPHER'S PERSPECTIVE One might say that this image is the result of making a mistake and then following where it leads. I was originally going to meet with a fellow student at the campus library, but since I had wanted to photograph the library building for some time, I brought a camera and got there early. What attracted me were the massive, highly polished, black larvikite stone columns set in front of large glass surfaces, and I had visualized a bold, almost abstract, black-and-white architectural study. Later, however, when studying the scan in my photo editor, I noticed a bit of curvature in lines that should be straight, which I wanted to correct. Being quite new to digital at the time, I had no idea how to do this. As it happened, my attempts only served to increase distortion rather than remove it. Seeing that this opened up a completely new interpretive direction, I continued to distort and twist the image in a radical fashion. Despite the twists and turns, however, all the elements that attracted me to trip the shutter in the first place are still present in

this image, distilled perhaps to an even purer degree. The blue toning was added to further emphasize the graphic quality of the image.

BIOGRAPHY I was born in 1975 and am based in Oslo, Norway where I pursue photography as a passionate hobbyist. Starting out from a love of nature and the natural landscape, my work has evolved to include an equal measure of extracts and abstracts of the urban environment—mainly in black-and-white. My major influences are Ansel Adams and Brett Weston.

You can see my work at www.bengtekelberg.com.

TECHNICAL For this photograph, I used an old Rollei TLR with modern, fine-grained film. A red filter was used to accentuate the sky and clouds.

Sleeping Halls
2009

GEORGE'S ANALYSIS I found this image by Sven Fennema in my random wanderings on the Internet and was captured by the light suffusing into this old building. It almost appears to be bursting through the doors and pouring in though the cracks. The flare only serves to emphasize the brilliance of the light and gives the building interior its atmosphere.

The near symmetry of the image works well: the columns and windows symmetrical, but the stairway flows diagonally up the image and is visible almost the entire distance, from bottom left to top right. On the right is the dark railing against a light area of the wall, while the railings going down toward the door are against a dark background and reflect light, giving the opposite effect. Both nicely show detail in the rails. The handrail in front of the window is at the absolute perfect height to show just a sliver of window under it.

Notice the difference between the two pillars. The pillar on the left is dark with a light background; the right pillar the opposite—even though the placement is mirrored. Good photographs tend to abhor randomness, but opposites can work very well.

The upper window is beautifully framed by the middle arch situated between pillars, with the circular window in the middle fully visible.

There are inconsistencies in the image. The right circular window has been boarded up; I only just noticed that, after viewing the image a dozen times. The inner doors are at different angles. Arguably these small random variations could spoil the pattern of the image, but each is small enough not to interfere with the strength of design, and they make the photograph more real.

The blue tinge to the image and the bare trees outside the windows create a somber mood, one of death and decay, or at least a feeling of winter. It is not immediately clear what kind of building this was—some sort of institution rather than a home is the impression. Were there school children running and yelling as they traversed the stairs, or something more serious—the ministry of justice, board of prisons, or an abandoned mental hospital?

I presume that Sven used exposure blending of some kind to record the gigantic range of brightness in play here, but unlike so many HDR images where the technique is flaunted; here we see the building, not the trickery.

THE PHOTOGRAPHER'S PERSPECTIVE Abandoned places have fascinated me for several years and are one of my favorite motifs in photography. The special thing about them is that there is so much history and atmosphere to them. They can tell so many stories, good or bad. It is always a little adventure to dive into the place, just keeping still for some time, breathing in the mood and letting my thoughts and fantasy fly around. While standing before a scene, and before I even place my camera, I am already considering what the final image might look like and only then do I start to plan camera placement to accomplish that imagined photograph.

It was a long trip of hundreds of kilometers to reach this abandoned military hospital complex with its unique architecture. It had been closed for many years, and the paint was slowly flaking from the walls and ceilings. We were lucky that we could go in because we heard rumors that this building would soon be locked up, but that's life in urban explorations! Often you're driving for hours to just be stopped by closed doors, and you drive home again filled with disappointment. On the other hand, if you finally discover a special place, it is like finding treasure.

The mood in these wonderful halls was amazing, the mixture of the beautiful architecture and the extreme contrasts of darkness and bright light flooding through made this hall really come alive for me. The scene was both exciting and difficult. The only way to succeed was to work with different exposures that I blended together later. I always do this manually with brushes and masks in Photoshop because I don't like the sterile atmosphere of automatic tools. I like high dynamic range, but it's also important to me to keep that mood and the shadow areas.

Another difficult point here was to find the right composition and framing. It was not easy as the room itself was not completely symmetrical, and also the height of the point of view was important. Tired and cold (it was early March), we started our long trip back after spending several hours there. It was then that the idea of the cold blue tones came into my mind.

BIOGRAPHY I am an amateur photographic artist, born in 1981 near the German Ruhr area. Today I live in Krefeld near Düsseldorf, where I also work in my day job in the technical operations department of an international software company.

I came to photography in 2007, partly through my existing interests in digital artwork but also through my wife, Phine, who was already in the photography scene due to

her activities as a model. Photography quickly became a real passion, and since 2008 it has became an important part of my life. Most of my free time is spent on photography-related activities, gladly sharing much of it with my wife, which makes this intense interest compatible with our relationship. I am well on the way to developing my own photographic style, always an ongoing process.

All my technical skills in photography and post-processing are self-taught. The big advantage to me in this is the freedom to develop my own style without heavy influence by a particular "school", finding my influences where I will.

It is difficult for me to list the artists who have influenced me; I wouldn't say that anyone specific has. I have collected inspiration from many different photographers of various styles. A street or landscape picture can inspire me as much as an architectural one.

I am excited about the release of my new book, *Anderswelten* (Seltmann & Söhne, August 2010). It is a hardcover photo book with 224 pages and is available in stores throughout Germany. It tells the story of several very special abandoned places, with a short text introduction followed by photographs made by me and my photo partner Björn Pretzel.

You can see my work at www.boundlessmind.net.

TECHNICAL The picture was made with a Canon EOS 400D (Rebel XT). Today I shoot with a Canon 7D. For this image, I used my favorite lens, the 10–22 EF-S lens from Canon, because I love the wide-angle perspective. I used four exposures for this picture and did an exposure blending because of the huge range of brightness, blending manually. For printing I always prefer large prints on a good paper. I especially like prints bonded on aluminum, sometimes with an acrylic glass covering. For my latest show, I have used canvas to make very large prints, and they look awesome, even if I do say so myself.

Comp 16/07
2007

GEORGE'S ANALYSIS I knew of Charles Cramer. He recommended the work of Hans Strand of Sweden—they are both in the book. In turn, Hans recommended I check the work of François Gillet. Despite the French sounding name, he too resides in Sweden. I went to his website and was astounded by the composite images I found there.

A 41" × 51" panel of nine photographs, these triptych photographs are beautiful. The individual images have been combined in such a way that the total image has subtlety in the soft light, and delicate tones and hues, while beautifully composed through the extreme care in which Francois has made, selected, and combined the individual images.

The concept of tiling a series of images is not especially new, but it is remarkably effective here. What really intrigues me, however, is that as I look at the image, the tiling seems to come and go. I can look at the image objectively and the joints are obvious—the photographer is making no pretence at hiding them—yet as I look at the image as a whole, the lines drop out for me and I see a continuous image of wonderful shapes and colors, and in patterns which form the composition for the final image.

The individual pieces do have intriguing shapes within, but it is when they come together that the photograph becomes powerful. The light, rectangular rock in the upper-right corner balances the light rock of the lower-left. The upper-left and lower-right tiles both have vertical shapes to them. Only three tiles contain the soft pink hue—upper-left, middle, and lower-right—again forming an organized pattern. Almost all the boundaries in the individual pieces have significantly different tones from others, so the concept of tiling is clear. Yellow rocks present in

only some of the panels form relationships that bind the whole.

One of the most intriguing things about the image is the almost glowing light. While the light tones are present in the individual pieces, it is when placed together that the glow is really revealed. The various shapes seem to float on the background rock, almost as if the rock forms were some sort of amoebae floating on pond water, alive, shifting, gone in the blink of the eye—a remarkable sensation for a series of pictures of rocks.

It is common for good photographers to treat subject matter as being the raw material with which to make an image rather than being the image itself. An abstraction can take place through unusual viewpoints—such as moving in very close or getting underneath—or in editing the image, or as in this case, through combining the parts into a cohesive whole, each part entirely without alteration.

Each time I look at the image, my eye seems to find a path through the various rock forms, but it is a different path each time, my mind making the connections, the routes, the turns and straightaways within the photograph.

THE PHOTOGRAPHER'S PERSPECTIVE For the first 30 years, the 10x8 large-format camera was my only tool. The size of the film provides a very wide range of tones, making it ideal to render the "feel" of things. Matter becomes almost palpable. The difficulty of looking at the ground-glass forces you to really look at your subject, instead of viewing reality through a viewfinder as it is the case with most cameras. As I have always avoided any kind of manipulation after firing the shutter, the realization of my pictures in studio has always been very complex, at times at the verge of impossible, and has limited my production to only a few pictures a year. Then, at the turn of the millennium, photography definitely came into a new age, and the high wire dancers lost their public.

The idea of a photograph as a proof of reality was suddenly obsolete. It is of extreme importance to me that the viewers know that nothing has been altered from the original scene in the editing of the images. We live in an age in which everyone is a photographer but few can see.

So, after over 30 years in my studio, I felt an urge for space, the need to discover—to rediscover. When an Aboriginal gets tired of everything, he disappears into the bush to regenerate. So I chose, in my turn, the Australian bush. I was there for the first time some 17 years ago, and I already felt a huge fascination for this massive, genuine country. It is another planet, another world: Genesis... In this virgin nature, one no longer seeks for subjects. They are here, invading, unavoidable. Nature is watching you. From the beginning, I had no premeditated plan. At the most, a sort of book of studies and first my genuine thirst to "see."

I have been tempted at times to call these pictures "scanning's," but they are, in fact, well chosen details: eyes looking at me from the rock, the amazing art-work of the sea-slug meandering across the rock-pool, or a brush-stroke from the stone which I love or recognize. Sometimes I can even tell the name of the artist! I am back at the very source of inspiration and creation through all ages, from Aboriginal Dreamtime to Pollock.

This new approach contrasts with my previous work. But if the actual picture is essentially spontaneous, and taken with a small format digital camera, "weaving" these final mosaics is not unlike assembling my large-format compositions. The choice of nine pictures, which is the smallest number necessary to provide me with a center, reminds me of the ground glass on my 10×8 Sinar.

This picture is one of the very early subjects that I found in South Australia. Some geological phenomena due to the presence of salt gave this crust the most amazing shapes and hues. The intensive light always at zenith gave the earth a drawing effect, yet strangely retaining its softness.

One more thing, obvious to me but worth mentioning today, the pictures are digital but in no way manipulated, i.e., full frame and still a proof of existence. Are the new projects an extension of my previous work, or is this a different path, yet offering new insights into my older work? As I see it today, both requestion existence through matter. Where my previous work starts from a whole and goes down to details, the new approach expands out into the universe.

BIOGRAPHY I was born in Normandy, France, in 1949. In my teens, I crossed the English Channel and studied language and commerce in Bournemouth, England. Although my prime interest had always been painting, in the late 60s, I took up a three-year course in photography at the Bournemouth & Poole College of Art and Design. I was soon fascinated by the medium. I worked hard, and was granted a "best-student-award" when I graduated in 1971.

I moved to Sweden when I was in my early twenties. I was first employed as a photographer at the Institutet för Färgfoto in Malmö, where I stayed for three years, working on a commission basis and experimenting a great deal. It was then I adopted the large-format camera as my main tool. My personal work introduced me to employment in Stockholm, and I was provided with my own studio by Arbman's advertising agency (at the time the leading creative agency in Scandinavia). Many award-winning campaigns in Sweden and Norway followed. After several portfolios in *Zoom Magazine,* I started working internationally.

I was at ease with more demanding subjects, as well as the ordinary and the non-spectacular, making me particularly popular with the advertising world. I have a preference for the projects that I can develop over a longer period of time. I first worked with Bonne Maman in 1985 and continued working for this client for over 20 years. I also handled The Brown Brothers Winery, with David Frost (who was art director of the project).

I have been fortunate to work with many legendary names of advertising, such as Paul Arden, Nigel Rose, Graham Fink, Parry Merkley, Bruno Lemoult, and Patrick Mikanovsky. I have always counterbalanced assignments with private work to such an extent that it is often difficult to clearly distinguish one from the other.

In the year 2000, I moved my studio to a small island in Stockholm's archipelago where I could more easily find not only the harmony I need, but also the pieces of the puzzle I slowly assemble. Over the last six years I have mostly worked on various private projects, such as the *Suite Automnale,* and more recently *Beyond Mystery-Bay* and *Le Pays du Rêve.* In 2007, I left my studio for the first time and travelled throughout the Australian continent, photographing nature.

While at college, I admired Bill Brandt and Lucien Clergue. Their influence was obvious in the two books I made at that time, *Eaux Sauvages* and *Adagio* (never published) about the sea and nudes. Then there was Irving Penn who showed us so much about quality and even how to fill empty space. The other great influences were the photographers whom we all followed eagerly at the time in *Nova, Vogue,* and *Zoom* as well as other magazines; and the new-wave people like Sarah Moon, Guy Bourdin, someone called Duc (who had been Bourdin's assistant), Max Maxwell, and Clive Arrowsmith (who I had the chance to assist for a week at Vogue Studios and who gave me self-confidence when I showed him my work).

The definite turn came when I stopped focusing on photographers only. I had been admitted to college with a portfolio of my paintings, and over time I grew more and more interested in the close relation between photography and painting.

More specifically, I was fascinated with the search for the most faithful, objective, ultimate way to represent reality—or should I say truth? Besides, at that time we were in the height of the hyperrealism period, and artists were spending months making their paintings look like photographs.

I am not all that fond of David Hockney's painting, but I think his photography is the most brilliant and creative since Man Ray. In his book *Secret Knowledge* he confirms my observation that the *photographic eye* came along long before photography was even invented. We are the children of the lens, not of the chemical process, which has been only a process, not an art. The list of artists who have opened my eyes is long and rich.

You can see my work at my website www.francoisgillet.com.

TECHNICAL I currently use an 8×10 view camera, transparency film, and LightJet prints. The Australian work, including every individual picture in this mosaic has been shot with a Canon G9 digital camera.

Whether working with giant 8" × 10" transparencies or the files from a digital camera, it is essential to me that the images not be manipulated in any way that would alter the original captured image. Being able to scan my transparencies has actually made it easier to retain the full quality of the transparencies, while I entirely avoid any digital enhancements to the images.

When it comes to making a print, adjustments serve only to get as close as possible to the original. In the past, it was difficult to match the full quality of the transparency. Today, with digital technology, it is possible to scan these originals to perfection, so I am now able to avoid the compromises, which I was forced to accept in the past when we used masks and all sorts of "cooking" and the results never matched the original anyhow.

I have never spent time on making my own prints. I have always had them made at the best possible lab. Today, I have LightJet prints made onto photo paper; Fuji or Kodak, according to the subject. The latest Light-Jets made from a 25-year-old transparency, are a joy to see, as I rediscover my own original for the first time after 25 years of compromises.

When it comes to my latest work, I assemble my mosaics on my computer and make proofs on an Epson inkjet printer until satisfied. My lab makes the final LightJet prints from the files I provide.

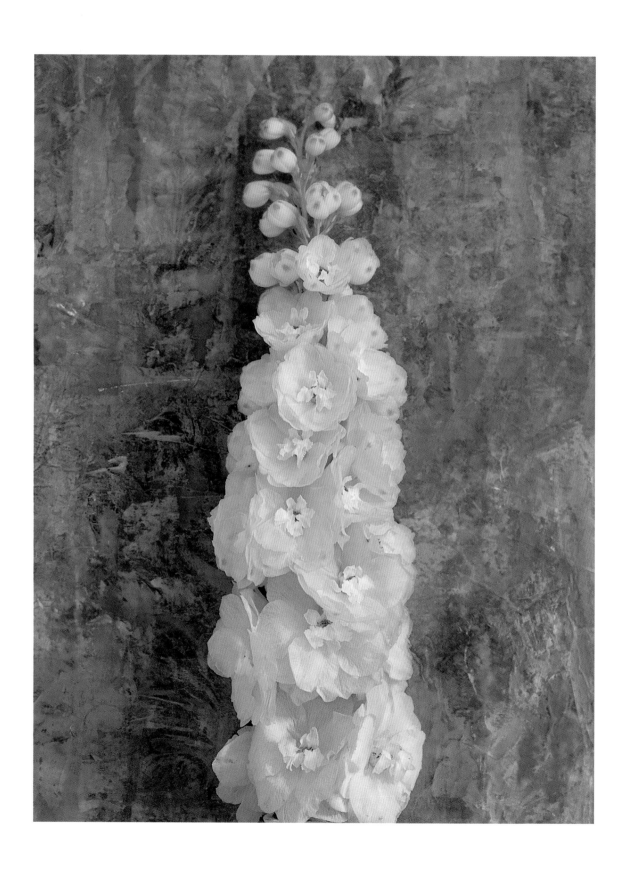

White Delphinium

2009

GEORGE'S ANALYSIS Carol Hicks's photograph is one of 3 flower photographs in a book of some 52 images, each quite unique in both style and technique. With her head-on view, Carol has foregone tricky compositional tools and even complex lighting to present the flower in a soft light, showing maximum detail. She then painted a quite detailed yet subtle background for it.

Simple compositions like this let us concentrate on the color and form of the subject. While the delphinium is described as "white", in fact the subtle hues of the plant are anything but simple white, with delightful gradations from cream to yellow and hints of violet. Nowhere in the photograph are there either intense hues or dramatic tones—it is just a riot of pastels.

The painted background reflects many of the shapes found in the flower, albeit in somber hues, tying the two together in a way that is so often missing in lesser portraits. The background reminds me of rock—heavy, solid, unmoving—in contrast to the delicacy of the flower. Backgrounds are often out of focus to draw attention to the main subject, yet here Carol has retained considerable variation: brown hues scattered through top and left, some almost white tones in the bottom right. It is unusual for a background to contain this much detail, yet it doesn't detract from the far lighter flower, thus becoming as important an element of the composition as the subject.

The gradation of hues is important to the image, from the violet at the bottom to yellow at the top. Studying the gradual progression of color is one reason to repeatedly come back to the photograph. I am intrigued by the change from the center of each blossom to the petals surrounding it, barely visible in some of the

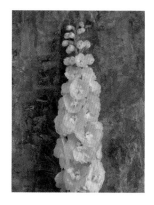

blossoms. Although there is very fine detail in much of the flower, at the same time it has a painterly quality.

I have used the term "painterly" in describing more than one image in this book, and were a photograph simply an imitation painting, it would be a failed image. There is nothing wrong, however, in taking advantage of some aspects of painting in any photograph, whether in composition, light, color, or texture. The image then needs to make use of the characteristics that photography brings to the subject: the recording of exquisite detail, the gradual changes in color and tone that would be difficult if not impossible in painting, and the application of lighting to even the smallest detail of the image.

In a world of images with dramatic lighting and bright colors, it is delightful to come across the kind of gentleness, understatement, and quiet sophistication of this photograph.

THE PHOTOGRAPHER'S PERSPECTIVE My passion is still life photography. My aim is to capture the ordinary everyday things we see and to reveal the extraordinary quality they contain. Working in a studio allows me to set up a simple still life in which the object itself can be viewed, contemplated, and photographed, allowing a sense of time to be present.

Some plants fascinate me and I find myself photographing them time and time again. Delphinium is one such plant. They range from willowy, fragile plants to sculptural, stately flower heads, and their colors range from whites to pink to deep blue. Seeing this through the viewfinder is a wonderful experience of nature's exquisite detail.

Subjects are chosen for their particular shape and detail they make when viewed against a backdrop. Most of my backgrounds are handmade and range from simple painted backdrops to complicated textural surfaces. This provides me with a welcome break for some contemplation and hands-on experience of using paper and paint. Texture is an important element of my photography and *White Delphinium* has a background made of layers of transparent painted paper.

The final print is on Arches archival hot-pressed watercolor paper that is hand-coated with an inkAID liquid digital coating prior to printing. This produces a softer, more luminous print that suits my images.

BIOGRAPHY I first trained in fine arts, obtaining an Honors BA as a painter, but became interested in digital photography in 2001 while taking photographs of my paintings. The ability to take a photograph, process it in appropriate software, and print out the desired results proved compulsive—since then I have never looked back.

I obtained an associate membership with the Royal Photographic Society in 2003 and I was invited to join Arena photographers from the south (of England) in 2007.

My photographs and articles have appeared in *Black & White Photography* and *Silvershotz*.

My work can be viewed at Chatsworth House Derbyshire, home of the Duke and Duchess of Devonshire.

I have been influenced and inspired by John Blakemore and Karl Blossfeldts.

My work is mainly based on flowers and vegetables, which I approach as plant portraiture. Future projects include working toward a fellowship with the Royal Photographic Society and producing hand-bound books.

My website is at www.carolhicks.co.uk.

TECHNICAL I use a tripod and Canon 5D camera with a 100mm F2 lens for my studio shots. Lightroom is used for processing the image, and prints are made using an Epson 3800 printer on archival watercolor paper coated with inkAID.

Caixa 1

2009

GEORGE'S ANALYSIS Architecture is one of the classic subjects of photography, with a long and honorable history. Yet because what is being photographed was designed and created by someone else, it has always been tainted with the associated questions of whether a photograph of architecture is legitimate art and who should take credit.

Perhaps the easiest way to answer these questions is to take advantage of the Internet to do a search for similar images. In several hundred images of this building in Madrid, including a few of the stairway, none duplicated this view, and only one approached its artistry. This suggests to me that the photographer does in fact contribute hugely to the success of this kind of image.

Camera placement in this image by Thomas Holtkötter is absolutely critical—even a few millimeters of repositioning would spoil the composition. Not only do we have the handrail coming to two corners, it disappears around the corner against the top edge while the top step comes precisely into the bottom left corner. There are three areas of highlights—top-left, bottom-middle, and top-right—a nicely balanced yet not symmetrical positioning. Each step reflects a different and sequential amount of brightness, adding to the organization of the image.

I don't know where the purple comes from but it nicely contrasts the otherwise warm tones of the walls, stairs, and railings elsewhere in the image. Note that there are three dark areas of the image—bottom-right, top-middle, and bottom-left—again forming an attractive arrangement. Having two different arrangements of threes (the highlights and the shadows) works together to add interest. A series of triangles is a potent compositional tool.

The saw-tooth pattern of the stair edges in the bottom-left is balanced by the less-aggressive line of the stairs curving in the opposite direction. Individual panels have sufficient texture and variation in reflection to be interesting. I find the mottled pattern of the landing and lower right wall to contribute to the success of the image—yes it shows the stairway in less than pristine condition, but it also confirms it as a functioning part of the building, not simply someone's sculpture.

THE PHOTOGRAPHER'S PERSPECTIVE The photo *Caixa 1* was made during a trip to Madrid. I had the job to photograph the new tennis stadium there, the so-called Caja Magica from the French architect Dominique Perrault. After finishing it, I took the opportunity to visit the Forum Caixa, a post-modern art gallery in the heart of Madrid. The Swiss architect firm Herzog & de Meuron converted this old unused industrial building into a museum. One highlight of the building is the staircase from the ground level to the lobby—a deconstructivistic piece of art itself, mainly made of stainless steel with wooden handrails. Being immediately fascinated by the design of the staircase, I tried various points of view to get a picture that emphasizes the unusual form, ending up with this wide-angle shot showing the staircase in this dramatic view, which requires the viewer to puzzle over the photograph before they understand the content.

In taking architectural photographs, one of my main concerns is always the unusual point of view. It is this little extra which makes a photo stand out from others.

BIOGRAPHY As an architect working for an international operating company, I'm in the lucky position to combine my main job with my passion for photography. Starting in the mid-1980s with travel photography, I became more and more interested in architecture, becoming something of a specialist in this field, with many images published in architectural magazines.

My work means that I travel a lot. I am on the road almost half of my working time, visiting our representatives and subsidiaries throughout the east. This sometimes allows me to photograph some pretty spectacular architecture.

I live in Aachen, Germany. A year ago I established my own company in addition to my main job, called 8-125 Photography. If time allows, I shoot architectural subjects professionally and also do natural-light portrait shoots. I like scuba diving and mountain biking. In addition I read and am interested in art. I also give courses on architectural photography at the Ludwig Forum, a well-known Museum for International Art in Aachen.

I'm not influenced so much by other photographers, but more by the architecture itself. Seeing an interesting building I'm always trying to make the special shot. That said, I like the work of the American photographer Arthur Leipzig, with his amazing New York pictures from the 1940s and 1950s.

My website is located at www.8-125.com.

TECHNICAL For this shot, I used a Canon EOS 30D and a 17–85 mm zoom lens. It was made in summer 2009 with the following data: 17 mm at F5,6 and 1/15 sec with ISO 400.

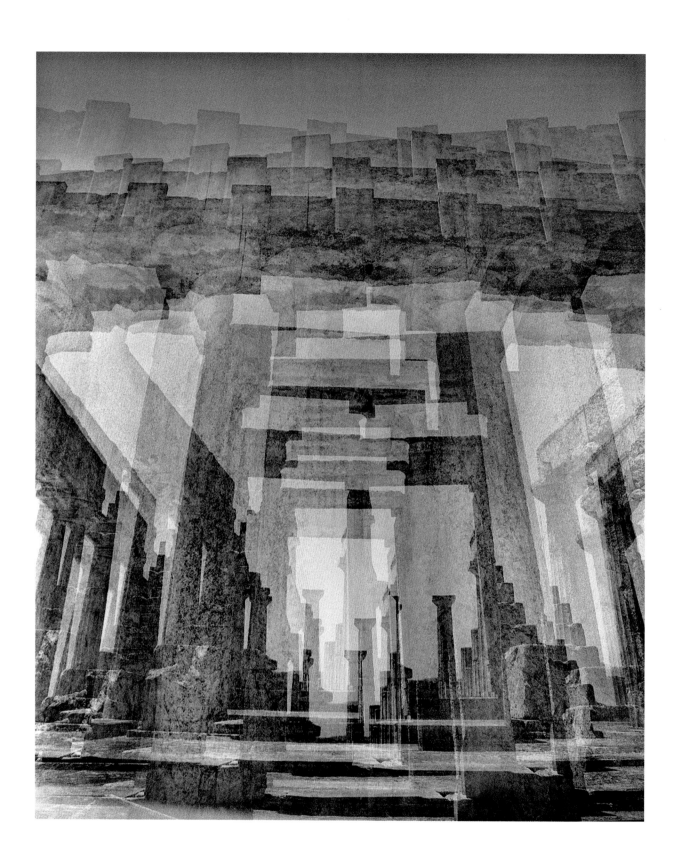

The Temple Of Godless Aphaia

2004

GEORGE'S ANALYSIS The combination of multiple exposures and photographing ancient ruins comes together perfectly in Milan's photograph of a temple. The sense of time passing, of change and decay, are perfectly portrayed. At the same time, the technique gives the image energy that no single photograph of the ruins could capture.

Elsewhere in the book are other examples of multiple exposures. In each case, the photograph is entirely unique, the technique of multiple exposure producing quite different results, depending on how it was applied and the circumstances under which it was used.

Sometimes photographers interpret their images in ways quite different from how others view them. Occasionally they even contradict themselves, coming up with a different interpretation years later. Sometimes, as in this photograph, the techniques make for a predominant interpretation visible to almost everyone. Elsewhere in the book are examples of images that encourage the viewer to select their own interpretation. Neither is better, and whether there is a clear explanation or an open invitation to interpret as one will is simply a choice the creative photographer must make.

The building looks ghostly and the translucency suggests impermanence of even these stone structures, as if one could walk through the pillars. Of course, over time some pillars have fallen, so this nicely represents the changes in the building as it experiences the ravages of time.

The tilted viewpoint gives the image energy and implies movement, which is a contradiction given the building hasn't gone anywhere in all these years.

The dark top of the image implies a roof to the structure, even though that has long since almost entirely vanished, the first part to suffer from earthquake, fire, or war.

Pay attention to the placement of the multiple images, with pillars nicely interspersed so as to show to best advantage. For example, at the right side, there are two obvious pillars, with white space between—think how much less effective the image would have been had the white space been obliterated and the individual pillars less separated visually. Overall, the patterns created through the multiple exposures produce a superb image.

Along the left side we see what appears to be three exposures with the same wall repeated in an enlarging pattern, yet because there are only a few exposures, we don't have the sense of simply standing there zooming in as we see quite often—here less is more.

Photographic trickery for trickery's sake pales quickly, easily becomes repetitive, and seems altogether a bit too clever even when new. Trickery that serves to represent what otherwise couldn't be photographed is a whole other matter, a tool rather than a trick. The photographer must match the tool or technique to the purpose, and only then does it become art.

THE PHOTOGRAPHER'S PERSPECTIVE The concept of the photos I present is to enhance the perception of three-dimensionality in an otherwise two-dimensional photographic image. I achieve this through multiple exposures of a single subject matter on one negative, with slight changes of the camera, lens, and focus distance. To enhance tonal range, I change the filters in front of the lens for each exposure.

Focus extends through the entire print, which gives a homogeneity and completeness.

Ultimately, a new reality results where all perspective laws have been maintained, and the rhythm enhances the illusion of depth. The final result is completed within the camera and on a single piece of film during the photographing rather than using the darkroom to manipulate the images.

Roll film is developed manually, with a very dilute developer for an extended time to tame the contrast range, an inherent problem with repeated exposures. Printing is on silver halide paper in the traditional way. My goal as a photographer is largely to relate to the past. These are religious temples and monuments from the Neolithic period through the period of the Roman Empire and up to the fifteenth century. They have been discovered both in my native Bulgaria and in the nearby countries of Greece and Turkey, all places where I like to work.

The combination of place and technique allows me to add elements of mysticism, mysteriousness, and spirituality to the photographs.

BIOGRAPHY I was born in one of the most ancient cities of the world—Plovdiv, Bulgaria—where I still live and work. My first impressions from photography go back to my childhood. My parents had brought me to a wedding party. There on a lawn, about 100 people were standing in the sun, wearing costumes and dresses, and just across from them a man assiduously worked to place a box on three legs. All this he did smoothly, with absolute accuracy. There was some kind of a sacred ritual in his movements! And at that moment he said, "Attention!" He then waved a hand in front of the lens and something flashed and boomed. That was my first encounter with photography, 35 years ago.

In 1977 in the city of Plovdiv, there was a big exhibition called "Photography in the USA". I was greatly impressed by the large-format pictures with print sizes of 2 to 3 meters, and the outstanding images of *Milk Drop, A Bullet Passing Through an Apple,* and others. There the darkrooms were illuminated in red lamps with giant enlargers, far better than I had in my own dingy darkroom. The strongest impression amongst the great noise and glamour of the show was a small hall with black-and-white photographs. These were perfectly printed portraits and landscapes put in white picture mounts and black frames. I stood in that hall for hours. I was enchanted. And that's how I got acquainted with Ansel Adams, Brett Weston, Edward Weston, Alfred Steiglitz, Man Ray, and others.

In 1985 I graduated from the Photographic College in Sofia. I have participated in more than 100 photographic exhibitions and projects. For the past 30 years photography has been my profession, my hobby, and my life—as well as my family's.

You can learn more about me and see more of my images on my website at www.milanhristev.com.

TECHNICAL For this image I used a Mamiya RB67 camera with a 50mm lens, and either Fuji Neopan 400 or ORWO NP22 film.

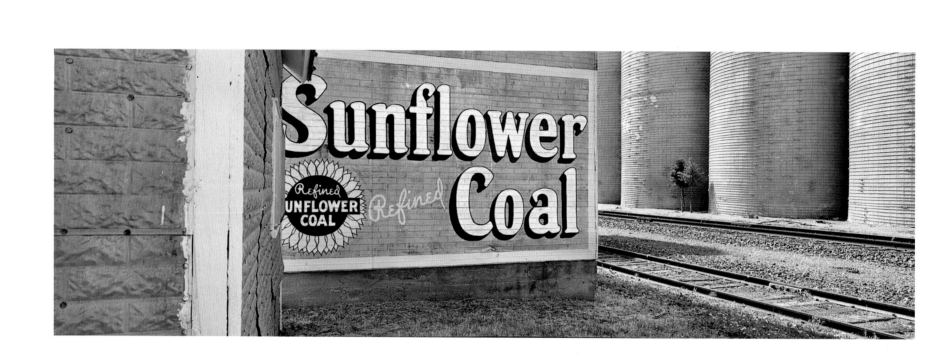

Sunflower Coal
2002

GEORGE'S ANALYSIS I could be accused of favoritism as George Jerkovich is a fellow physician, but truth is I discovered these small-town, middle America images by George a few years ago and repeatedly go back to look at them with pleasure.

George's images stuck with me because I could so easily relate them to small prairie towns, full of old trucks, fake stone siding, faded signs, and railway tracks. George has managed to distill the essence of "small town" while eliminating any distractions from that message, not only avoiding anachronisms but also paring surplus detail that, while not contradicting the message, does nothing to add to it. This makes it easier for us to associate the images with small towns of our own experiences. In his images there is one old vehicle, but not dozens. There are no people, but seeing real people means it is harder to imagine ourselves walking down these streets, entering these stores, or parking our pickup truck.

This image of the Sunflower Coal sign works this way. While the composition is exactly right, it isn't overly tricky and in no way distracts from the image. Note the green tones that run throughout the image, tying it together nicely—even the fake stone siding has a green tinge to it. The name Sunflower seems something left over from the 1950s. All surfaces appear weathered and reflect aging; little has changed here in years. Old freight cars or an old truck would have added interest but weakened the image. At some level we have to decide whether we are primarily creating art or document. While a historian might argue, "the more the merrier", the artist cannot be guided by such philosophy.

Notice how perfectly that little piece of roofing is placed relative to the sign, the point perfectly touching the inner edge of the S. The track roadbed (the area

between the rails) nicely meets the corner of the image bottom right. The subject is well suited to the panoramic format without being too obvious. Sometimes it seems the panoramic format is used because it is the least problematic solution to a not quite great photograph, but with this image, it makes perfect sense.

Even the shadows on the tracks, the dry grass, and the spilled grain between the tracks add to the photograph. What about that group of tiny trees in the angle of the silos, balancing the grass on the opposite side of the tracks, but more importantly adding an incongruous point to the image, reflecting the passage of time without shouting modern. I think you will enjoy George's other small-town images, similarly crafted, yet each unique.

THE PHOTOGRAPHER'S PERSPECTIVE My main motivation in taking photographs is the joy I derive from discovering, processing, and printing an image. The Sunflower Coal sign was found on a trip to Wilson, Kansas. I took many photographs that day. When I viewed this particular image in the viewfinder of my Fuji 617, I instantly knew it would be good. I had that instantaneous gratification that occurs rather infrequently. Something suddenly came into place. This was a keeper. I liked the composition, the depth, and the subject matter. The splash of yellow was invigorating. I usually do my "serious work" in my local environment. This way I am not distracted by the novelty of the subject and can concentrate on composition. The small towns and prairie of rural Kansas provide an endless supply of subject matter to keep me sufficiently challenged.

BIOGRAPHY I am 53 years old and have been living in Kansas most of my life. I was born in Croatia but came to America at an early age. I am a physician and practice psychiatry. No, I do not photograph as a way to "escape" from the stress of my profession ... nor does my profession guide or inform my photography. I am a very visual person and have been interested in photography for as long as I can remember. After my first year of medical school, I sold my microscope and used the money to buy camera equipment. I have the largest collection of panoramic nature photographs of central Kansas. I don't know of anyone else who does primarily panoramic photography in my area.

My influences are Ansel Adams, Terry Evans, and John Sexton.

My work can be seen on the websites of the galleries that represent me. It is easiest to google my name and find the URLs for the Courtyard Gallery, Strecker Nelson Gallery, and the 75th Street Gallery.

My email address is gjerkovich@cox.net.

TECHNICAL I have shot with a Fuji 617, but now I use a Canon EOS 1Ds Mark II and stitch the images using Adobe Photoshop. My printing is done on an Epson printer using Epson's UltraChrome pigment inks.

Fugue
2008

GEORGE'S ANALYSIS Kim Kauffman's *Illumitones* portfolio was recently featured in *LensWork* magazine, and the images were breathtaking. I liked them all. You might think that praise to be faint, but I find that it is rare for me to like even a quarter of the images in any portfolio. Oh, I can *admire* them, but *like,* no. As so often happens, however, some images connect with the viewer more than others, and this image is one of several that I think are superb.

There is much to be said for an original concept. When that fresh idea is fully developed, the concept becomes admirable, and every so often a successfully developed concept "clicks" with us, and *wonderful* becomes *possible*. Were Kim to write instructions on how to make this and her other images in the portfolio, without letting us see any of the images, I am certain that our results would look nothing like Kim's photographs, and very likely they would be nowhere near as successful.

Elsewhere in this book I have mentioned the rightness of a composition. Here the three main shapes of the image work off of each other and with the edges of the photograph. There is balance between the left and right. The two curves of folded paper face each other. The relation of the two shapes to the lightning bolt shape in the center is complex. The right-hand figure seems to be buried in the side of the bolt near the top, yet we can see at the bottom that it is behind the left figure, which is in turn in front of the bolt. This puzzle, almost like an Escher drawing, adds intrigue.

The composition takes advantage of the nature of rectangular images, the edges and corners as compositional elements. It is interesting to note that the triangle halfway down the left side has been truncated: Many would have had the

point of the triangle touch the border. But consider the cut-off corners of paper within the print in the upper-right and the distance from the edge of the print of the two curves in the bottom-right. In a way, there is a consistency in how the edges are handled, with the main shapes either not quite there or extending a small way past the edge. Having the points of triangles exactly touch the edge of a print can work well, but done too often in a print it can seem unnatural, too manipulated.

How the three main shapes relate to the edge is noteworthy. One comes from above the border of the image and stops within, one comes from above and carries on below, while the third starts and finishes within the borders of the image. We don't know if Kim did this deliberately or discovered it in making the photograph. Does planning trump instinct? I don't see why it would. There is considerable controversy in discussing the concept of previsualization that Ansel Adams espoused, in which the final appearance of the print was planned from the start. This is in comparison to the sense of discovery that other photographers consider vital to their work when they take the negative or RAW file and start to work with and upon it.

When I viewed these images, they were in *LensWork* magazine and necessarily in black-and-white, and it was their beauty there that led me to select one for this book. Only when I went to Kim's website did I find that the originals were in color. I find it difficult to decide which I prefer. On the one hand, the black-and-white version has wonderful tonalities, is perhaps cleaner, and certainly is simpler. The color image, however, has a greater sense of transparency, and the top of the right-hand shape looks more like a window onto the sky, creating an entirely new relationship for the objects of the photograph.

A new layer of object relationships to add to the composition and balance of the image is acquired when color is added. We now have connections between areas of similar hues and possibly even opposite hues, and in color saturation too.

The left-hand shape is largely olive in color, but one fold has definite hints of pink, and elsewhere there are more subtle pink tones defining some of the edges. The right shape is overall cooler in color but again has one area that shows pink tones, and now we have a new relationship between pink objects. The background "lightning bolt" doesn't just fade into the background; there are purple hues before black. In real life, shadows are often subtly different from the rest of the image, typically lit by blue sky instead of sun or, even more interesting, by objects opposite them.

Notice that although this is not a real three-dimensional construction, there are "shadows" on the lightning bolt that correspond to the shapes ostensibly in front, so in one sense there is logic to the arrangement, while on another level, it is entirely fantasy. Interestingly, I hadn't noticed the three-dimensional effects in black-and-white. I first noticed them in the website image and perceived the full effect when Kim's full-size file arrived for the book.

THE PHOTOGRAPHER'S PERSPECTIVE Why would anyone take pieces of paper from the recycle bin, twist and fold them, then put them on a flatbed scanner to record them? Why, after that, combine up to a dozen of those scans to create an entirely new image? My answer to "why" became a body of work called *Illumitones,* of which *Fugue* is a pivotal image.

I'd had an idea percolating—a new project that would allow me to revisit my love of abstraction in photography. It was important not to rehash what I had done before. Having worked primarily with color the past 15 years, I wished to return to black-and-white, my first photographic love. Recalling the sophisticated photograms by Man Ray and Moholy-Nagy, I realized how compelling these images remain for me. Their dynamic contrast and prominence of form continue to inspire me. How could I acknowledge this tradition while making a new contribution to it?

I have been immersed in making cameraless images for other projects since 1998. The process incorporates the use of a flatbed scanner to record three-dimensional objects, and photo-collages of multiple scans to create the final image. An image made with a flatbed scanner is in many ways a modern-day equivalent of a photogram, a direct recording of an object without the use of a camera or negative. It seemed that this method would be a fitting point of departure. When working with paper—a very malleable and compliant subject—twisting and folding it reveals its sculptural and chameleon-like nature. Limiting myself to one subject/object makes the resulting images less about the object and more purely an expression of the visual space that evolved in my mind's eye while making the photo-collages. I believe the elements of composition that artists work with— line and form, light and shadow, rhythm, balance, and repetition—are ways of structuring space that is hardwired in human brains. The blank sheet of paper became an excellent metaphor for my newest exploration of abstraction.

Why use a scanner when today's cameras are so good, not to mention portable? The quality of light in scanner images is very different than in camera-derived images. The object is wrapped in gorgeous light as the scanner light travels the length of the bed. The scanner can capture an incredible amount of information, recording detail almost unseen with the eye alone. I often think of it as an 8.5×11 view camera (minus the swings and tilts). Working with a scanner requires previsualization skills unlike any in my previous photographic experience. As the scanner records objects from the bottom

up, I must arrange them with an eye to how they will be recorded when reversed. This is similar to how a printmaker works, visualizing and creating the plate while anticipating how the image will render in the final print.

Creating photo-collages with a computer and software differs greatly from working with a camera and lens. I create the final composition on my monitor rather than isolating a scene in the viewfinder. This method of building an image has many similarities to painting. The process and technology allow for endless possibilities. For an artist drawn to "what if?" this is both a blessing and a curse. Someone recently related a quote to me: "The work of being an artist is to finish the work."

BIOGRAPHY I was born in 1952 and I am a resident of Lansing, Michigan. I have been making photographs for over 30 years, during which several serendipitous events have contributed to my current practice. Armed with a camera given to me by my father, I explored photography informally while studying social science in college. After graduating, I took what I considered to be an interim job at a community college photography program while considering my future. That fateful step, with its immersion in photography, led to a change in course as it became clear that photography was my true calling. Later I worked as a photographer's assistant—an experience that further cemented my commitment to the medium.

In 1983 I opened a studio, making photography my full-time endeavor. Throughout this period of professional exploration, I also developed an enduring love of gardening with an

appreciation of its importance in my urban life. I sought to share my experience through my photography but in an uncharted way. What followed was a period of experimentation culminating in the cameraless photo-collage technique that I now use to create the *Illumitones* images.

I advise photography students on portfolio development, teach seminars on my cameraless technique, and give talks about my work to classes, artist groups, and gallery patrons. I enjoy working one-on-one with students and sharing my experience in all aspects of photography, including business skills that are not readily available in photography curricula. Currently, I continue to explore *Illumitones,* as it is a direction I feel will challenge me for some time to come.

My influences are Arnold Newman, Olivia Parker, and Ralph Gibson.

My work has appeared in the magazines *LensWork* # 84, *Whisper In The Woods* (Autumn 2005), *Photo Design* Jan/Feb 1992; and the book *Flora: A Contemporary Collection of Floral Photography* (Graphis, 2002), among others.

You can find out more about my work at my website www.synecdochestudio.com and may email me at kim@synecdochestudio.com.

TECHNICAL To create my cameraless photo-collages, I use the following equipment: Epson Perfection 3200 flatbed scanner, Macintosh 2×2.8Ghz Quad-Core Intel Xeon computer, Adobe Photoshop CS4 software, and a Wacom Intuos 3 Graphics tablet and stylus. I make archival pigment prints with Epson 3800 and 7800 printers using Epson's K3 ink set. I print on Moab Entrada Natural 300gsm paper.

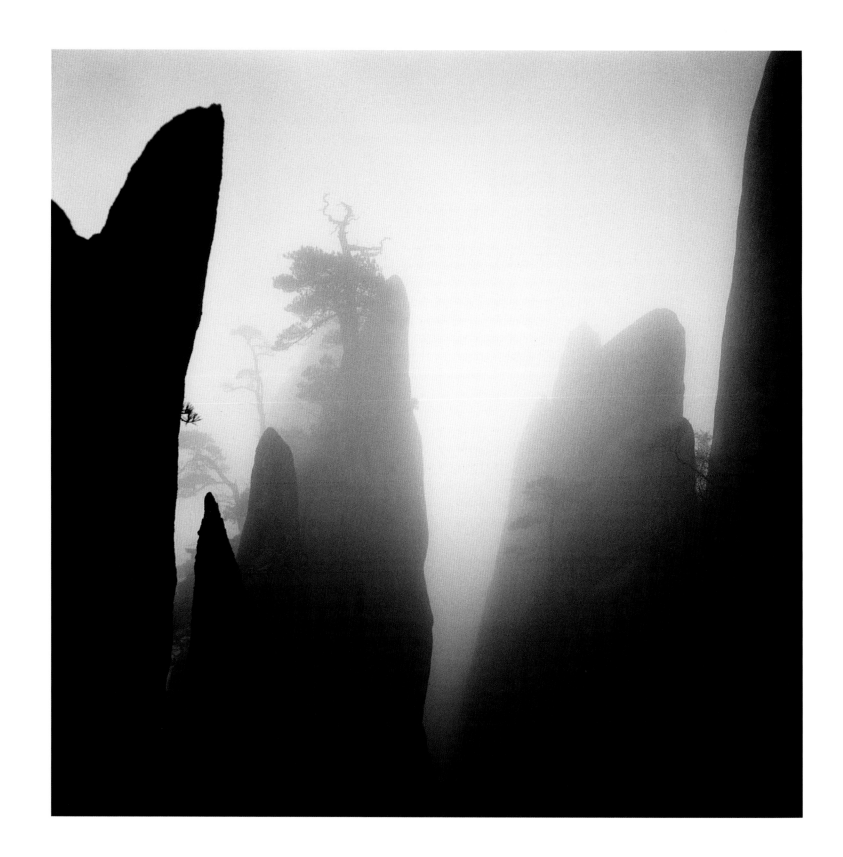

Huangshan Mountains, Study # 19

2009

GEORGE'S ANALYSIS *Mysterious, exotic, scary; ominous, hidden, intriguing:* these are the adjectives that come to mind in describing this photograph. Perhaps they are appropriate for the way many in the West see China. That's a lot for any one image to portray, but that is the nature of Michael Kenna's photographs.

The best photographers have a consistent style while managing to avoid repetition. At first glance, this photograph looks nothing like Michael's previous work. At the same time, it is typical of Michael's work. He uses weather to simplify and clarify his vision. In other photographs, Michael uses darkness or long exposures of moving water; snow or clouds; or just careful positioning to create compositions of relatively few elements, of simple and very strong design. Here we have only the six main shapes against the background of light coming through the mist. Devoid of detail, we are able to concentrate on how each shape relates to the other elements of the photograph, from barely to dramatically different.

The shapes are intriguing—unlike landscape in most of the world. That they all meld at the base of the image gives me the sense of being trapped by a wall of pinnacles, with no way through. At the same time, both pinnacles and trees have a delicacy to them that suggests they are fragile or unstable.

Perhaps the single greatest strength of a black-and-white photograph is in its ability to capture subtle changes in tonality. In this photograph we have the play of the bold pinnacles and the barely visible branches. The photographic print is able to portray this better than any other artistic medium. It is vital for the artist to match his or her vision to the appropriate tools and techniques rather than

selecting the tools and then forcing every subject to somehow work with them. Michael has found the equipment and methods—medium format, film, square images, and small silver gelatin prints—that allow him to express himself and his vision most effectively.

As a composition, one is reminded of Michael's work with the Ratcliffe Power Station cooling towers, the right pinnacle reaching outside the print while the left pinnacle has some sky above which makes an interesting shape of the upper left corner of the print. Three of the pinnacles lean right to a matching degree while the others stretch vertically. Although there are an even number of elements, split in the middle, symmetry is not forced upon us, the shapes of the composition on the two sides being quite different.

There is a duality of the photograph: One can see it as a series of shapes on paper, varying in tone and resembling a monochromatic watercolor of quiet oriental design. It can also

be seen three-dimensionally, as the thickening mist gradually hides the further details and conveys their depth.

I find the bare branches above the center pinnacle fascinating: a figure reaching for the sky. The deep cleft between pinnacles in the center suggests that despite the barrier, there may be a way through to the light. We are left uncertain.

The photograph captures our attention with the bold and exotic shapes, keeps our interest as we perceive the subtleties barely revealed in the mist, and then encourages us to think of metaphors for the experiences of our own lives, all without shouting or stating the obvious.

THE PHOTOGRAPHER'S PERSPECTIVE This image is part of an extended series on Huangshan (Yellow Mountain), in Anhui, China. This mountain range has been an inspiration for artists throughout the centuries. My efforts are very much an homage to the thousands of poets, painters, and others who have gone before me. The weather conditions on top of Huangshan are unpredictable and changeable; bright sunlight and blue skies, rain and snow, fog and rising mist can all occur within 24 hours.

As a photographer I realize that nothing is ever the same twice, so I try to make the most of every available opportunity. I photograph during the day and also at night. I make short and long exposures. I utilize a number of different focal length lenses. I try to explore and expand whatever creativity I have been blessed with. Sometimes, many of the ingredients work together to produce something that excites and thrills me. This image is a good example. At the end of a long day of hiking, with light fading and visibility limited, I came across this location. Climbing on some rocks I was able to make a number of photographs before it grew dark and extremely cold. I was fortunate, and very happy with the results.

BIOGRAPHY I live and work in Seattle, Washington; often scheduling gallery exhibitions around my marathon running events. I spend a substantial part of each year traveling to other countries to photograph: China, Egypt, England, France, India, Italy, Japan, Korea, Norway, Russia, etc.

I was born in Widnes, Lancashire, England in 1953 and attended a junior seminary school where I began training to be a Catholic priest before switching directions and instead opting to attend the Banbury School of Art, and later the London College of Printing. I became a commercial photographer even though my major interest was in the landscape, because at the time, I felt that it would not be possible to make a living from fine art photography in England.

A trip to New York in 1976 showed me that my dream was not impossible to realize. I moved to the west coast of America, where I worked in a framing shop by day and assisted the photographer Ruth Bernhard by night. An extremely demanding printer, Ruth helped to hone my printing skills and at the same time she became an enthusiastic supporter of my work.

For over 35 years, I've been photographing landscapes throughout the world. I believe in keeping images simple, abstract, and with a strong design. I photograph whenever I can, throughout the day and night, making exposures of up to 10 hours while enjoying the time of being alone with my cameras.

I don't like to previsualize the final image when I photograph. I prefer to discover and then explore the potential of the resulting negatives. I am more drawn to suggestion rather than description. Details do not greatly interest me.

At a time when gigantic digital prints are so popular, I still prefer the tonality and quality of small hand-made silver prints and I enjoy the discipline of the square format.

Many photographers spend their time learning about new equipment, experimenting, and changing. That doesn't work for me. I am completely content to use the same equipment as long as possible. I prefer to put my energy into making art rather than testing new techniques.

More than 40 books and catalogs of my work have been published, most recently *Venezia* (Nazraeli Press, June 2010). *Michael Kenna, A Twenty Year Retrospective* (Nazraeli Press, March 2003) and *Retrospective Two* (Nazraeli Press, Jan. 2004) are also readily available. The complete catalog can be viewed on my website.

I have been most influenced by the photographers Eugene Atget, Ruth Bernhard, Bill Brandt, Harry Callahan, Mario Giacomelli, Alfred Stieglitz, Josef Sudek, and Hiroshi Sugimoto; and the painters John Constable, Amadeo Modigliani, Mark Rothko, and Joseph Turner. I love the sculptures of Alberto Giacometti, Michelangelo, and Auguste Rodin. There are writers and musicians galore. Influences are everywhere.

My work has been shown in numerous gallery and museum exhibitions throughout the world, and prints are included in such permanent collections as the Bibliotheque Nationale, Paris; the Museum of Decorative Arts, Prague; the National Gallery of Art, Washington, D.C.; the Shanghai Art Museum, Shanghai; and the Victoria and Albert Museum, London.

More of my work can be viewed on my website www.michaelkenna.com.

TECHNICAL I work with older, entirely mechanical Hasselblad 500 c/m cameras and I use many different films, depending on their availability in the countries where I am traveling. My current favorite films are TRI-X 400 and T-MAX 100. My exposures can be up to 10 hours long. I make my own sepiatoned silver gelatin prints in a traditional darkroom.

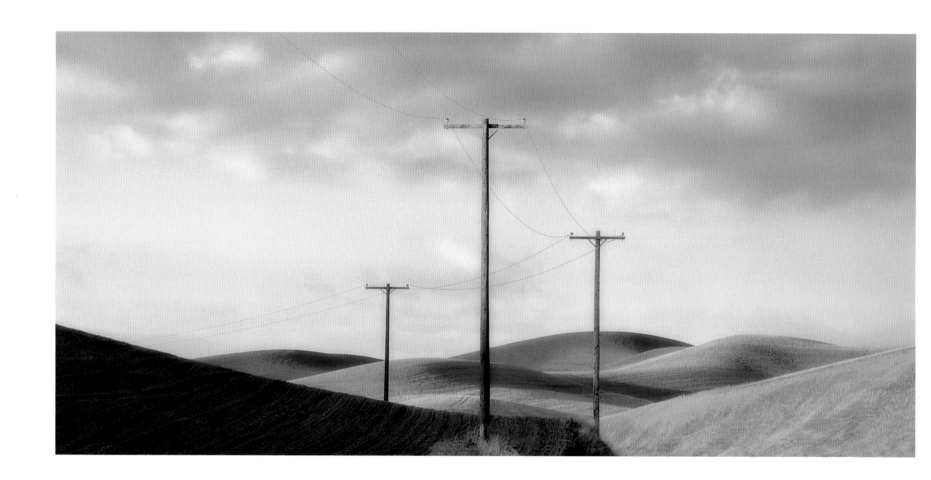

BRIAN KOSOFF

Three Crosses
2003

GEORGE'S ANALYSIS I look at this image and there is a cleanness, a simplicity, a softness to it that is very obvious. Undoubtedly, this comes from a combination of how the scene was handled in the field and in the image editing. I have seen this diffusion of highlights overdone and it can really grate, but it is so well controlled in Brian Kosoff's image that I am not only happy to accept it, I see it as an essential element of the photograph, part of the charm of his work.

This photograph initially looks like something a graphic designer might make, but then you realize that the detail in the clouds and grasses and the subtlety of tonal variations is photographic. The result is a luminous quality that is both beautiful and unique.

On the left we have the shadowed hill and the lightest sky, and on the right, just the opposite. The arrangement of the three poles couldn't be better. In theory, there is nothing to balance the wires going off to the left in the distance; in practice, this is taken care of in the right-hand pole being larger than the one on the left.

It is remarkable that the left-hand pole touches but does not cross the second hill from the left, while the right-hand pole is positioned where the hill to its right tapers to a point—a matter of extreme care in placing the camera, both left and right and forward and back.

So often, one sees trees and poles get darker as they reach into the sky because of poor burning of the sky in the editing, but here we have just the opposite; the higher parts of the poles receive more light and are lighter, and everything about the image looks natural. We don't know if the photographer did a lot of editing

work, but it doesn't show and therefore doesn't matter to the viewer. How hard the photographer had to work isn't and shouldn't be apparent.

There is a nice sense of distance in the hills against the sky. Their roundness in the sense of the center compared to edges of the hills is readily apparent. It is so easy in a photograph for the third dimension to be poorly represented, if at all, with objects appearing as cardboard cutouts. The furrows in the shadowed hill on the left are easily seen, whereas in many a photograph they would be dull and flat. There are a total of seven hills, yet each one is a different tone than its neighbors, nicely separating them and reinforcing the rolling nature of the landscape.

This would have been such an easy image to overprint, with a dramatic sky and more contrast in the hills. One could easily have argued for more brilliance in the light, more drama in the whole scene. It would, of course, have been an entirely different image, with no parallels to the feelings created by this photograph. It would have been much more ordinary—clever instead of wonderful. Those hoping to improve their printing would do well to carefully study the tonalities of this photograph.

All in all, this is a peaceful, elegant image, with much to come back to, again and again. An odd thing to say about some hills and power poles, but true nonetheless.

THE PHOTOGRAPHER'S PERSPECTIVE I came across this scene in Washington State, in an area called the Palouse. It's an area where many millions of years ago the crust of the Earth bunched up due to some massive force, most likely the Pacific and North American plates colliding. Over time, the sharp creases have worn down to soft, gently rolling hills. In spite of the difficulties in farming on such land, Man has done an excellent job of growing a variety of crops there. It is common to see tractors with six wheels abreast, and an amazingly low

center of gravity, tending the crop on slopes that a person could barely climb upright. The fact that it is cultivated land gives it a manicured look as all the plants are planted at the same time, at the same density, and grow at the same rate. Because I'm a minimalist, this neat, groomed look appeals to me. I don't want unnecessary elements or distractions in my images. In the Palouse I get texture, pattern, the sensual curves of the land, and most of all, order.

I knew at the time I shot this image there was something to the composition. It reminded me of religious paintings that I had seen of the Crucifixion. I'm not religious but so much of early European art portrays the Crucifixion that it's hard not to reference it when a scene with similar elements presents itself.

Even though I shot the image in 2003, I didn't produce a final print until 2008. Early attempts at printing it did not yield tones to my satisfaction, so I put the negative back in the file. It's common for me to live with an image for a while before committing to it, or being satisfied with its direction. Some of the difficulties were due to my having captured the image with a camera format smaller than my usual, and then making matters worse by cropping into the image. A smaller film area results in coarser gradations within an image. It took me five years to figure this print out.

Ordinarily I would have just named it *Three Poles* because I name images purely based on the content of the image, with no metaphors or embellishments. But *Three Crosses* just felt right.

BIOGRAPHY In my last year of high school I joined a school program that allowed me to intern with several advertising and magazine photographers. When I started my freshman year at the School of Visual Arts in New York City, I was already working as a freelance photographic assistant. I left SVA in my second year to assist full time. That same year, at age 18, I had my first NYC solo show.

I was never afraid to call people or show them my portfolio. And much to my surprise, I started getting editorial photography assignments in my late teens. By age 21, I was subletting a photo studio in Manhattan and had steady work. I spent more than the next two decades photographing thousands of assignments (mostly still life) for magazines and advertisements.

In 1998, I was at a point where I wouldn't even pick up a camera unless I was getting paid. This was not what I had planned. So I decided to go west and spend a few weeks shooting landscapes. Landscape photography had a similar deliberative approach as still life, but with far less control, very different from studio work. In 2001, after a successful show of my landscape work at a local co-op gallery, I contacted some NYC galleries and was offered representation. Within a few months I had several galleries representing me—and what seemed to be the start of a new career. At the end of 2002, I decided to close my Manhattan studio and pursue landscape photography full time.

I have had many photographic influences, but two stand out: Ansel Adams, whose contribution to photography is unmatched, and Irving Penn, simply the best all around photographer ever, and a nice man.

You can see my work on the web at www.kosoff.com.

TECHNICAL For this image I used a Fuji GX680III camera and a 400 or 500mm lens: T-MAX 100 film, most likely a red or yellow filter, and printed with selenium-toned silver gelatin.

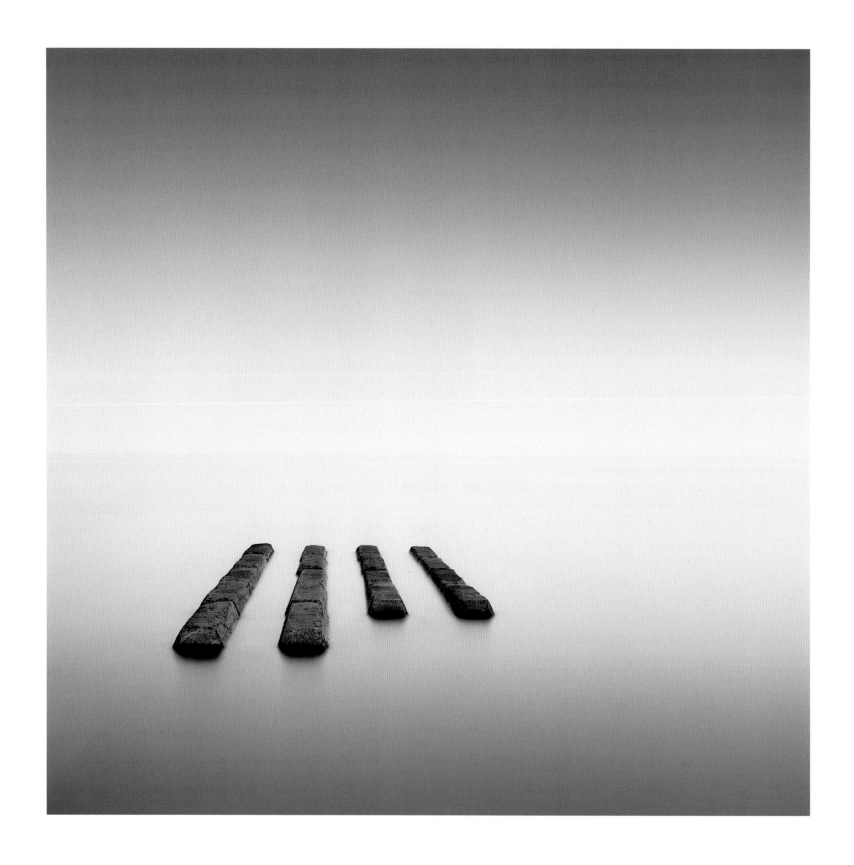

MICHAEL LEVIN

Code
2009

GEORGE'S ANALYSIS Elegant, simple, meditative, very oriental. This photograph is unique yet representative of much of Michael Levin's work. His photographs are an invitation to use our imaginations and to look at the simple design and smooth gradations of tone as one would look at a Japanese rock garden—an environment of peace, tranquility, and harmony.

How is it that such a "simple" photograph, one of Michael's least complex images, is also the one I like most of all? Why is it that Michael too considers this a favorite?

Michael has used the technique of long exposure to create the smooth gradation of tone in both sea and sky, to turn ordinary water into a magical surface, as insubstantial as fog and as hard as a block of ceramic at the same time.

The stones appear to float on or even above this background, the dark shadows and reflections suggesting a detachment from the water. The stones appear as fingers, complete with knuckles, splayed out toward us while at the same time pointing toward something beyond the horizon. The darker rich tonalities of the rock contrast with the sea, which is devoid of any detail.

Why two short and two long lines? Understanding the meaning of these man-made structures is beyond me, intriguing and at the same time frustrating—a reason to come back to the photograph repeatedly, as though next time we view the image the tide will be out, the answers revealed.

Oddly, the medium of photography, which is capable of recording vast amounts of fine detail, is also ideal to reproduce the completely smooth textures of the water and sky, with their infinitely fine gradation of tone, while at the same time depicting stones that appear nearly three-dimensional. It seems as if we could feel

the texture of the stones if we brush our fingers across the image.

The total effect is of an eerily mystical composition, with hidden meaning in the fingers of stone arranged for the entire purpose of having us stop and contemplate. This, of course, is Michael's creation. If we were actually standing at the scene, we would notice splashes on the rock, seaweed floating, waves washing, planes flying over, and clouds passing, all of which would totally distract from the power of the image. This is the artistry, the imagination, and the skill of the photographer: To see the scene as is and be able to understand what it could be and have the wherewithal to make it what it will be.

THE PHOTOGRAPHER'S PERSPECTIVE It's a challenge to look at the obvious and see something more. Not every common object will rise up off the page just because you take its picture. I sometimes think that I have to feel the rhythm of a scene before I think to take the shot. Something sparks me and all of a sudden I can see the place and the photograph together. I see it whole in my mind before I see it in my camera frame. But I'm never sure when and where things will come together, and it happens less often than I might like.

Code was photographed in Japan near the end of a trip I took there in 2009. While I've photographed in places as diverse as France, Iceland, and South Korea, I return over and over to Japan. The way the landscape is shaped interests me. For this trip, I spent most of my time in the southern part of the country. Maps and tourist brochures rarely help me, as they are only useful if you know what you are looking for, and I never do. Most of my favorite photographs come from random places. So I end up logging a lot of miles in my rental car. Even if I spend a few weeks in a country, I often only return with a couple of photographs that I will further develop. On this particular trip, I had yet to find anything that intrigued me. I was still looking for that spark.

I remember that it was very late in the day and I was quite hungry and ready to give up my search and find some sushi. Still, I enjoy the hunt for a great photograph—my eye keeps rushing forward trying to see around the next corner. I appreciate all the opportunities that I'm allowed in taking photographs. I relish everything that I get to witness, but I'm not out there as a tourist, and I have definite goals in searching for suitable photographic subjects.

When I find a location and I feel a strong connection to the subject, I might stay there for a couple of days with the purpose of getting the right shot. With long-exposure imagery, there are a number of variables that can dramatically alter the negative. Although I prefer to photograph at sunrise, I do shoot throughout the day and often use a variety of neutral-density filters, depending upon the light. Part of the pleasure in photographing with long exposures is the unanticipated outcome. Although I'm very selective when I shoot and I have a fairly good idea of how I want the final print to look, one of the benefits of long exposures comes from how fleeting and dramatic weather can be. With a long exposure, you get to include all those shifts; all that unexpected possibility that you can't plan for.

Code was found after scrambling over a high fence that separated me from the ocean. From the hill above looking down on the scene, the raised concrete fingers looked plain. Still, there was something about the arrangement and their order that drew me closer. The tide was pulling out, and I know how fickle my eye can be when I see something interesting. A great photograph can be gone in an instant. I managed to expose four negatives before the water receded so much that the mood of the scene was lost. But I got what I was looking for. Even now, *Code* remains something of a riddle for me, which explains the title.

BIOGRAPHY I didn't start using a camera until later in life, and I became a fine art photographer in almost an indirect way. For many years, I played flamenco guitar, having learned the instrument from several teachers in Spain. Unlike classical guitar, which is governed by an established set of rules, flamenco guitar is more spontaneous as it works to color and shade the performance of the flamenco dancer. You have to be sensitive to the mood of the dancer and provide a musical backdrop to the performance that is both dark and light. Flamenco guitar is instinctual and moved by emotion. It ended up being a great training ground for how I approached my photographs.

It was during my time in Spain that I started using a video camera to record my travels. The subjects that interested me were fairly commonplace because it was more my experience of these places that mattered. I'd just let the camera run and capture a lot of empty space. It wasn't until I went to San Francisco years later and saw the work of Michael Kenna and Hiroshi Sugimoto that I understood a film camera could achieve the same end. In a Sugimoto photograph, the subject matters less than his extended experience of it. That insight made a key difference when I started taking photographs.

I always think that being a good photographer is less about knowing rules than knowing yourself. What I make of a subject comes from inside of me; it's a personal vision more than something that everyone sees.

I was initially influenced by the work of abstract expressionist painters like Mark Rothko, and it wasn't until I began visiting photography galleries during a month-long trip to California in 2003 that I began to draw upon the work of other photographers in the formulation and further development of my own work.

It was in San Francisco that I discovered the great tradition of Californian photography. I liked how ambitious these photographers were, yet how their subjects were often so simple. My trip to California left me more curious and more inspired.

Since then, I've looked at the work of other photographers such as Ed Burtynsky, Rocky Schenck, and Hiroshi Watanabe. I like how raw and confident and beautiful their works are.

My work has been featured in numerous publications including the magazines *B&W* (USA), *Black and White* (UK), *PHOTO+* (Korea), and *Silvershotz* (Australia). My first monograph, *Zebrato,* was published by Dewi Lewis Publishing, 2009. My second monograph will be released at the end of 2011.

My website is www.michaellevin.ca.

TECHNICAL I primarily use an Ebony 4x5 field camera with three lenses. I also use an 8x10 and a Hasselblad medium format camera. My film choice is usually Kodak TMAX 100. All images are archival pigment prints, signed and numbered. Sizes range from 10" × 10" to 42" × 42" and are priced from $650 to $5,500, depending on size.

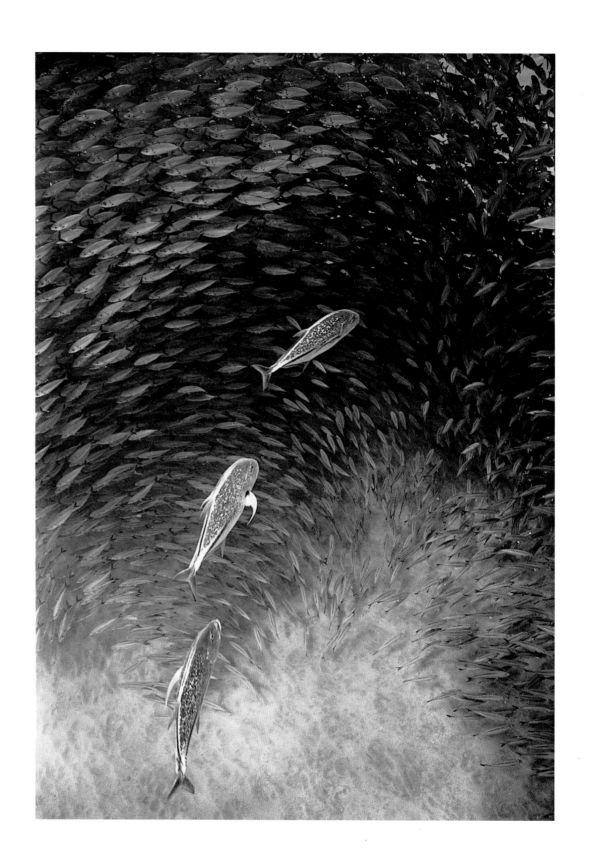

Bluefin Trevally Herding Akule

2000

GEORGE'S ANALYSIS It simply never occurred to me that a beautiful photograph could be made from schooling fish—interesting maybe, but actually artistic? It was quite a surprise to find Wayne Levin's portfolio in *LensWork,* but I could quickly appreciate the beauty of the images which are definitely art.

Good photographs often benefit from great reflective surfaces and nice tonal gradients. Sometimes the effective reflections occur en masse—for example, with leaves turned inside out in the wind and changing the tones of a tree. I knew that individual fish can be iridescent but hadn't appreciated the effects of a huge school of fish. More power then to Wayne for recognizing the potential where other underwater photographers have not.

In this photograph we have an explosion of light at the bottom. It is not clear if this is sandy bottom or something else entirely. If it is the bottom, then why the dark waters so nearby? We see a multitude of akule fish bursting out from this area, blossoming in spreading paths. The gradations of brightness in the fish give the image depth, while the orchestrated swimming patterns provide wonderful curving lines through the image.

Wayne has used his position to control the lighting and provide the range of tonalities across the image, undoubtedly through considerable experience. We see no murky waters or sun-filled background. I dare say a diver would understand the picture better. I prefer to accept it as magic.

The three predatory trevally fish offer the only brilliant highlights and are quite menacing. They swim in line too, arcing slightly and in opposition to the fish below

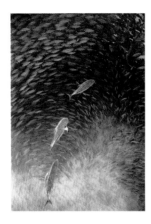

them. It is hard to estimate scale, not knowing the fish. I have the sense that these are huge fish, shark sized, yet I suspect the truth is more mundane, the scale smaller, but the scene no less impressive.

The photographer has managed to imply movement without the need for a long exposure, the darting of the threatened fish implied by their head-to-tail lines of direction.

Some images are beautiful, others informative. Here Wayne has managed both, to our collective surprise considering the subject. Looking at photographs is very much about discovery.

THE PHOTOGRAPHER'S PERSPECTIVE In 1999, while swimming in Kealakekua Bay, a few miles from my home in South Kona, Hawaii, I saw this huge school of fish. The school was so large that at first I thought it was a coral reef. I stopped and took a few pictures, then swam on to photograph a resident pod of dolphins. After having similar encounters with the school over several months, it finally clicked that this massive fish school might be a more interesting subject than the dolphins. Over much of the next decade I became obsessed with photographing these amazing schools of akule (big-eyed scad). This work is now being published as a book, *Akule,* which is scheduled to come out this summer (2010).

I would usually climb a trail that went part way up the cliff that faces the bay. From an elevation of several hundred feet, I would be able to spot the school by using polarizing sunglasses. I would then swim out to the school and take photographs while free diving (breath-hold diving) about 30 to 50 feet down to the school.

On this occasion, while photographing the school, it seemed to explode, as a group of bluefin trevally aggressively stalked the school. The school then disappeared, followed by the trevally. It took me about 15 minutes to find the school again. When I did, the trevally were with them, herding and shaping the school. I shot my roll of film of this encounter, and this was my favorite image on the roll.

BIOGRAPHY I was born in Los Angeles in 1945. For my 12th birthday my father gave me a Brownie camera and a little kit to develop my own film, and from that early age I was hooked on photography.

After graduating from high school in 1962, I attended Brooks Institute of Photography in Santa Barbara, California. Motivated to participate in the Civil Rights movement, I left Brooks in 1964. Over the next several years I worked with the Congress of Racial Equality and the Mississippi Freedom Democratic Party. No longer a student, I lost my deferment and was about to be drafted into military service when I decided a better choice would be to join the navy. I spent two years aboard the USS Hornet, seven months of which were off the coast of Vietnam. While I was in the navy, my family moved to Hawaii, and upon my discharge in 1968, I moved there to join them.

My interest in travel and photography led me to travel around the world for a year-and-a-half, documenting my travels through my photography. The resulting images later becoming the basis for my first solo exhibitions. In the early 1970s, I was hired as an assistant for the renowned Hawaii photographer Robert Wenkam. After several years working with Wenkam, and architectural photographer Augie Salbosa, I started my own commercial photography business.

In 1976, I decided to continue my education, majoring in fine art photography at the San Francisco Art Institute. There I studied under Linda Connor, John Collier, Henry Wessel, Larry Sultan, and Ellen Brooks, among others, obtaining a BFA in photography. The following year I attended Pratt Institute in Brooklyn, New York, studying with Arthur Freed and Phil Perkis, and received an MFA in 1982.

I moved back to Hawaii in 1983 to teach photography at the University of Hawaii and purchased a Nikonos IV

underwater camera as a graduation gift to myself. I began an underwater photographic study of surfers, receiving a National Endowment for the Arts Photographers' Fellowship for this work in 1984. Later that year I was invited to go to the Leprosy Settlement at Kalaupapa on Molokai to photograph. I documented the settlement between 1984 and 1987 using black-and-white film and a 4×5 view camera. This work culminated in the book *Kalaupapa: A Portrait*, copublished by the Arizona Memorial Museum Foundation and the Bishop Museum in 1989.

In 1986 I started the photography program at La Pietra, Hawaii School for Girls, where I taught as an artist-in-residence for a year. I received an Ohio Arts Council artist-in-residence at the Dayton Art Institute for two years in 1987. During my residency there I produced and exhibited several bodies of work including an in-depth study of Hospice of Dayton. This project earned me an Ohio Arts Council Photographers Fellowship.

I then returned to Hawaii and married in 1990, relocating to Kona on the Island of Hawaii. A friend suggested I photograph the dolphins in Kealakekua Bay, which led to a re-immersion into underwater photography. During the following years I received magazine assignments to photograph throughout the Pacific and Caribbean and further developed my reputation as a black-and-white underwater photographer. In recent years I have continued to focus on depicting the underwater world in black-and-white, photographing sea life, surfers, canoe paddlers, free divers, swimmers, shipwrecks, seascapes, and aquariums.

My influences are Henri Cartier-Bresson, Linda Connor, John Collier, Paul Caponigro, Wynn Bullock, Van Gogh, Monet, Beethoven, and Charlie Parker.

My work has been published in the books *Through a Liquid Mirror* (Editions Limited, 1997), *Other Oceans* (University of Hawaii Press, 2001), and *A Day in the Life of Hawaii*. My work has appeared in the magazines *Aperture, American Photographer, Camera Arts, Photo Japan,* and most recently *LensWork*.

An updated and expanded version of my 1989 book *Kalaupapa: A Portrait* is scheduled for release in April 2011.

My website is located at www.waynelevinimages.com.

TECHNICAL I use a Nikonos V with Technical Pan film and a Nikkor 2.8 20mm lens.

Precipitation

2009

GEORGE'S ANALYSIS This image was featured on the website The Online Photographer in a review of a Pentax camera, the image taken and the review written by Gordon Lewis. There was a groundswell of interest in getting a print of this image, and subsequently it was made available and a number of prints were purchased through the site. So what is it that got us excited about the photograph, most of us not caring which camera took it?

Images like this can only be anticipated, not fully planned. You could, I suppose, see the parking meter and the interesting "graphic" on the wall and simply wait for the decisive moment when someone interesting happens by. Apparently this was a favorite technique of Cartier Bresson—his images are not quite as spontaneous as many people think.

On the other hand, the meter and the wall and the pattern in the sidewalk in and of themselves are of so little impact without the lady, without her forward lean, without the umbrella, that it would take either a great leap of faith or a great deal of experience and patience to anticipate a possible great image from such an inauspicious beginning.

That the woman and the umbrella did come by works beautifully. Placement of the wall patch graphic and the lady, the framing of the sidewalk and the diamond shape, and the inclusion of the rather prosaic parking meter combine into an image that simply works.

Images like this are quietly satisfying. It isn't a grand landscape; there is no dramatic lighting or long shadows; and no one is starving, dying, or being abused. It is simply the kind of image that you could walk by once a day, nod and mutter a quiet and satisfied "yes," and get on with your day.

You might find it profitable to imagine which of the components of the image you could or would remove and what its impact would be on the final image—that little yellow sign, the meter, the diamond, the patches on the wall, or the umbrella? My thought is that each adds to the image, and I wouldn't want any removed. The yellow sign is certainly the smallest component, but she might be reading the sign, and now we wonder what it says. I'd almost be disappointed if in a print you could actually read the sign—better to leave it as a puzzle.

THE PHOTOGRAPHER'S PERSPECTIVE I attribute the success of this photograph to luck and preparation. It was by luck that I was testing a new camera on a rainy fall day. I parked my car near the town center with the intention of snapping a few photos. I was familiar enough with the area that I knew a few photogenic locations. Among them was the gray cement wall, which was only a few yards away from my car—hence the parking meters in the foreground. The "figures" in the center are cracks that had been patched with darker cement. The small yellow box on the right is a placard that credits the "artists."

No sooner had I exited my car than I noticed the woman with the umbrella turn a corner and start walking parallel to the wall. I had only a few seconds to make sure the camera was on, check the settings, pre-focus, and frame. I got only one shot of her passing by and this was it. The camera was set to automatic exposure and white balance. Both were spot-on, which was lucky for me because the file format was set to JPEG. What you see is the file as it came out of the camera, with only slight cropping and sharpening. Despite the spontaneous nature of this photo, it's consistent with my overall style and favorite theme: careful framing, a limited color palette, and the relationships between human subjects and their settings.

BIOGRAPHY I am a Los Angeles born photographer and currently reside in Elkins Park, Pennsylvania. I developed my first roll of film at age 12, using cereal bowls and a towel jammed under the door of a closet. Over time I eventually progressed to cramped bathrooms, dank basements, and drafty garages. At various points in my career I have been employed as a copywriter, technical writer, TV sitcom writer, and part-time photographer. Thanks to the advent of digital photography, I now work in a warm, dry, well-lit office.

My photographs and articles have been published in magazines such as *Camera 35, Camera & Darkroom, Petersen's PHOTOgraphic,* and *Popular Photography*. I have also worked for clients such as Vivitar, Canon, United Airlines, and Toyota. Although I favor street photography, I am also experienced at portraiture, travel, commercial, and architectural photography. I now divide my energies between my family, my work designing web-based training for corporate clients, and my photoblog, Shutterfinger (www.shutterfinger.typepad.com).

I was less influenced by individual photographers than by photography magazines. I was a voracious reader of *Modern Photography, Popular Photography, Camera 35,* and *Petersen's PHOTOgraphic*. Ansel Adams and Phil Davis were strong influences when it came to the Zone System and how to produce top-quality prints. My main lighting guru was Dean Collins.

My web portfolio is located at www.shutterfinger.zenfolio.com.

TECHNICAL For this image I used a Pentax K-7 camera set at 35mm focal length, 1/800 second, f4, ISO 400.

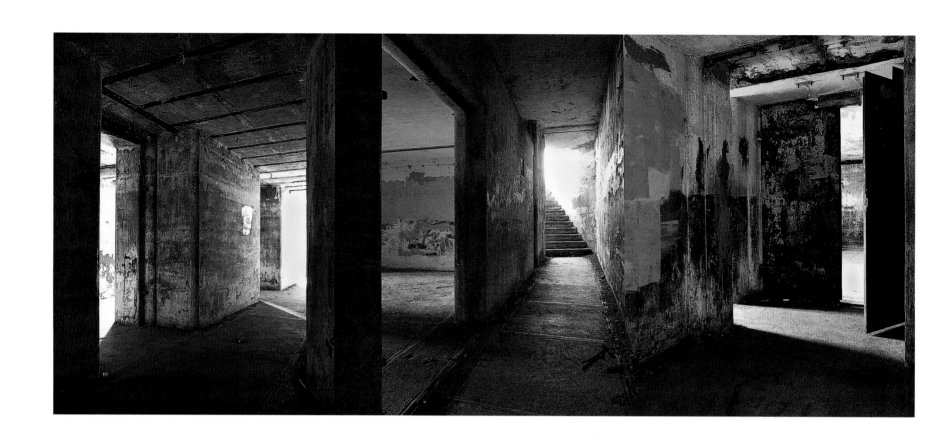

Labyrinth 01

2005

GEORGE'S ANALYSIS The concept of a triptych—three related images near or touching each other, either in a single frame or separately displayed—is not new. Joe Lipka has taken the concept a step further, aligning images that aren't, in fact, part of a single view, and not a normal panoramic stitch, but which, when placed next to each other, give the impression of a single stitched image. The net result is a total image that never existed as such, but which beautifully illustrates a location and makes a strong overall image. There are hints that this is not a single panoramic image—the levels of floors and how corners are handled—though you have to look carefully, and even then it leaves you wondering.

In making the image this way, Joe created a single image in which there are a total of five openings through which light pours in. There are remarkable textures and shapes. The puzzle of the placement of the separate images gives the viewer something to ponder, to possibly solve. Tools and techniques that keep the viewer's attention are to be valued.

The lighting makes for interesting tonalities—bold areas of brilliance alternating with the intriguing varied tones of the walls made up of layers of paint, corrosion, and the texture of old poured concrete. The open metal door on the right is nicely separated from the triangular shadow below it by light getting under the door. The subject is perfect for a monochrome interpretation, the sepia coloring softening some of the harshness of this abandoned military facility.

The multiple pathways and stairs give the viewer the opportunity to try wandering around the facility in their imagination. But because this is a "made" composition, there isn't necessarily any logic or real path to connect the various open doorways, corridors, and steps, defying the viewer to make sense of it all.

This is one of a series of images titled *Labyrinth* to be found at Joe's website. It would be an interesting exercise to look at all the images, over and over, and figure out which you prefer and why. Some are longer and narrower, some have fewer light sources, and some make more or less sense. Consider how you would handle a similar subject.

Although the image is a made composition, notice the consistency in the roofline diagonals, which all slope down and left at roughly the same angle, from the doorway on the right to the opening to the stairs, and from the ceiling line in the interior room next to it to the lower radiating lines in the roof on the left (the ones that line up with the others extending all the way to the top-right). There is even a short segment of similar line seen in the opening on the extreme left. This consistency in an otherwise quite disparate set of lines and angles, shapes and elements, ties the image together in an important, one might even say critical, way.

Perhaps you are a photographer and can think of a subject that you might handle in a similar way. Starting with your own home wouldn't hurt, and you could even put the same people in various rooms, another clue to the unreality of the image—no not original, just fun, creative, and possibly successful. Historians celebrate firsts; viewers of fine images are quite content with interesting, unusual, informative, attractive, intriguing. Not bad for a day's work.

THE PHOTOGRAPHER'S PERSPECTIVE The labyrinth started with a single image made on my annual photo safari. I fell in love with this image but had no apparent reason behind my affection. I printed the image and hung it in my cubicle at work where it became part of my daily life for a year and a half. I finally figured out that I was attracted to the image because the composition gave the viewer a choice of how to proceed through the image. The choice between dark and light had both visual and metaphorical meanings. The next photo

safari's objective was to make a series of photographs that met these visual and metaphorical specifications: two ways out of the photograph, that is, one exit into light and the other exit into darkness.

I completed my self-assignment and was fortunate enough to have the images published in the bonus gallery of *LensWork Extended, #64*. During production, I had to review the title page of the gallery. The first title page design started with one photograph and did not look right to me. The second title page with two photographs also did not look right. When the third attempt showed three photographs on the title page with a little space between the images, I knew a triptych was the ultimate visualization of my project.

The new visualization meant the criteria of a "good" image had changed. Individual images were now judged in combination with other images. I began to play with many single images to create the triptychs. After learning a new vision,

aesthetic, and work process, I completed the labyrinth triptych project. That new project (including this photograph) was featured in the print version of *LensWork, #71*.

There are several steps that contributed to the success of this project. The first was deciphering the meaning of the original photograph that captured my attention. That inspired me to create various images with the same theme. The *LensWork* layout suggesting triptychs as a means of enhancing the original idea of the project was the ultimate key to success. I thought, planned, and worked on this project, and the final step that contributed to the success of this image was listening to and acting on the feedback from other people whose opinions I respect.

BIOGRAPHY I was born in Lorain, Ohio (near Cleveland), in 1951. I attended University of Notre Dame in Indiana, earning a BS in Mechanical Engineering and a MBA.

My introduction to photography wasn't by design. Hoping to secure an elective in my senior year at Notre Dame, I arose at 3:00 a.m. to stand in line for one of the 21 seats available for the Beginning Photo class. Unfortunately, other students had the same idea and I found myself 22nd in line. Happily, the fellow ahead of me was in the wrong line and I secured the last seat. The creative aspect of this mechanical and chemical process led me to take six photography courses at Notre Dame.

My informal training has come by way of workshops with Bruce Barnbaum, Ted Orland, and David Bayles and a long-standing (20+ years) annual photographic safari with Brooks Jensen.

While I make a living as a business analyst/consultant (my family has always insisted on wearing shoes, living indoors, and eating regularly), I spend much of my personal time and resources on photography. I have two grown daughters, Catherine and Victoria, and live with my wife, Debi, in Cary, North Carolina.

My most recent projects have been in the realm of site documentation of abandoned farms and small towns in North Dakota, and the ongoing transformation of an old school into a community art center in Cary, North Carolina.

My influences are Eugene Atget, Walker Evans (from the FSA era), Edward Weston, and Dominique Issermann's book *Anne Rohart* (Schirmer, October 1996).

I have contributed articles to the following issues of *LensWork:* #4, #6, #10, #51 and #76; and to *LensWork Extended* issues #65 and #76. My photographs have appeared in *LensWork* #71, and in *LensWork Extended* #57, #64, and #71.

My website is www.joelipkaphoto.com.

TECHNICAL INFORMATION The left third of the triptych was made on May 29, 2005. The other two images were made two days later. The camera was a Fuji S7000. The three images were assembled as Photoshop layers. Masking, blending, and cloning were used to disguise the transitions between the three images. I make prints in sizes 6" × 13" and 12" × 26".

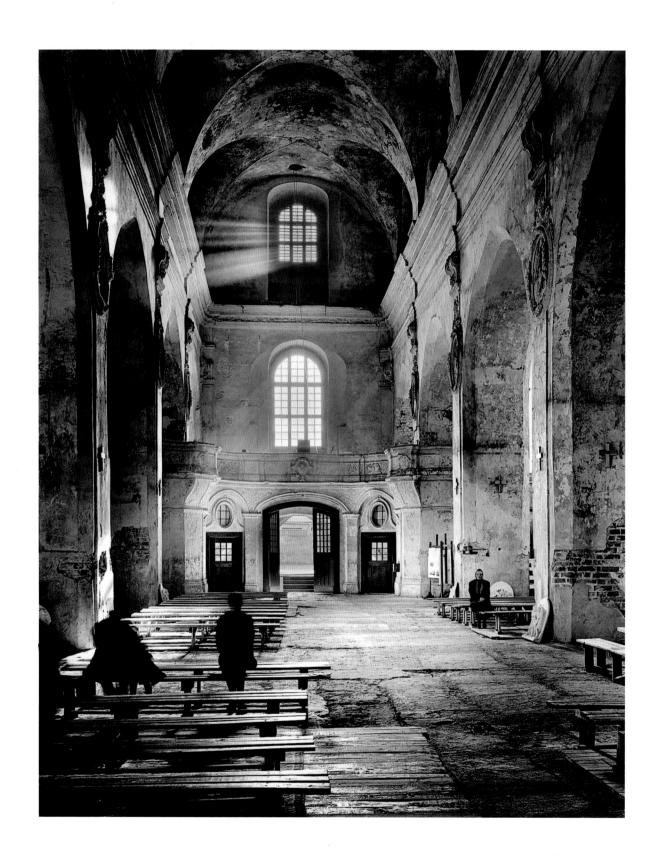

Franciscan Church, Vilnius
2001

GEORGE'S ANALYSIS We see an old, poor church, walls faded and peeling, an uneven floor, and only a few rickety benches at which to pray. A few hardy souls still come to find solace, peace, or forgiveness. The light pours in through the windows and reflects around the church, softly illuminating the right side of the interior, with more dramatic light and shadow on the left. This is a photograph that many can identify with, whether church-going or not.

The photograph is a celebration of light, displaying both its power and subtlety. From the rays of the sun coming in the windows to the glow in the walls of the alcoves, from the light reflected off the simple benches to the varied tones of the floor, the image is about light. Even the arched ceiling is well lit. Undoubtedly, Roman Loranc photographed it in the ideal light. I wonder how often the light is this wonderful. As many of Roman's images do have a subtlety to the lighting and tones, it is clear to me that the beautiful tonality of this photograph owes much to his skill in both photographing and printing.

The building is intriguing, without all the trappings of the usual tourist-route-type churches and cathedrals. There is no organ, no pulpit, and the wooden benches have been polished by many bottoms through the ages. The building is remarkable for both its simplicity and its sense of make-do, with items leaning against the pillars and walls, and no sign of loudspeakers and fancy lighting.

The photograph was never going to be completely symmetrical, the sun's rays shining toward the left as they do. Roman has selected an off-center camera position, playing off of the direction of the light. The dramatically lit left-side wall is seen more in line and thus reducing the relative weight of the bright areas. The right-hand alcoves open up more. Despite the off-center camera position, the line

of benches runs right down the middle of the print to the open doorway. The two doors are asymmetrical, which appears more natural. The benches on the left have highlights, while the floor is darkest to the right.

These exemptions to symmetry give the viewer more to contemplate, another level of interest, one more reason to revisit the photograph. Were the left and right unrelated, the break in symmetry would mean nothing, but as we have arches and alcoves on both sides, each side is tied to the other, yet opposite.

The worshipers appear as black silhouettes, anonymous in person and purpose other than to feel a need to sit in this wonderful building. One doesn't need to be religious to recognize that this is a place to come and meditate.

The photograph has interesting detail and texture everywhere; from floor to vault, the surfaces of the pillars, and the Stations of the Cross simply leaning against the pillars. The movement in the congregation suggests a ghostly element, hinting at changing eras and values.

THE PHOTOGRAPHER'S PERSPECTIVE I had always wanted to photograph Lithuania but was never able to do so while the Russian occupation persisted. Specifically, I wanted to photograph and hopefully capture the effects of the occupation and war on places of worship, be they churches, synagogues, or other. Although not affiliated with any specific organized religion, I recognize the presence of God and the spirituality of these special places.

Most synagogues and churches in Lithuania were destroyed or stripped to their bare architectural bones. Relieved of the usual "trappings" of gilt, icons, statuary, etc., the true and pure essence of the structures was revealed in a special way. This particular church had been used as a storage warehouse during the occupation, but the strength and power of it had not been lessened. In fact, if anything, it had been

increased. With the opening of Eastern Europe in the last 20 years, I have been able to travel extensively and rediscover the rich heritage belittled but not destroyed.

Although it is not my practice to ask for permission to photograph such places, in this instance I did. The priest was so fascinated with my concept that he gave me a key to the church and allowed me after-hours access. One day, before receiving the key, however, I was accidentally locked inside the church for the better part of a day. I spent the time studying the light and trying to determine the ideal conditions and time for capturing what I saw in my mind as the image I wanted. It was an incredible experience. I later learned from the head restorer that the church was designed to maximize light spilling onto the altar during the times of Mass.

After almost two months of repeated visits and images that did not quite capture what I was hoping to, this image was accidental (or perhaps preordained). I went to the church to hear some choir music. Arriving early, the workmen who were in the process of restoring the church were just finishing up. Dust particles stirred up during their work filled the air. I happened to turn at a particular moment and saw the image you see captured in the print. The light was incredible. I knew that I had to work quickly. I ran to my car, grabbed my camera, and rushed back into the church hoping that the light was still there. It was. I set up and exposed the film for about 15 minutes. During that period a few people came and went, and some sat quietly for almost the full exposure. The effect created is that of almost ghostly images. And one "miraculous" image.

BIOGRAPHY Some photographers believe their strongest work comes from exploring their immediate surroundings. I think of myself as a regional photographer, but that does not mean the photography cannot be understood beyond the region. Right now people all over the United States indicate to

me that regionalism, born of an informed attachment, has universal appeal. I shoot most of my pictures within an hour's drive of my home in California, but I am also interested in exploring my ancestral roots in Europe. For this reason, I make occasional photographic forays to Poland and Lithuania, and more recently, Croatia and Portugal.

I'm fascinated by the ancient churches of my homeland. These are holy spaces where millions of people have prayed for hundreds of years. They are places of great humility and they remind us how brief our lives are. I feel the same way when I'm photographing ancient groves of native oaks in California. I wasn't conscious of this when I began, but upon reflection, I think the oaks are just as sacred as the old cathedrals of Europe. They are sacred in that they have survived for so many years. I'm aware that the native people of California held all living things as divine. For me a grove of valley oaks is as sacred as any church in Europe.

I think about how interconnected the world is. When I'm out on a crisp winter's morning, shooting a stand of native oaks, I see oak galls hanging from the trees. These were once used to make the pyrogallol chemicals I use to develop my negatives. So the oak trees I am photographing played a part in the developer I use to process my negatives of those trees. It is healthy to remember that we are often linked to the natural world in ways we don't even suspect.

I was born in Bielsko-Biala, Poland, in 1956 and emigrated to the United States in 1981. In 1984 I moved to California and shortly thereafter fell in love with the Central Valley. In 2007, I left my cherished Valley for the open spaces of the Mt. Shasta area and the different perspectives it offered.

I have been influenced by Jan Bulhak, a great Polish photographer; Edward Weston; and Roman Vishniac, a Latvian born photographer. Also influential to my work have been Polish painters such as Chelmonski, Gierynski, Stanislawski, and Pankiewicz.

My website is www.romanloranc.com.

TECHNICAL I use a 4×5 Linhof Technika camera, shooting the majority of my photographs with a 210mm Nikkor lens, exclusively using Kodak's classic TRI-X film and hand-printing my negatives on multigrade fiber paper. The innate drama of the landscapes is reproduced through a variable split-toning (sepia and selenium) technique. All the printing, spotting, and archival mounting are done by me.

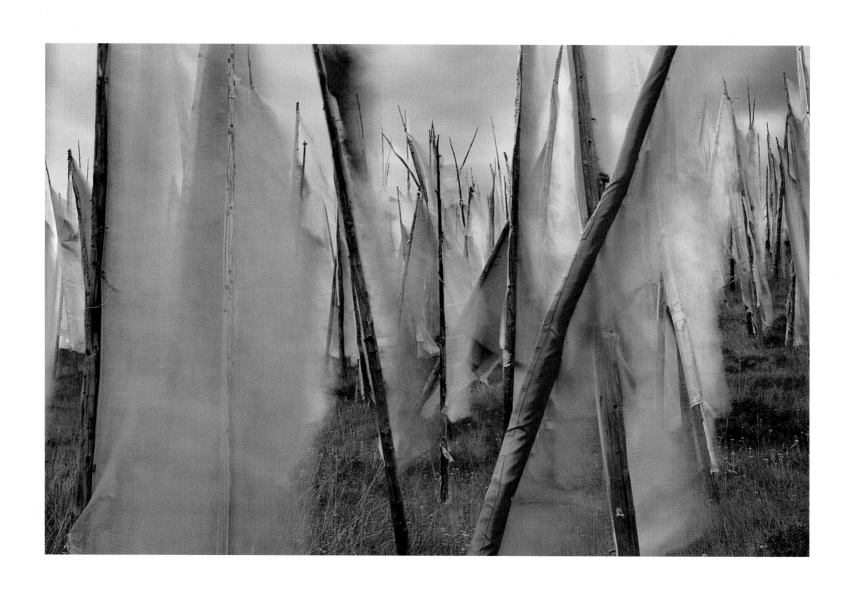

Color Prayer Flags – 2

2009

GEORGE'S ANALYSIS The great thing about the Internet is that one site leads you to another; the first photographer introducing you to the work of the second...

I'd barely begun viewing Larry Louie's website when I came across his series of images of prayer flags from Tibet. Here we have a photograph of something steeped in mysticism and exotic religion and philosophy while at the same time looking very much like an abstract, but with some mundane clues in the grass. I see sailboats and Native American tepees, and the whole thing is like a watercolor painting—just lovely.

The muted tones and a limited palette work perfectly, the overall brightness a bit lower than one might expect, but adding both to the serious intent and the abstractness of the image. The blurring caused by the slow shutter speed in the wind is absolutely perfect for the image, adding a ghostly or spiritual element to the photograph. Did the photographer simply know what was right or did he experiment? It hardly matters. Getting it right is what counts.

Composition is strengthened through the repetition of the near-vertical diagonal lines of the staffs and the tall, slim, triangular shapes of the flags. The pattern at first appears random, but starting at the left we have far, near, far, near, and far again, providing a pattern to the randomness, a link across the image. Notice how the various groupings are at angles to each other. At the right edges, there is a tendency to lean left; then we have the boldest red-flag-wrapped staff leaning right. Behind it is the strong left-leaning staff. In the middle of the image is a series of vertical or near vertical staffs and flags, before the second left leaning red staff, and so on, nicely alternating.

The two foreground flags in red contrast with the background, consisting of mostly neutral tones, but with turquoise distributed throughout and a handful of slim salmon-colored elements.

Areas of the photograph are very abstract, but taken in total, making sense. One can enjoy coming up on the image repeatedly, then spending time with part of it, exploring the shapes and lines, and then stepping back to enjoy the whole once again.

THE PHOTOGRAPHER'S PERSPECTIVE This image was taken in October 2009 in the Tagong grasslands. Sitting at an elevation of 3,700 meters, it is one of the highest grasslands in the Sichuan Province of China. I was continuing on my series on the Tibetan culture on this trip. I hired a local guide and driver, and went to places where Tibetan traditions and way of life were still alive and well. Prayer flags are a big part of the Tibetan culture and religion.

Blessings are printed on the flags, and these blessings are carried by the wind across the grasslands to loved ones. That is why they are to be found in such impossible places, like high up on the mountainsides, across wide rivers, and on cliffs and in canyons—anyplace where they can catch a lot of wind. I looked up at some of the places they are located and I had no idea how people could get up there, let alone hang these flags.

What caught my eyes in the prayer flags in Tagong is that instead of the typical triangular flags on a string, they were fields of large rectangular flags, usually laid out in a triangular pattern. Fortunately, I was able to hike up a few of the mountains despite the ultra-thin air, not an easy task with my two camera bodies, two lenses, and a tripod. My young guide was hopping around the mountainside like it was nothing, and I was feeling my age and weight with each stone-laden step up the mountain. Being an avid hiker in Canada, I don't consider myself to be unfit, but my lungs were definitely screaming at

me during that whole trip. But it was all worth it! The scene that opened up before my eyes when I got up to the side of the mountain was breathtaking. The late afternoon sun was setting against an angry sky and all the prayer flags were fluttering crazily around me. From that moment on, I saw and heard nothing but the movements of the flags. I saw the image of a strong graphic design displayed by the various fields of colors of the flags. The longer exposure of a cloudy day resulted in a painterly feel to the photograph, and so I kept this image in color even though I usually work in black-and-white. It is almost like a watercolor painting with atmosphere.

BIOGRAPHY I am 48 years old and live in Edmonton, Alberta, Canada. I am an optometrist by profession and consider myself a semiprofessional photographer. I had always wanted to be a *National Geographic* photographer. The sense of adventure and new discoveries were enticing to me, but I had very practical Oriental parents who strongly encouraged me to enroll in a professional program at a university; to study something at which I could earn a decent living.

I joined camera clubs in school, and when I graduated, I joined the Images Alberta camera club where I met some really great photographers and made life-long friends.

I was in medical school for two years at the University of Alberta before I switched to optometry at the University of Waterloo. I was actually late for my first optics exam because an amazing fog had rolled in—I was out shooting and lost track of time.

Ontario had incredible fall colors, and in Alberta we have the wonderful mountain parks, so most of my initial photographs were colorful and dramatic landscapes. I started studying photographs and buying books, and then when I was able to, I purchased fine art photographs. In the first year I was working, the first photograph I purchased was an Eliot Porter

print of the Glen Canyon—and that was even before buying a car.

It was an exhibition of Josef Koudelka's work at the Guggenheim that made me fall in love with black-and-white documentary photography. I developed darkroom skills in black-and-white and then in 2006 started shooting digitally, using RAW files and converting the images into black-and-white, which is the majority of my photography.

It was not until my wife wanted to turn my hobby into a tax write-off that I got serious again. She was tired of looking at my slides, so we started printing my photographs and sharing them with patients and putting them up in our office. She then entered one of my images in the annual *National Geographic Traveler's* contest and we won a trip to Ireland. I received the Lucie Award in New York for my Tibetan series along with the *National Geographic* International Photo Essay contest.

For me, my passion in photography is the active part of the shoot, finding that image or story. My focus is on the people and their stories. I also work with local non-governmental organizations (NGOs) and SEVA, a project to eliminate preventable and treatable blindness around the world by 2020. I am also working on a series called *The Underbelly Of Kathmandu*, which documents the newly rising slums in the Valley of Kathmandu, and also a series called *Vanishing Cultures—Tibet, Tibetans under Chinese Rule*. I use my photographs to highlight social issues in places that we travel to.

My influences are Josef Koudelka, Sebastiao Salgado, and Steve McCurry.

In this past year, I have won a Humanitarian Documentary award in Madrid and was named the Visual Culture Maker for Cultural Peace at the Charleston Center for Photography in South Carolina.

My work has appeared in the *Silvershotz* annual portfolio issue (January 2010); *Phot'Art* (Spring 2010); the *British Journal of Photography, International Photography Award 2009 Book*; *PDN* (February 2009); *Asian Photography Magazine* (APAC) Feature Photography (November 2008); and *National Geographic Magazine* (Photo Essay Winner) (November 2008).

You can see more of my work at my website, www.larrylouie.com.

TECHNICAL I shoot with a Canon 5D Mark II, mostly with the 24 mm F1.4 lens. Output is to archival pigment inkjet printers and paper.

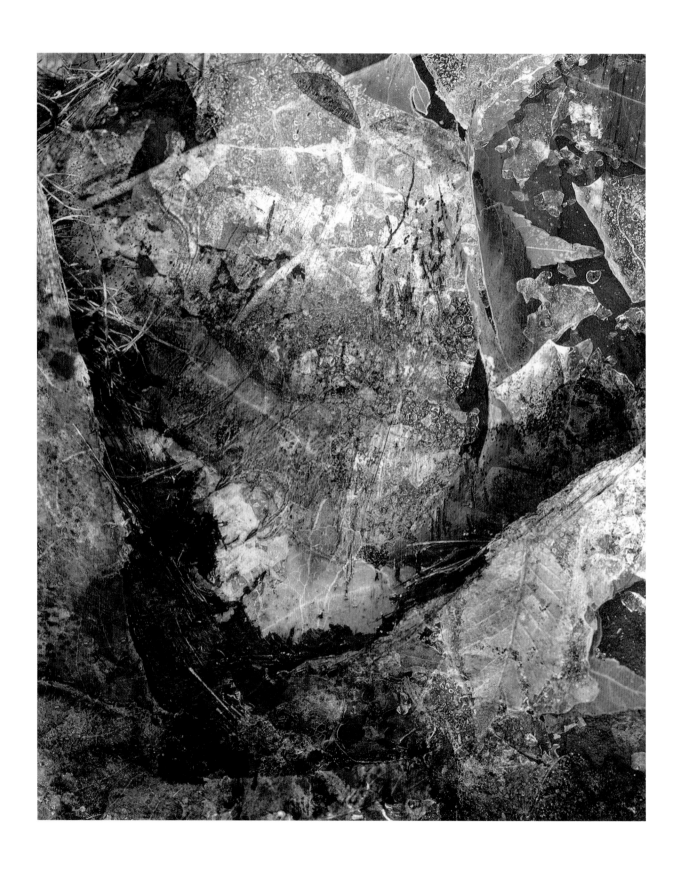

Fire & Ice
2000

GEORGE'S ANALYSIS Combining exposures has been around as long as photographers have been loading film into cameras. That we now have to do this deliberately instead of making double exposures by accident, as was the norm for the first 150 years of photography, is somehow amusing. In the days of large format, it was all too easy to put a film holder back in the camera with the same side forward and make a double exposure, whether intentional or not. Undoubtedly the first creative efforts were accidents that led to recognition of potential. A few photographers have taken the concept to amazing heights—Jerry Uelsmann, for example.

Paul Mahder has created a very abstract image in this photograph. Whereas Uelsmann takes objects from a series of negatives, each clearly identifiable in the combined image, with Paul's sandwiching technique, we have to pay attention to see a leaf for what it is—its texture altered by the other image, borders overlapped. I can see leaves and ice, but it's almost as if I'm under the ice looking up instead of the other way around. It isn't clear how he has created this image, and while I'm curious, the how doesn't really matter. I should point out that some of Paul's other images are, in fact, more allegorical and more closely related to the real world. I suggest you look at them. It was, however, the abstractness, the invitation to make relationships in viewing rather than the delivery of already made messages that attracted *me* to this particular photograph.

There are many colors, but the greens are quite muted and occupy a small fraction of the image. Really, we are mostly dealing with brown, yellow, and various hues of blue. The color saturations are natural and well contained. There is texture everywhere.

I find the composition especially pleasing, with the diagonal on the left, the wedge near the bottom, and the curve in brown toward the right forming a cup for radiating streaks, which seem like bare trees converging as they reach for the sky. The base of the image is darker, giving it stability, while there are more lines and textures toward the top, which even if you don't see as sky, gives the area more energy.

All manner of interesting shapes appear in the image—the perfectly straight line in the upper left, a small triangular shape below it, round bubbles, and various streaks. There is a diamond shape formed by a series of straight lines and overlapping objects that imply other more or less straight lines. The corners of the diamond touch the top and both sides.

One of the most abstract images in the book, it is nonetheless made from straight photographs and contains elements that are recognizable as "real". Elsewhere are images of varying degrees of abstraction, some recorded, others constructed. Photography offers a marvelous array of possibilities for the imaginative artist.

THE PHOTOGRAPHER'S PERSPECTIVE *Fire & Ice* is a composite of two 4x5 transparencies. The first image was taken during an early winter ice storm in St. Louis, Missouri, of fall leaves trapped under ice on the cracked asphalt outside my rooftop window. The second image was taken eight years later of a palm tree trunk in Dolores Park, San Francisco, California. This close-up shows the V-shape created where a frond of the tree has fallen off.

The combination of these two images created interesting juxtapositions between summer and winter, between the warmth and brilliance of fall leaf colors and the transparent clarity of ice, and between the tropics and the wintry north. The black cracked asphalt creates a solid dark background upon which the colors stand out, as if the colors are at once encased under the ice yet bursting out from it at the same time. *Fire & Ice* refers to the compatibility and beauty of opposites.

BIOGRAPHY I grew up with a strong interest in music, in particular, composition. Later, I learned and enjoyed dancing as an amateur. I received a BA in arts management from Webster University, St. Louis. In 1993 I turned to fine art photography as an art form to help me answer larger, specific life questions, such as, "What is the essential reality of our being and our relationship with nature? Is it sacred? How is it evident and can I capture it in a photograph?" I've continued to explore variations on this theme throughout my photographic career. My work has been shown internationally in museums, galleries, and churches, and in private collections worldwide.

In 2001, I became an art gallery director and currently own my gallery in San Francisco, California. I represent established-to mid-career painters, sculptors, drawers, and photographers from around the world.

I have been influenced by Eberhard Grames, Jan Saudek, and Sebastiao Salgado.

You can see more at my website www.paulmahder.com.

TECHNICAL *Fire & Ice* is a composite image of two 4×5 positive color images. They were taken with a 4×5 Wisner Technical Field camera using outdoor natural light. I stacked and cropped the slides on a light table. What I saw on the light table is exactly what the viewer sees in the final print. This image was unaltered by digital computer methods or printing techniques. It is an archival, museum-quality print and limited to an edition of 15. Because of the large amount of fine detail, I most often print this as a 30" × 40" image on Fuji Crystal archival paper and mount onto Plexiglas.

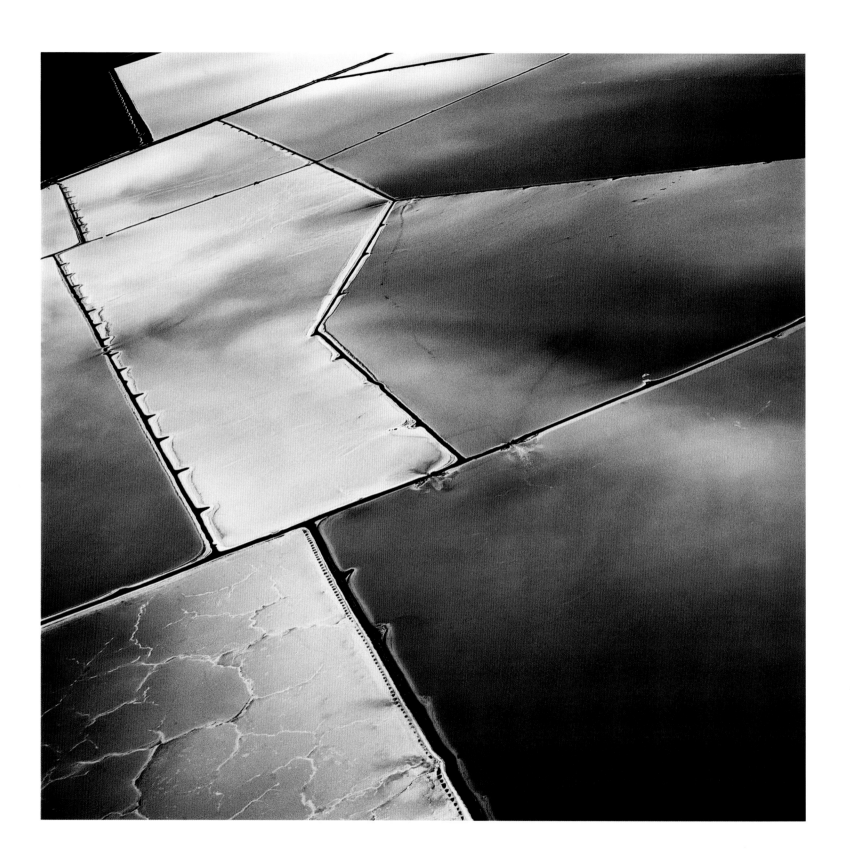

Terminal Mirage 8
2003

GEORGE'S ANALYSIS Photographing industry is nothing new. Edward Weston photographed Ohio steel plants, and people have been photographing industry since not long after the beginning of photography. Some photographers emphasize situation over abstraction (Ed Burtynsky comes to mind) while David Maisel leans more toward the abstract. This image is one of his more abstract and appeals to me for that reason. Some of Maisel's images retain clues as to scale—things like roads that help us orient ourselves—but none of his images are simply illustrative or documentary, and all have elements of abstract painting.

The environmental message of destruction to the landscape is more obvious when the surrounding areas are included and scale is descernible, but there is something nicely perverse about making an image from sludge and spoils and poison and turning it into something beautiful.

I have referred elsewhere in the book to puzzles within photographs, but while some perhaps don't know what it is that David photographs, most do or will find out, and it is the idea of making the viewer have two different emotions opposing each other that makes images like this work. The image is beautiful and I love it, but now I have said I love industrial waste. That can't be ...

Photographically, this is a very strong image. The panels of the image have their own tones, ranging from cream to yellow and then orange, rust, and red, while each panel varies within itself. The small area of black in the upper left has an intriguing shape and nicely balances the larger but not as dark area in the bottom right. The dark panel near the top could almost be standing out from the "field" or sinking in.

The "spikes" along each edge are fascinating. One almost has the impression that the panels or fields are actually some thick syrupy substance that is pouring onto the black lines separating them, though I suspect in reality it is the other way around.

The zigzag line of the upper-left corner is repeated in the adjacent panels. The lightest panel is bound by the darker panel on the middle-left edge, nicely holding it into the composition.

With its collection of straight lines, the subject clearly isn't anything natural. The colors have more to do with hell than heaven, yet the tones, shapes, and lines and the black corner make for a striking image of beauty. This split personality of the image makes us feel a bit uncomfortable without slapping us in the face. By introducing this duality, the photograph stays with us where a more obviously horrifying image of pollution might have initial impact but is soon rejected as unpleasant to look at. It's a matter of choice for the photographer, to have the viewer have flashbacks to the shocking image or live with the image because of its beauty. Both are valid approaches to the subject of environmental damage. David's approach is subtle and indirect, yet nonetheless extremely effective for its methods.

THE PHOTOGRAPHER'S PERSPECTIVE I photograph evidence of man's hand on the land while exploring the aesthetic elements of these sites. The images are intended to stand on their own, without political overtones, although revealing the damage done to these environments is an essential part of why I make these photographs. *Terminal Mirage,* a series of aerial images of the Great Salt Lake in Utah, exemplifies my intentions. Vivid pools and planes of color are formed by bacteria staining the drying mineral beds, or by tailings ponds from industrial complexes containing toxic dioxins.

When photographing from the air, I work from varying elevations in order to compose full-frame images that abstract the subject and eliminate clues as to scale, location, and cause. I instruct the pilot to bank and circle around the areas that interest me, leaning out of the airplane and photographing the shifting compositions.

BIOGRAPHY I was born in New York City in 1961, and received my BA from Princeton University, and an MFA from California College of the Arts, in addition to study at Harvard's Graduate School of Design. I have been the recipient of an Individual Artist's Grant from the National Endowment for the Arts. I live and work in the San Francisco area with my wife and daughter.

My photographic practice has focused primarily on environmentally impacted sites, in a multi-chaptered series called *Black Maps.* My large-scaled photographs show the physical impact on the land from industrial efforts such as mining, logging, water reclamation, and military testing. Because these sites are often remote and inaccessible, I frequently work from an aerial perspective, thereby permitting images and photographic evidence that would be otherwise unattainable. In my recent project, *Library of Dust,* I continue to investigate a zone bordered by aesthetics and ethics. The series depicts individual copper canisters, each containing the cremated remains of patients from a state-run psychiatric hospital whose bodies have been unclaimed by their families. The canisters are now blooming with colorful secondary minerals as the copper undergoes physical and chemical transformations. Sublimely beautiful, yet disquieting, the enigmatic photographs are meditations on issues of matter and spirit.

I have been influenced by the artists Robert Smithson, Gordon Matta Clark, El Lissitsky, Lebbeus Woods, Ed Ranney, and Frederick Sommer. As an undergrad at Princeton, I worked

closely with the photographer Emmet Gowin, who introduced me to aerial photography at Mount St. Helens.

I have published the following books: *The Lake Project* (Nazraeli Press, 2004), *Oblivion* (Nazraeli Press, 2006), and *Library of Dust* (Chronicle Books, 2008). *History's Shadow* will be published by Nazraeli Press in Fall 2010.

My website is located at www.davidmaisel.com.

TECHNICAL I use a Hasselblad 6x6 cm camera, a medium telephoto lens, and I still utilize film. I have no particular desire to move to photographing digitally, as I love the results of film!

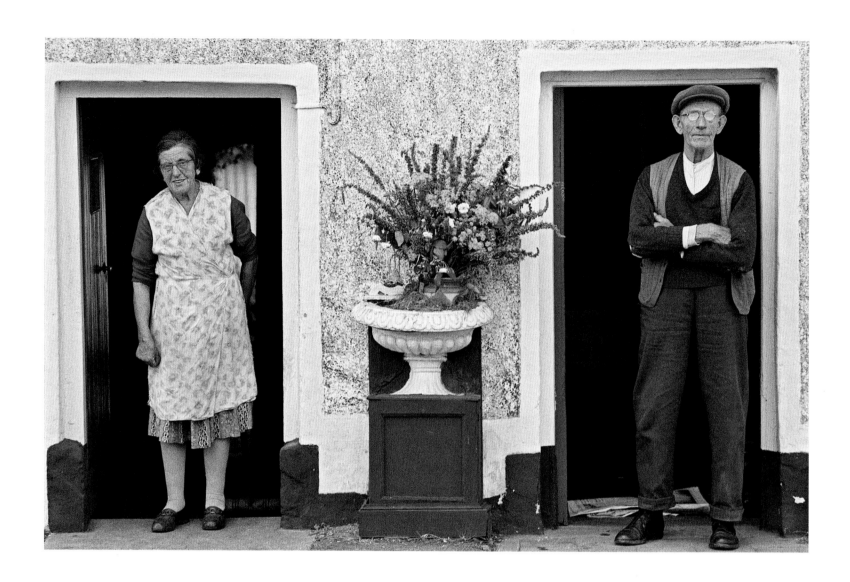

Two People / Two Doors – Carlow, Ireland

1964

GEORGE'S ANALYSIS Harald recently released the book *Photography Unplugged* (Rocky Nook, September 2009). I had already seen his work on colour and design and recognized an excellent photographer with a superb sense of both. *Photography Unplugged* is both a beautiful book and a bargain. In thumbing through the book, I came across these two people standing outside their doors and the photograph immediately caught my attention. Arguably this isn't "my" kind of photograph, yet every time I went through the book, I stopped at this image.

The two elderly people intrigue me. I can't see why there would be two front doors to the same home, so that would make them neighbors rather than a couple. But perhaps this situation is like my friend's, who keeps his Epson 9800 printer in the bedroom (it is 6 feet long) and finds it best to live next door to his girlfriend. So, are they friends, perhaps more than friends? They stand in their doorways looking like the figures often found atop a cuckoo clock. The figures on the clock are the markers for a hygrometer, measuring humidity and predicting the weather, typically one male, the other female, with the latter representing dry and sunny.

The woman's glasses are transparent and she's smiling at the camera; the man has his chin up, his glasses reflecting, as if not quite comfortable with the photographer. One house has a back window showing in the doorway, the other doorway is completely black; one has a tidy stoop while the other appears to have an old newspaper lying there. One door frame needs to be painted, the other does not.

The crossed arms of the man certainly suggest he's less relaxed, less open. The woman's pose reduces her height while his emphasizes his. He appears to be

guarding his entrance while the woman is welcoming. One imagines that a cup of tea and a scone await the visitor to her home.

I wonder who did the flower arrangement, which appears to be a live plant rather than cut flowers. Who is the gardener? I would really like to get to know both of these people, even if it might take some time for the man to open up.

The two figures against the dark background create an ideal composition. The color of the man's trousers are a near match for the gray of the lower wall, while the woman's stockings are similar to the upper wall. The blue of the woman's skirt matches the man's door. Her green sleeves are similar in hue to the green of the plant. The framing of the photograph is not "perfectly" aligned, as it is tighter on the woman's door than the man's, but note that the building isn't perfectly regular either, so the irregularity of the building works with that of the framing. The square-on presentation and symmetry of the image are essential to the presentation of the two figures. The largely pastel palette with only small areas of fairly intense blue suits the photograph and the situation, but it is interesting that it is the man, apparently the more conservative of the two, who has the bright blue door, even if the image downplays its presence. A fascinating image.

THE PHOTOGRAPHER'S PERSPECTIVE It is impossible to show a photographer's style or his work with just one image. But there are images that are waypoints in an artistic career. I took this shot in 1964 in Ireland, and the images I brought home from this trip caused me to receive a fair amount of recognition as a photographer in Germany. It was a significant

step in my transition from amateur to professional status.

When I came upon this scene, I actually just wanted to capture the flower bouquet between the two doors, when the left door opened and the Irish lady came out. Kneeling in front of her, I asked permission to take a picture. She knocked on the other door and yelled, "George, come out!" This is the result, and I never took the image of the flowers.

BIOGRAPHY I was born in Berlin in 1936. In 1957, I won a scholarship to the painting department at the College of Applied Art in Wiesbaden. I came into contact with the ideas of the Bauhaus through Professor Vincent Weber, one of the original Bauhaus students. In 1960 I purchased my first camera, financed by delivering newspapers.

In 1964 I started a successful professional career via a three-month photo tour driving through Ireland in a Citroen 2CV. From 1966 to 2001 I taught fine art photography, beginning with adult evening classes, then later at the University of Applied Art and Sciences in Dortmund. For the past seven years, I was dean of the Design Department there.

In 1969 I published my first textbooks on composition and color design, later followed by more textbooks and then coffee table books on Tuscany, Canada, Austria, and Ireland. In June 2010, my 36th book, *Die Fotoserie,* a textbook about serial photography, was published by dpunkt.verlag.[1]

In 1988, I and my wife Eva Witter started a major art project called "Bildräume (Image spaces) – Diaphane Metamorphosen

1 This book will be translated into English and published in February 2011 by Rocky Nook with the title *Serial Photography.*

von Schlössern in Europa", a black-and-white photographic work combining exterior and interior spaces of European castles on multiple exposures. In 1993, a second project "Weitsichten" was initiated by Eva and me.

I retired in 2001 but I'm still teaching at various universities and giving workshops around Germany and Austria. I live and work in Schwerte, Germany.

My influences are Harry Callahan (United States), Erwin Fieger (Germany), Ernst Haas (Austria), Herbert List (Germany), and Pete Turner (United States).

My work has been published in the following books: *Serial Photography/Die Fotoserie* (Rocky Nook/dpunkt.verlag 2010); *Photography Unplugged,* (Rocky Nook/dpunkt.verlag, 2009); *The Photograph* (Rocky Nook, 2008); *Das Foto* (Verlag Photographie, 2007); and *Motive kreativ nutzen* (Verlag Photographie, 1996).

There are several websites where you can see my work: www.harald-mante.de, www.simultanfotografie.de, and www.dpunkt.de/sammlungmante.

TECHNICAL The photograph was made with a Zeiss-Ikon Contarex and Carl Zeiss Tessar 1 : 2.8 50mm on Kodacolor film.

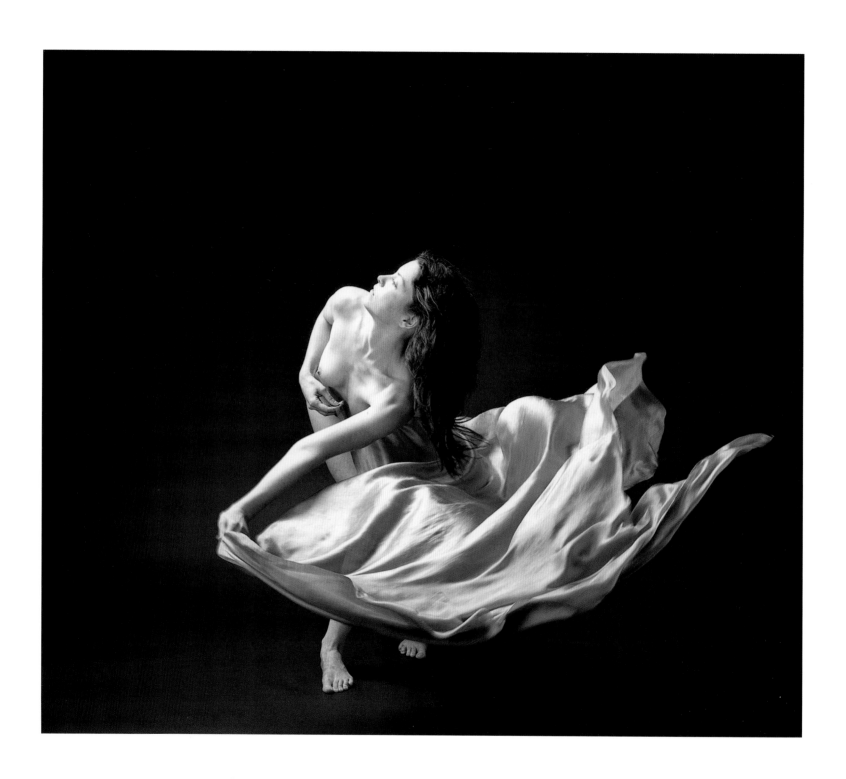

Dancer
2005

GEORGE'S ANALYSIS The human figure has been a central subject of art for millennia. Whether angels or cherubs on frescos or erotic reclining nudes in the paintings of the 1800s (or throughout the history of photography, for that matter), the human figure forms one of the major themes. Despite what would appear to be a relatively limited subject, creative photographers continue to come up with different ideas and compositions; informing, titillating, or moving us in new, interesting, and wonderful ways.

This photograph by Dennis Mecham, simply titled *Dancer,* shows wonderful grace. The position of the dancer is clearly part of movement, of the dancer expressing herself. The exposed breasts and the tonalities of the chest are so beautifully duplicated in the lighting on the flowing cloth that this "nudity" seems entirely natural—why would you have it any other way? The hands are in natural positions that complement the movement, the turn of the head an extension of the turn and sweep of the body. The feet confirm that this is part of a series of movements, in other words, not a pose.

Tonally the photograph is wonderful—the highlights brilliant yet not harsh, the shadows beautifully outlining the folds in the cloth and the shape of the body. Even the comma-like shape of the hair complements the curves of the body and of the cloth. The dancer appears completely unaware of the photographer, wrapped up as she is in the music, the light, and the movement.

In the print that Dennis sent me I can see into the hair, and the background nicely separates from black to frame the dancer with appropriate shadowing.

This photograph is so "right" for black-and-white, removed from the real world of a full color picture. We can focus entirely on the tonalities of the skirt, the

luminosity of the skin, without the distraction of color and the associations of reality.

The composition is superb. The curved lines of the skirt orbit the body of the dancer and provide counterpoint. The parallels of the dancer's left arm and the nearby straight edge of the skirt match the back edge of the skirt. The flowing shape of the hair is an attractive shape and balances the curve in the body and right arm. The folds in the skirt are wonderful, and the "tail" of the skirt separating on the right edge and flowing further is perfect, breaking up too much regularity and adding further interesting shapes and lines and curves. The face appears to be centered directly above the curve of the skirt and the dancer's body and that somehow seems just right. That both feet show below the skirt suggests an element of normality, yet the right foot is off the ground, further demonstrating the sense of movement started by the sweep of the skirt and aided by the movement in the left arm.

Look at the lines of the neck and throat, the chest and shoulders, the swell of the breasts—magnificent tones and shapes radiating from the center of the chest.

THE PHOTOGRAPHER'S PERSPECTIVE

I decided to create *Dancer* from a desire to explore further the aspect of movement in a photograph. I love to explore the narrative, and this would be a new challenge. The image was, as in many of my images, previsualized but always leaving room for surprises. This image would be a significant addition to my commitment to photography of the female form. I want to thank my model, Jenevieve Hubbard for her part in creating this photograph.

With *Dancer* I would have much less control than in many of my images as it would be impossible to predict the movement of the silk fabric. I positioned two fans to provide the best flow of the fabric coupled with the model's movement. It was shot, like much of my work, in 4x5 black-and-white in my studio. Even though the model did a wonderful job with her

consistency of movement that we had choreographed earlier, the fabric would be a great unknown. After making Polaroid proofs to check the lighting, I exposed 10 sheets of film and, after processing them in my darkroom, was pleased with this result. But, of course, the great excitement comes when printing, and the silver gelatin prints turned out beautifully on a warm-toned paper.

I felt my challenge was successfully met as I usually create situations in which I will grow as a photographer and artist.

BIOGRAPHY

I am a fine art photographer who has photographed for over 25 years, attempting to understand the silent dimension underlying our world as well as ourselves. Having grown up in the high deserts of Utah and the Colorado Plateau, I was surrounded by luminous light. I think, on some level, many artists' lives are a love affair with a special light that touches their souls.

I work mostly with large-format black-and-white and enjoy the journey of creating expressive silver gelatin prints in my darkroom. My darkroom is a sanctuary of discovery. Printing from the large negative always gives me a sublime yet powerful expression of the image. Whether I'm capturing movement or stillness, the grandeur of a space or structure, or the intimacy of the human experience, the large negative gives a fuller experience of the thought behind the image.

I'm always working toward breaking down my own walls. I try to take risks and enter a world of uncertainty in the process. This uncertainty keeps me living in the moment.

I currently live in Salt Lake City, Utah, though I have also lived in California. My interests include the female figure in the studio as well as location, portraits, and architecture. I enjoy creating images that invoke a sense of mystery and passion incorporated into the narrative. I earn my living through my photography, whether it be from print sales or commercial architectural projects. I photograph designs and portraits. I teach

private lessons as well as workshops and do fine art printing for other photographers both in color (Ilfochrome) and toned silver gelatin black-and-white prints.

I'm currently working on a new body of work about eroticism with a sense of elegance and understatement with a more classic style of lighting. I still have a few more images to create in my *Parasol* series as well as the *Skirt* series. I am also working on a series on a completely restored B-17 airplane. I can be drawn into any subject that evokes a sense of mystery and visual wonder so that I can keep my mind open to what may enter my life.

I have been influenced by Joyce Tenneson, Robert Mapplethorpe, Richard Avedon, and Helmut Newton, though to be completely honest, I was more influenced by painters like Maxfield Parrish, among others.

My work has appeared in many publications, including a cover for *Focus Magazine* with an article and interview and a *Yorba Linda* magazine cover with interview and article, among others.

My website is www.dennismecham.com.

TECHNICAL　I use a 4×5 view camera and print toned silver prints. I also use a Rolleiflex 6×6 TLR for my roll film work.

Sir Edward James Garden Sculpture

2001

GEORGE'S ANALYSIS I recently had occasion to spend several hours looking through images made by alternative methods, assorted printing techniques, and a variety of odd cameras. My consistent observation was that concept trumped technique; that these photographers seemed to think that a good idea and an unusual method were all that is needed to create great art. I found myself feeling frustrated and disappointed.

The truth is that there needs to be a great idea, a choice of tools and techniques that complement that idea, and then skill in execution. By the latter, I don't mean technical skill but the entire gamut of photographic skills, from seeing and working the scene to composition.

It is refreshing, then, to see the work that Billie did with a strange and wild garden of sculpture in Mexico. The garden was offbeat and exotic enough to form a solid idea for a project. Billie thought that black-and-white film and using the unique characteristics of the Holga camera would be suitable. Then Billie brought her experienced eye to the garden and executed a lovely portfolio of images that ideally matched this unique garden.

Holgas are medium format, poorly made cameras with a crude lens that causes substantial blurring of the edges. The lens doesn't quite cover 120 film, so there is significant vignetting, yet the image in the center is quite sharp, the blurring a gradual increase toward the edges. There is often a large amount of flare, and the inclusion of bright areas often spreads the light in attractive ways, as has happened here with the very much brighter sky. Image edges are irregular and ill

defined and oddly provide an attractive folksy craft look to the images.

Billie has chosen a low viewpoint to contrast the sculpture with the lacy branches and sky. The slight tilt to the camera implies that the sculpture is reaching to the light and adds to the dynamism of the image. The dark bottom of the print along with the darker branches on the left edge nicely frame the sculpture and sky. There is even movement implied in the softness of the recorded branches along the left, top, and right.

Notice the slightly darker ark of treetop just to the right of the rightmost limb of the sculpture, nicely framing that part of the sculpture. Likewise, the one horizontal branch near the top that reaches across the top of the sculpture as if trying to touch it works well.

The base of the sculpture is lost in shadow, and that helps the image, leaving the impression that this "thing" somehow grew out of the jungle—some exotic bulb about to bloom.

THE PHOTOGRAPHER'S PERSPECTIVE The reason some-one makes a photograph is really the sum of many experiences, and that is certainly the case for this image. I had worked on a series of images for several years that required a medium format camera on a tripod. I was beginning to feel hemmed in. I saw some Holga images, liked what I saw, and soon purchased a Holga camera to play with. At the same time I was starting a large garden at a new home, so photographing the garden with the Holga was the natural thing to do. This was so liberating! I learned the quirks of the Holga and found that with Ilford Delta 3200 film, processed for 400 ISO I could get a good tonal range, but I never really knew what I would get until the film was developed. I learned to let my muse take over rather than my head. Photographing my own garden developed into a project. The project was not about a particular garden but about the light and space in any garden.

I remembered an article I had read and saved several years previous about a surreal garden in Mexico with giant concrete structures. It intrigued me and seemed an ideal subject for the Holga. When I finally walked into this garden, I was over-whelmed with the light that filtered through the jungle canopy and onto the bizarre structures projecting up from the jungle floor. The garden is very difficult to get around in. The paths and steps are slippery and uneven. The jungle felt like a steam bath. I carried two Holgas and was thankful that they were light. I was attracted to this "tulip" and photographed it from various places on the paths through the garden. This view was the most powerful one, but I was photographing it with the light behind it and I had no idea whether the Holga would end up producing just a silhouette against a white background. My muse was with me.

There is one other thing that went into the making of this image and it was digital printing. I have printed this image as a silver print but had never been totally satisfied until I was able to scan the negative and make a digital print. Finally, I could produce the image that I saw and felt when I saw the "tulip."

BIOGRAPHY After photographing for about 20 years, I found the Holga camera, and since then most of my work has been with the Holga or with a Holga lens on a DSLR. I like to photograph the commonplace, and I find that the square format usually fits my vision. My best photographs are those made right in my own neighborhood, whether that is in Houston, Texas, or where I have retired in Colonia San Antonio in San Miguel de Allende, Mexico. Sometimes a project is in mono-tone and sometimes in color, sometimes with film and sometimes with a digital camera, but all my printing is done digitally.

Last year for the Solo Foto Book Month, I completed an eBook, *Eastwood Today,* and I have plans to add to it before

self-publishing. I am also working on another book of square, color images made in Mexico for self-publishing. My work has been in numerous group and individual shows and is in museums and in public and private collections, including four large prints in the art collection of the Federal Reserve Bank, Houston, Texas.

My influences are Ansel Adams, David Plowden, and Frank Armstrong.

You can see my work online at the following locations: *Eastwood Today,* an eBook at
http://issuu.com/bmercer/docs/eastwood-3;
a gallery of my images at www.pbase.com/billie_mercer;
and my blog at www.billiemercer.blogspot.com.

TECHNICAL The photograph was made with a Holga 120 film camera.

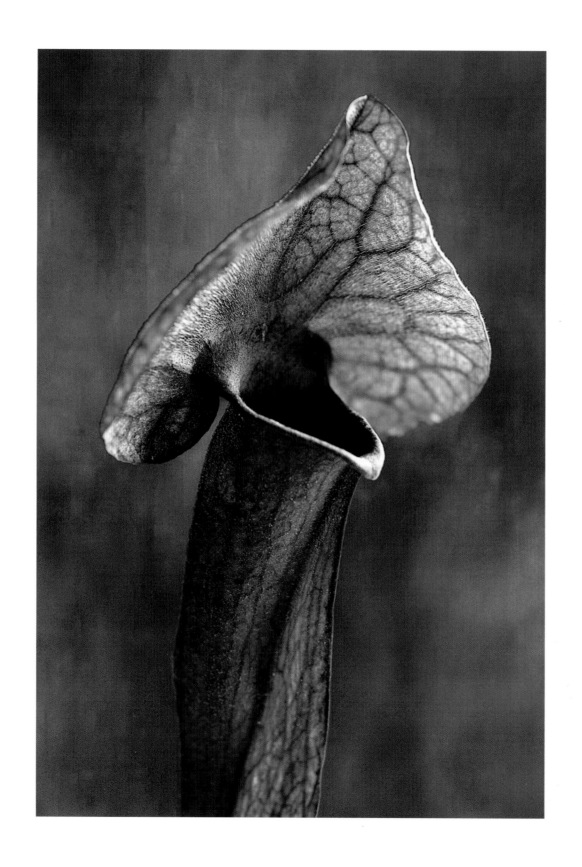

Trumpet Plant

2008

GEORGE'S ANALYSIS A portfolio of Beth's carnivorous plant photographs is in *LensWork* #85. Apart from the technical excellence of the images, some are downright creepy while several seem quite erotic to me. While *Trumpet Plant* somewhat resembles a penis, the gaping opening would appear to have more in common with the female anatomy. That these plants take in insects and devour them has overtones of Freudian dreams.

On a more prosaic level, the plant is superbly lit, the tones luscious (it seems entirely appropriate to use terms that are more normally associated with eating). Composition takes a back seat to form and tone, the tonality helping with the erotic effect. That said, the three-quarter view and slightly diagonal line of the plant give it more energy, offset the hood from perfect symmetry, and allow the part of the hood behind the lip of the plant to be thrown out of focus. I know this is a small detail, but it is an accumulation of small details that are right, which are frequently found in the best photographs. For example, note the separation of the bottom of the hood on the left from the stem of the vessel—and how much less effective it would be were it overlapping the edge of the tube.

The background is simple and the tones work well with the subject, with just enough variation to make the image look like it was taken in a natural setting rather than in a studio. I understand that Beth prints only platinum, which is known for its subtleties. While I haven't had the privilege of seeing this image printed on platinum, I understand how this medium would be an ideal match for the portfolio. Notice the very subtle light edges to the tubular structure, just enough to separate the plant nicely from the background.

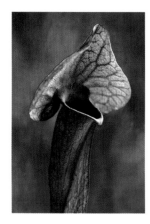

In this photograph, there must be some backlighting because the hood seems quite transparent, the veining showing more than would be expected from front lighting. The gradual darkening of the entrance to the funnel is superbly handled. The lip of the funnel "pouring" on the right and sweeping up to the hood, with a lighter band extending across the base of the hood, is a sensual shape.

The image makes me want to run my hands over the plant. Yes, I know it is too delicate and probably sticky or waxy or yucky in some way, making it unpleasant or impractical to touch, but the way it has been photographed makes me wish it were made of stone so it could be fondled.

Beth explains that she came across the plants with her son, which nicely makes the point that ideas for subject matter can come from anywhere and at any time, and we must be alert to the possibilities of every situation we find ourselves in. It is all too easy to limit ourselves to pretty landscapes and old buildings. We admire the work of Walker Evens but forget that he photographed contemporaries in then modern buildings. He had the ability to see the subjects we discount and take for granted and miss as fodder for our work. How fortunate we are that he didn't refuse to photograph the current and the ordinary, and that Beth was intrigued by the plants of her son's school project.

I particularly recommend that you look at the whole portfolio because the feelings vary with the images. It is quite a tour de force for a simple portfolio of a dozen plants. And you thought plants needed color!

THE PHOTOGRAPHER'S PERSPECTIVE My son, age 12 at the time, became interested in carnivorous plants and began collecting various species. We read about their history and unique trapping methods. In 2008, we went to a carnivorous nursery, and as we browsed through the many varieties, I

found myself drawn in by the entrancing dichotomy these plants possess, pulled into their dark, yet beautiful world.

Looking back, it is hard to believe that I spent hours that stretched into days with each plant. I wanted to see the plants as an insect might. I used a digital camera like a Polaroid back to study numerous angles at different times of the day. A wide-open macro lens gave an incredibly shallow depth of field. I used the natural light that comes into my office through a floor-to-ceiling window space draped with gauze to diffuse the direct sun.

It was not obvious to me at first what the best angle was for each plant until I photographed them from all sides, while studying the effect of the light upon the various parts of the plant. Some were very hairy while others were smooth, yet others glistened with sticky liquid in droplets on extended

appendages. Many of the plants had very thin membranes that cause the light to be reflected within the vessel, giving off an advantageous glow, inviting insects to come closer.

This particular trumpet plant with tiny hairs growing at a downward angle directs the crawling insect to the very slippery lip, while doom and digestive fluids wait in the vessel below.

It was tempting to render the images in color, but I found black-and-white afforded fewer distractions, as did separating them from their backgrounds. What came through for me was a clearer view of form and design. So it really comes down to a long list of decisions that start before the photograph is taken.

BIOGRAPHY I was born in Wisconsin and studied fine art at the University of Wisconsin. Classes in painting, life drawing, sculpture, and design would set the groundwork for my work in photography, which was to come years later.

After college, moving to England, a country with a love for all things arboreal, gave me a fresh look at a land that boasts the largest concentration of ancient trees. I envisioned photographing these landmark trees, not as a literal documentation, but instead as an exploration of time and survival.

I experimented over the next 10 years as my photographic style evolved.

Unhappy with the photographic tonality and stability of inkjet printing, I started to experiment with alternative printing processes, learning the Mike Ware method of platinum/palladium printing. The wide tonal scale and ability to choose hues from blue blacks to earth-toned browns, unique to this method, made this the ideal process for my vision. I concentrated on mastering this printing technique while adding to my series of tree portraits and beginning other various photographic projects.

I have been influenced by Julia Margaret Cameron, and Robert Demachy.

My work has been published in the following: *Digitalis Foto* (Hungary, 2010—12 photos and text); *Zoom International* (Italy 2009, 6-page spread with interview); *The Savage Garden* (*LensWork* 2009, portfolio, cover, interview); *The Savage Garden* (*Shots* 2008, 8-page spread, interview); *Black and White Magazine* (September 2008, Spotlight — 8-page spread, article); *Thy Kingdom Come* (*Camera Arts* 2008, portfolio, cover, article); *Portraits of Time* (2007 *LensWork*, portfolio, interview); *Where Art Embraces Photography* (*Silvershotz* 2007, 12-page spread).

You can see my work at www.bethmoon.com.

TECHNICAL I use a Pentax 6×7 and a Canon 5D Mark II. My prints are hand-coated with platinum/palladium metals onto heavy, French, archival watercolor paper and contact printed.

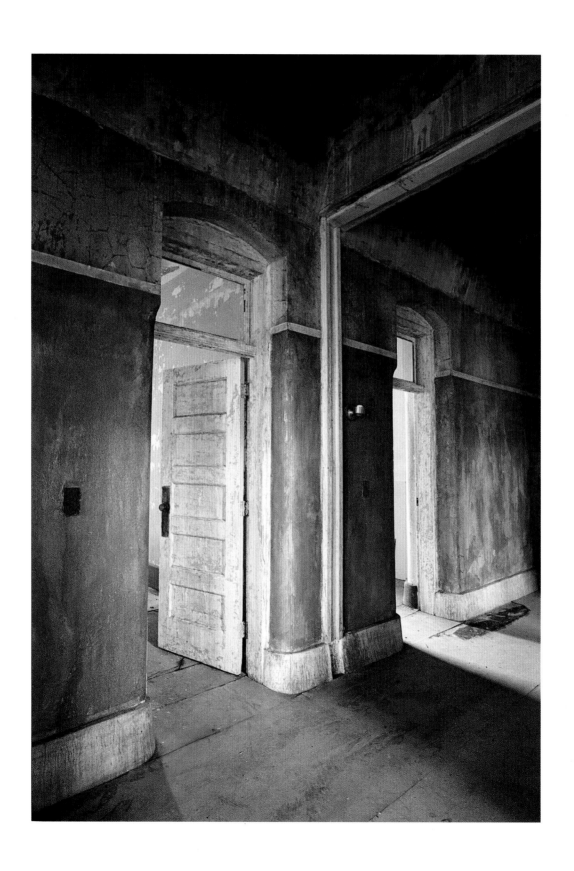

Asylum Doors
2000

GEORGE'S ANALYSIS Shaun O'Boyle is now an established photographer, published in *LensWork,* with images of strength. A few years ago he was still finding his legs. He responded to a blog entry of mine and I had occasion to look at his images. There were some interesting industrial images—fishing boats and whatnot—and also a series done of an abandoned mental hospital. There was some good use of color, but for the most part the images weren't all that strongly composed, and none really moved me until I came across this image. It was utterly beautiful, full of light and color, of nostalgia and sadness, incredibly well composed. It succeeded on a number of levels.

I contacted Shaun to tell him how superb I thought this photograph was. I'm not sure that Shaun was aware at the time of how much it stood out from his other work. It hasn't taken him long to learn though.

This process of making one image that is significantly better than our other work is, in fact, one of the main ways in which we make progress; and this is true of all photographers at every level, including the greats of history. Look at the work of any of the great photographers and you will find a limited number of images that many identify as being much better than the others. That there is almost universal agreement on which images are outstanding suggests that it isn't a matter of taste or interest; some images are simply more universal, stronger, and more beautiful than others.

This photograph of Shaun's succeeds on so many levels. The colors are wonderful together—cream, green, and maroon. As is common with many good images, there is not a rainbow of colors. Three colors often work really well together—less often there are many or only one or two colors that work.

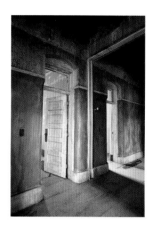

There are fantastic textures in the walls, doors, and floor. The light pouring in gives the image a sense of life that contrasts with the obviously abandoned look of the building. The shadows created by the light add to the composition.

That it is an abandoned mental hospital is poignant, and one can't help but wonder what happened to the inmates: Did anyone get better and go home? Did they simply move from an institution to living on the street?

I have a sense that the archway in the hall is like the frame around a mirror. Close inspection of the image proves that can't be, yet that impression persists with me. The image was made with a small camera, and verticals have not been corrected as they would likely be in a view camera. The interesting thing is that the uncorrected verticals make interesting angles with the edges of the image, giving it more energy and a feeling of spontaneity.

There is repetition of lines that strengthens the image and a collection of diagonals that tie the image together. Consider what element you might remove from the image without weakening it. This is one of those images in which every single element works toward the whole.

In some ways the photograph looks like a painting—with texture in the subject emulating brush strokes. Technically this cannot have been an easy image to photograph, with its brilliant highlights and deep shadows. Shaun photographed this on film, and the control of contrast is remarkable for that medium.

This was a watershed image for Shaun, and his current work, while looking nothing like this image, is nonetheless a development from it.

THE PHOTOGRAPHER'S PERSPECTIVE I came to the asylum project out of pure curiosity on my part. I had driven past the expansive grounds of Northampton State Hospital (formerly known as the State Lunatic Asylum at Northampton)

many times, and could see the massive asylum buildings sitting at the top of the hill, windows empty, the buildings abandoned.

With my background in architecture, I wanted to explore this Dr. Kirkbride design building. His philosophy of fresh-air-and-sunshine for patients led me to explore the building, in part for the architecture and also to answer questions I had about these state-run institutions and the notorious reputation they had. The grounds of the hospital were open to people who walked their dogs and jogged. With a bit of determination I was able to gain access to the buildings, and on five separate occasions, spent about 40 hours exploring and photographing this site. For safety, I normally explore abandoned sites with someone else. But on my first visit, a time in which I had not intended to enter the buildings, I found myself in the pitch-dark basement of the asylum, no flashlight, wandering around, bumping into things in the dark, and looking for a stairway up to the upper floors.

I still remember how my heart was racing the entire time, in part because of the opportunity to photograph this unique structure, and in part because of the surroundings. Between listening to half-heard sounds down the wide hallways and peering into the side rooms devoid of all light, I managed to take a few photographs before having to go back down through the basement to make my escape of the premises. After getting the film back, and seeing the potential of this historic structure, which was slated for demolition, I was hooked: I knew I had to return.

This photograph was taken in an area that particularly fascinated me due to the colors of the walls and the lighting. The building was designed to give patients as much light and air as possible while segregating the various populations. I did a series of studies of the hallways and the doors. My goal was to capture the melancholy yet beautiful mood of this place—not a difficult task given the state of decay and the beauty of the original structure. Throughout my many visits to this location,

I was continually struck by the idea of the buildings and rooms as containers of memories. When I looked carefully enough, I was able to find details that would suggest stories about those who spent time here.

BIOGRAPHY I currently work as an architectural and mechanical designer at a small architectural firm. My photography has developed in parallel with my interest in architecture and the built environment, so there is a lot of cross influence and interest there. I studied at Parsons School of Design in New York City during the 1980s, and worked in the City at an architectural firm before returning to Berkshire County in Massachusetts where I make my home.

Working at a massive shipyard as a laborer in New Orleans before college had a significant influence on me. That job and the industrial work environment in general have continued to fascinate me and have lead to other photography projects in the steel and coal industries.

Among my major influences are Eugene Atget, Josef Sudek, and Eugene Smith.

In the fall of 2010, my book *Modern Ruins: Portraits of Place in the Mid-Atlantic Region* will be published. My *Bethlehem Steel* portfolio appeared in *LensWork* magazine (# 77, July-August 2008).

Five other self-published books on various projects are available from my website www.oboylephoto.com/ruins.

TECHNICAL This photograph was shot with a rangefinder camera on film, and with a tripod. Exposure was in the 30-second range. I liked the rangefinder camera for its size and weight and the quality of the lenses. The Northampton State Hospital project dates to 2000, before digital was available at an affordable cost. All current projects are shot with full-frame digital SLRs.

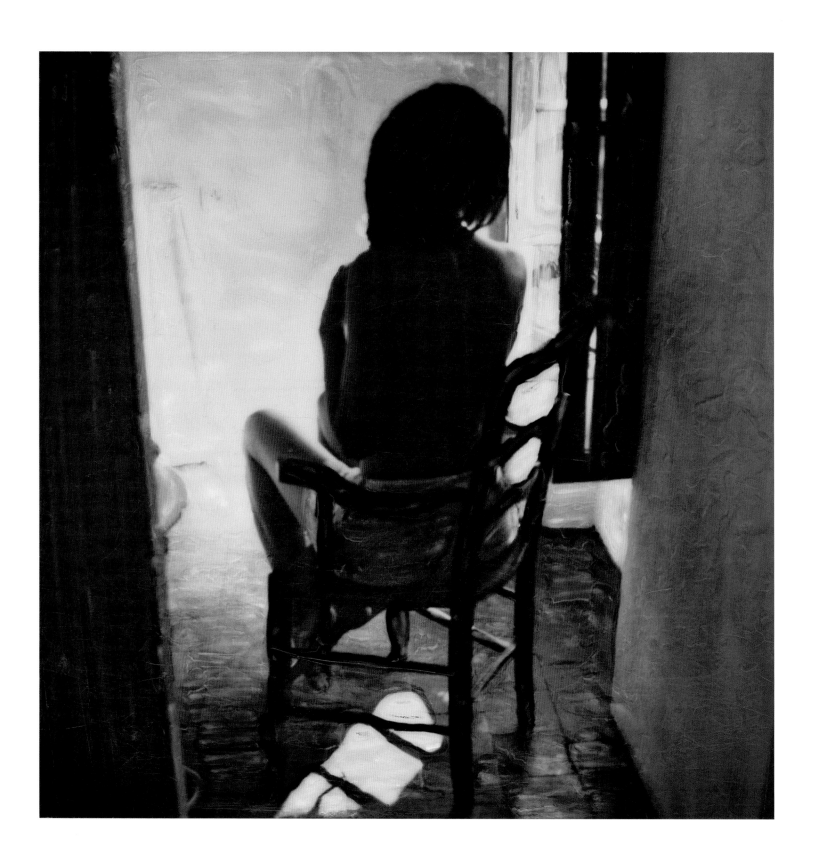

Waiting

2002

GEORGE'S ANALYSIS Many of us "of a certain age" played with Polaroid SX-70 cameras. Someone realized you could use a stylus to stir up the pigments of the images before the picture had fully fossilized and a whole genre of wavy lined imitation paintings was born. Some of the images were really quite nice—but of course, you had to make a good photograph in the first place, as technique never replaces artistry. Very few photographers have fully understood the capabilities of the medium and taken maximum advantage of it so that the SX-70 palette of colors and the manipulation of the image, combined with strong seeing in the first place, come together to produce some magical images.

Waiting by Elizabeth Opalenikis one of those images. Take for example the fact that the subject is in shadow and is surrounded by brilliant light—hardly what you'd call normal technique but superbly applied here—with just exactly the right amount of highlight and shadow detail: A loss of either would have destroyed the image. The warm light and shutters make me think of the Mediterranean—of warmth and sun and certainly not Canadian winters.

In looking down, we have the converging lines of the walls, shutter, and even the back of the chair. The roundness of the arm of the chair matches the clothing at the model's waist, with the model's elbow just high enough to separate it from the arm of the chair and from her thigh in the image.

The angled shapes of the converging verticals work nicely with the tilted lines of the tiled floor. The light on the floor balances the larger bright area of the far wall. I like the idea that the floor seems to disappear into the wall on the left, as if it isn't clear just how far the room goes. Little details like the lines and curve adjacent to the dark area on the left edge of the image add interest and increase my

curiosity—a bath and towel rack perhaps? That little highlight on the model's right shoulder is exquisite.

When I look at an image like this, I don't see these individual compositional elements: I just see the rightness of the arrangement, like someone enjoying a particular piece of music, without having to think why. That recognition, however; only fully developed after I was taught to recognize all the little things that the photographer does to make an image look right, is rather like the more you know about music, the more music you like, and the more wonderful passages you can recognize and relate to.

Of course, so far I have only discussed the elements of the image and not the image itself, of a woman sitting, half dressed, in what appears to be an old building (shutters and imperfect walls), looking out on warm brilliant light. The pose looks thoughtful, which is interesting given that we can't see her face, but she's sitting forward, hand raised, head turned.

The photograph's title is *Waiting,* yet with or without the title we are free to interpret the circumstances and thoughts of the sitter, to make up our own stories of what's going on here, of what could happen next.

THE PHOTOGRAPHER'S PERSPECTIVE I had heard about this lovely "gîte" (summer cottage accommodations) located near where I taught my annual workshop in Provence, so I went in search of personal inspiration. Though being in the south of France should be inspiration enough, when you are the teacher, it is still a job. I was determined to give myself some alone time with my ideas and models. As I researched the gîte website, I was taken by the light in the rooms, especially the room used for this shoot, and immediately imagined myself there. I remember feeling compelled to organize a day with the models, long before I had physically seen the space.

My images have always been about light and feelings, both of which I have always found in the south of France. I was working with conventional black-and-white films, but also playing with Polaroid SX-70 manipulations. I considered the Polaroids my "therapy" and a great way to share ideas immediately with models.

I believe photographs are self-portraits, and from the moment I saw that sunlit room, I was basking in that light. Inspiration comes from many places when we let our minds travel into possibilities.

BIOGRAPHY Raised on a farm in western Pennsylvania, I was trained in common sense and to have a keen eye for observing life and its minute details. To this day, each walk becomes a visual journey as I discover four leaf clovers along the way. At age 21, I spun a map and left home to the sound of peace marches and my mother saying, "I knew you were different from the time you were two." Though I landed in Westport,

Connecticut managing Continental Oil Company's accounting department, I knew my heart and creative soul wanted more.

Travel was awakened, managing jazz clubs fed my childhood interest in music and dance, and as an "MS-Placed Lady" I found freedom with my own interior design and construction company. In 1979, while attending a two-week workshop at the Maine Photographic Workshops, my life changed. I sold everything I owned and returned to stay a year. No regrets. Today, as a photographic artist and educator, I strongly believe in the workshop way of learning. I am still committed to my Oakland, California darkroom where my pleasure comes from working in processes like Mordançage, hand painting, and exploring the mystery of infrared.

People and figures are my passion, as well as anything in water. I recently published my first monograph *Poetic Grace: Elizabeth Opalenik Photographs 1979–2007*. In fulfilling my dream, I learned about myself, closed some doors, and moved on to new projects. With a wonderful sense of completion, I am now working to record movement and create painterly images in new forms and media. I lecture and teach photographic workshops worldwide; and I am represented, published, and exhibited internationally. For me, making art—any art—is a gift.

My greatest influences are Cartier Bresson, Jean Pierre Sudre, Craig Stevens, Sarah Moon, Lucien Clergue, and Sean Kernan.

My work has been published in the books Poetic Grace, Elizabeth Opalenik Photography 1979–2007 (self-published); *The Book of Alternative Photographic Processes* (Delmar Cengage Learning 2008); *Polaroid Manipulations* (Amphoto 2002), and *Visions of Angels* (Stewart Tabori& Chang 1998), to name a few.

Recent magazine articles that include my work can be found in *Zoom, Camera Arts, Black and White Magazine,* and *Color Magazine*. Previous articles appeared in *PDN, Edifice Progresso, Collectors Photography,* and *Silvershotz*.

My website is www.opalenik.com and my email is elizabeth@opalenik.com.

TECHNICAL The photograph was made with a Polaroid SX-70, the image 'stirred' with a stylus during development.

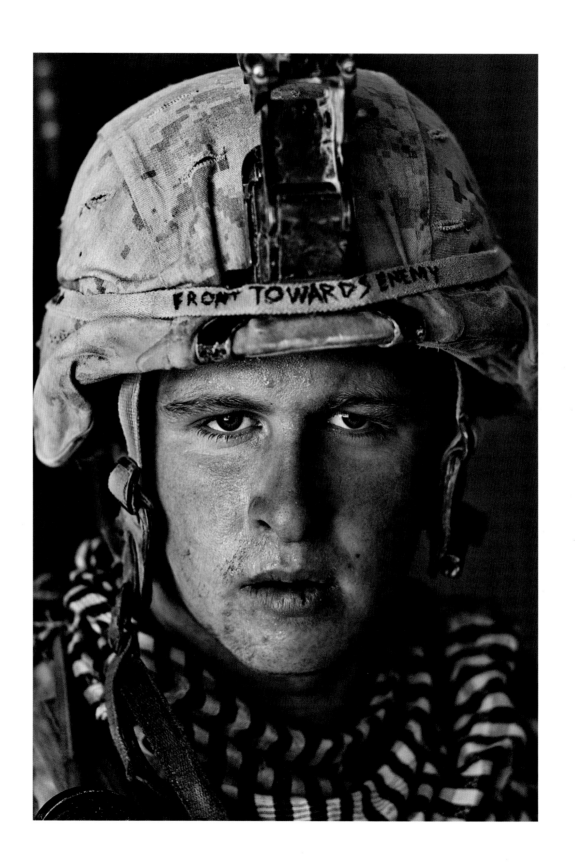

Front Towards Enemy

2008

GEORGE'S ANALYSIS The face of war, so young, so innocent looking, barely shaving, yet there is weariness in those eyes that speaks of fatigue, experience, pain, and loss. Without the story behind the image, we don't know which warzone if any this was. Louie Palu tells us that the young man is an American soldier, but it could have been any modern army. The helmet confirms he's English speaking.

Louie is a photojournalist, not a commercial portrait photographer, but the pose is somewhat formal, with studio-like lighting. The almost formal setup contrasts with the dirt and sweat and cracked lips that imply the end of a mission, the fatigue in the eyes further emphasizing the toll on these young people. To capture so much in a warzone photograph is remarkable, probably more revealing than the soldier might prefer to be seen by those back home.

The message on the helmet is clear in its statement, but hardly in its purpose. Is this a joke played by platoon mates, a philosophy of the soldier, or a reminder to oneself in situations that could quite reasonably make one terrified?

The helmet is askew and shows considerable wear. The uniform has been "customized" with the neckerchief, almost an adoption of local dress. Was this empathy with the local people, or simply a practical way to keep out desert sand?

As a photograph, it reveals the youth of the face, its smooth curves and lack of lines, which might not have been as obvious had the subject been photographed out in the sun. The face is framed by the helmet above, the striped neckerchief below, and the straps of the helmet on the sides: the young man a prisoner to his circumstances.

While one might not think that image quality is an important issue in photojournalism, in fact, when one studies some of the best street, news, and even war

photography, the best work tends to be well composed, the original prints have rich tones, and the images are beautiful in their own way.

THE PHOTOGRAPHER'S PERSPECTIVE This photograph was made after a patrol in Garmsir, Helmand Province, Afghanistan. It is from a portrait series of fifteen images, later exhibited as 20" × 24" prints. I also have audio interviews with most of the subjects. This U.S. Marine was involved in some of the heaviest fighting of 2008 when U.S. Marines launched an assault on a Taliban stronghold in this area that was named the Snake's Head by the British. The forward operating base (FOB) his unit was based in was called Apache North. I traveled to this FOB after covering over two months of bitter fighting in Kandahar and arrived nearly as exhausted as his unit, 1/6 Alpha Company, who were in their last month of a seven-month tour.

I had been ready to go home long before arriving here and I had little will left to take pictures. I certainly hadn't planned to make a series of portraits. I had exhausted all my energy and creativity covering Canadian troops fighting in the green zone outside Kandahar City. I had been experimenting with portraits all summer long but could not make it work for one reason or another. At my wits end to make anything happen visually, one day I took a look into an empty bunker, which had the most remarkable available light. There was little to no power in this combat outpost located in the middle of nowhere. I feel that war can be seen in more than just literal photos of the fighting. War can also be expressed in the haunted faces of these human beings. These portraits became as much an expression of how I felt and looked as they were of the marines in the portraits.

Photographs of people are all about building relationships with your subject. Every day I went on patrol, I would spend two to three hours talking to a marine, getting to know them, opening myself up to them, and over time they opened up to me. After the patrol, as soon as we arrived back at the FOB, we went into the bunker and I took some photographs, the portrait session lasting between five and ten minutes. Back at the base, I would put my cameras away and spend even more time talking to them and getting to know them. This was what I could not make work anywhere else, investing time in your subject. In some cases I spent several days and months getting to know a single marine before taking their portrait.

The writing on this marine's helmet, "FRONT TOWARDS ENEMY," refers to the instructions on a Claymore anti-personnel mine, which is a weapon. Perhaps the marine is referring to himself as a weapon—I never asked. The use of this form of personal self-expression seems to break with the conformist nature of the military. It also has historical roots with soldiers in Vietnam, where the practice of writing statements and slogans on their helmets became popular, as in Horst Faas's image of a similar picture in which the soldier wrote, "War is Hell" on his helmet. I remember the day I took this photo. It felt like the hottest place and day on earth; it felt like hell. After taking this photo, I passed out for two hours on my cot in a pool of sweat.

BIOGRAPHY I was born in Toronto, Canada, to Italian immigrant laborers. I have been a professional photographer for over 20 years (I started at the age of 16 and am now 41 years old). My interest in subject matter has always been in social and political issues. I do little to almost no commercial work and focus completely on documentary projects, mostly long term. The vast majority of my work is seen in a split between editorial platforms such as magazines, newspapers, and books and galleries, museums, and photography festivals. For the past four years I have been photographing in southern Afghanistan. I am now working on a project on the military prison in Guantanamo Bay, where I have been several times. I always

have between four and five projects and essays on the go. Some may last months, and many span several years. The editing is painfully slow as I watch the pictures go from random selections to a body of work. I currently live between Toronto, Washington D.C., and Kandahar, and I live on the road quite frequently.

My major influences have been Don McCullin, Bill Brandt, and the Farm Security Administration (FSA) photographers.

My work has been published in the magazines *Newsweek, Virginia Quarterly Review,* the *Toronto Star,* the *Globe and Mail,* and the *Atlantic.* The monograph *Cage Call: Life and Death in the Hard Rock Mining Belt* was published in 2007 as part of the Critical Mass award.

My website is www.louiepalu.com.

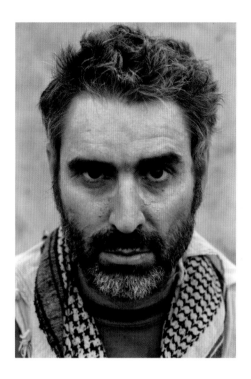

TECHNICAL Nikon D2X, Nikon 50mm f-1.4 lens, shot in RAW format. Converted to grayscale. Photograph taken in bunker made of sand bags, natural light, no reflectors or artificial light.

Melange Un
1997

GEORGE'S ANALYSIS I was very tempted to include one of Freeman Patterson's images of Namibia, but I expressly do not want to leave people with the impression that an image is great only because of its exotic location. In fact, the vast majority of Freeman's images are made within a day's trip from his home in New Brunswick, an area with no soaring peaks or deep canyons.

Some will discount this image as simply being "a manipulation", as if somehow that disqualifies the image from being beautiful. In truth, every photograph is a manipulation to one degree or another. Black-and-white photography, in eliminating all color, creates an appearance totally foreign to the human eye. The act of compressing the ranges of brightness seen in the real world onto a piece of paper is necessarily a gigantic manipulation. Any photograph with shallow depth of field is "fake" because that's not how we see (unless we are hopelessly nearsighted). Monet painted *impressions* of a garden, and while he had the skill to record every blade and branch and to record the overall view—that just wasn't what he wanted.

What we really have here in Freeman's image is a scene that any of us could easily find, probably photographing it at a convenient time with quite ordinary equipment that most of us could afford, so there really is no reason we could not make an image like this. The skill comes from seeing the potential of this clump of flowers and coming up with a photographic technique that will interpret the scene in a way that is meaningful to the photographer. It doesn't matter whether this was one of several techniques tried or a one-off attempt—only that this was the one chosen, no doubt based on previous experience and a sense of adventure.

Looking at the image for what it is, we have a wonderful palette of colors. The technique used produces a painterly effect while at the same time giving an

impression of movement and a feeling that the flowers really are blossoming forth during the exposure. Because of the multiple exposures, as I stare at the photograph, I have a sense of being able to move within and around the flower bed—a feeling that would be difficult to create any other way.

This is a photograph that can be enjoyed as a whole, but it can also be appreciated up close and in detail, looking at the interaction of the colors within a myriad of small areas of the print. The image has impact, mystery, staying power, and a promise of offering more on a return viewing.

This is not the only multiple exposure in the book yet it is totally different from the others. The effects of multiple images depend not only on how many exposures are made, but also how much shift of camera, subject, or lens focal length there is between exposures and how those exposures are handled. This means that one basic concept—that of multiple exposures—can be used in many ways, the photographer matching technique to purpose.

Interestingly, I first viewed Freeman's image on the Web. The colors were strongly saturated. When the full-size image file arrived for inclusion in this book, I realized that Freeman had made a photograph of much softer hues; a quieter, more thoughtful, more peaceful image. The photograph as Freeman intended it showed transparency and subtlety.

THE PHOTOGRAPHER'S PERSPECTIVE The natural world for me is a constant source of awe and wonder and a primary creative stimulus; I feel very much at home in it and nourished by it. Only rarely do I preconceive images; instead I create them as a response to what I am experiencing and seeing and how I feel about it.

This image is as much a document of me as it is of the subject matter. Sometimes I want the subject matter to speak entirely for itself and then I make as few subjective decisions as I can. Other times the subject matter functions as a symbol of what matters to me, often on very deep levels, and then I may manipulate it as a potter does clay. I have a huge series of images on "integration" of which this photograph is one. As I have grown older, the importance of integrating all my life experiences has risen ever more strongly to the fore.

My other primary stimulus is people, also a part of the natural world. Human interactions—feelings and ideas—challenge me profoundly. However, I need and give myself private time and space. Often in such situations my meditation takes the form of making photographs.

I have elected to continue shooting film almost exclusively because I prefer not to spend time sitting at a computer. When necessary I can use Photoshop on scans, for example, but because I endeavor to get everything "right" in-camera, I very rarely use it.

BIOGRAPHY Freeman Patterson has been a freelance professional photographer, teacher of visual design, and writer since 1965. He is the author of 12 books illustrated with his own images and coauthor of three others. Freeman has given thousands of workshops, seminars, and lectures around the world, most particularly in Canada, South Africa, and

New Zealand, but has lived since 1973 at Shamper's Bluff, New Brunswick, Canada, near his childhood home.

Freeman writes, "Participants in my workshops have been and still are the biggest influence on my photography. However, the works of visual artists of every sort (sculptors, ceramic and fabric artists, painters, etc.) and that of performing artists (contemporary and ballet dancers, musicians, etc.) are also extremely important to me. Also, I am quite a voracious reader, and derive special inspiration and guidance from writings in both depth psychology and quantum physics, particularly the relationship between the two.

"I feel strongly that pictures, like music, are for everybody and that the best place in the world to see and make photographs is wherever you are."

Freeman's website is at www.freemanpatterson.com.

TECHNICAL I generally don't give technical information on my photographs or list lenses because it puts the emphasis in entirely the wrong place. To do so would be like a painter listing brushes, oils/acrylics, paper/canvas with a painting, or a novelist prefacing her novel with a statement saying that she wrote on a Dell laptop with an external French keyboard. The important thing for me is that although I was weaving or stitching different parts of my garden together by using multiple exposures (nine), my underlying purpose was to express symbolically my natural desire to "integrate" (my life experiences). I was not dealing with the concept of "integration" in a preconceived, detached, rational way.

It's more important to consider *why* we make photographs (feelings and thoughts) and *why* we make them the way we do than always to be asking or telling *how*. A useful analogy would be that I've long loved riding motorcycles, but I'd much rather describe the sensual experience of a ride than tell people how I learned to ride, what gear I was wearing, and the mechanical details of the machine.

A June Evening, Hornby Island

2003

GEORGE'S ANALYSIS There is a strong tradition in photography of placing oneself at a location that shows potential, often repeatedly and for hours each time, waiting for something extra to happen that will turn *nice* into *special, pretty* into *beautiful,* and *interesting* into *intriguing.* Other times we come across the magic without looking for it and we know it isn't going to last, and so it is a mad scramble to take advantage of it before it's gone.

In Blair Polischuk's photograph, the twisted rock and sand must have seemed to be the potential subject, and the addition of that magnificent sky the gift of magic. Interestingly, it is the lighting from this uneven sky that has caused the landforms to glow, with light reflecting in the pools, and enough directional light to separate and add dimension to the rock forms and sand bars.

The diagonal line of light cloud coming from upper-left is nicely terminated by the cloud group at the right edge and is emphasized by its presence between dark clouds. The cirrus cloud in the upper-right seems to reach away from the diagonal line and balances the light sky on the lower-left. Notice how that horizontal puffy cloud in the middle of the sky has its upper edge outlined in a lighter white, the outlining continuing into the clouds on the right and separating them from what is behind. The same thing happens in the distant hills with the bank of fog separating one set of hills from the larger ones behind, creating a bold dark stripe across the photograph just above the light band of the water in the distance. The line of fog tapers to the right, but one's view seems to be held by the diagonal coming down to meet with the tapering distant shoreline.

Between wet sand and actual pools, there are beautiful highlights in the foreshore. Three main areas of light in the foreground are separated by the dark rock forms, bringing emphasis to the light areas. The largest rock shape (right-middle) is capped by that interesting bank of sand yet separated from it by the horizontal band of wet sand at the base. The dark shapes on the left have more pools as background in the distance.

When we see interesting forms, it is easy for us with our two eyes and moving head to separate elements of the scene. Even while looking through a viewfinder we may kid ourselves into believing the forms will separate in the print, yet when we check the proofs, it's often all one muddle. Only through careful and thorough exploration of the scene can we achieve in a print what we saw while standing at the scene. Careful printing can emphasize separation that already exists but cannot create it de novo. It is true that there needs to at least be the possibility of separating the elements. Sometimes the most important skill a photographer can have is to recognize when this is not the case and be willing to move on or, better, to realize that in different circumstances, elements that now blend will later separate; such as in different light, after rain, or even at a different time of year.

Here, the combination of a magnificent sky, a fog bank, water, ponds, and wet sand twisting between rocks have come together to make a beautiful photograph.

THE PHOTOGRAPHER'S PERSPECTIVE f/64 and "be there"....

Actually it was more like f/22. By the time the tide rolled out it was 9:20 p.m. and too dark to focus on my 4×5. A Pentax 67 was the backup plan, allowing me about five minutes to run about the beach making twelve different exposures.

I recall staring up at the stripe in the cloud and then down at the ever-darkening foreground imagining how it would look in print. A friend approached me while looking at the same scene and asked, "Hey Blair, what are you taking a picture of?" I love it when people ask me that! I proceeded to point out all the areas of the scene that I would bleach in the darkroom: the highlights on the rocks, the tips of the clouds, the approaching weather, the fog bank, and of course, the stripe in the cloud. A few weeks later I gave my friend the first 8" × 10" print.

Of the twelve exposures made that evening, this particular arrangement made the cut and has since earned a spot in my solo album (read coffee table book) that I hope to publish before I hit 50 (I've got 3 years to go).

My work has been published in *B&W* and *Photo Life* magazines.

BIOGRAPHY In my previous life (the 1980s), I was a full-time professional musician. I am constantly reminded of how closely related music and photography are and I consider the act of crafting an image to be equal to that of writing and producing a piece of music. My darkroom is the recording studio; my images are my songs.

Today in my professional life I wear many hats, all of which support one another and all related to photography.

I have the privilege of teaching film, darkroom, and business as part of the Professional Photography Program at North Island College on Vancouver Island.

My other hats include that of fine art photographer under the name Silverwork Studio & Gallery (www.Silverworkstudio.ca), and I am owner and senior "photoboothologist" of Island Photobooth, a Vancouver Island based company offering custom branded digital photo booths for rent at special events.

I attribute much of my development as a photographer to the images and writings of Edward Weston and Ansel Adams. Two individuals who had a significant impact on my photography, specifically my printing, are Bruce Barnbaum and Don

Kirby. These guys are giants in their field and I feel blessed to have learned from them.

My website is www.polischuk.com.

TECHNICAL I used a Pentax 6×7 for this photograph, although I use a 4×5 for much of my landscape work. I work exclusively in film and I print my images by hand in a chemical darkroom. Long live the silver print!

A June Evening is one of my most challenging images to print, and as fate would have it, it is my best-selling print.

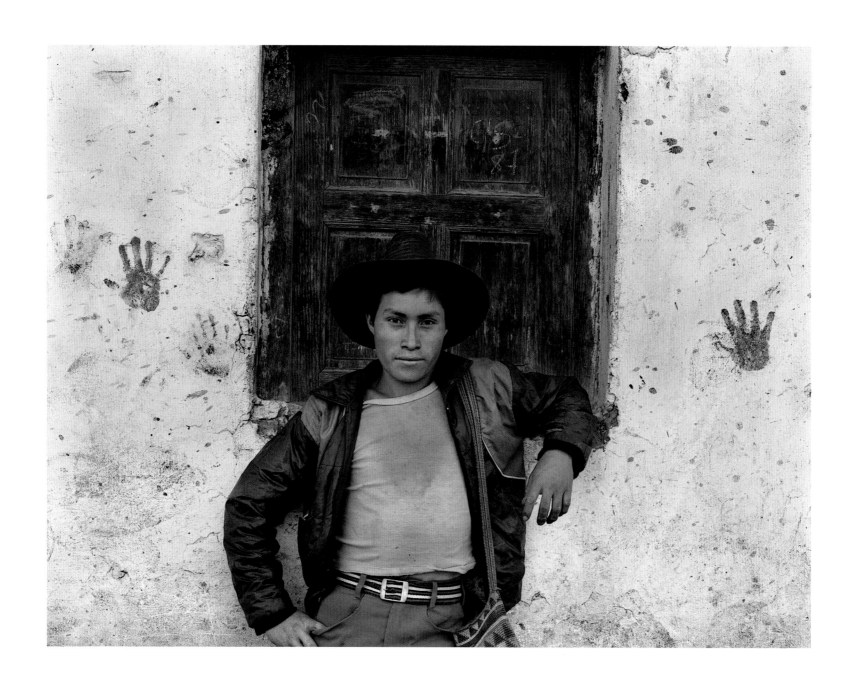

Vincente, Nebaj El Quiché

1990

GEORGE'S ANALYSIS Craig Richards has been photographing the people of Guatemala since 1987 having first visited in 1978. We are not talking about a drive by, snapping tourist here; this is serious commitment. Vincente doesn't look like the kind of fellow to please a tourist.

There is a lot to this apparently simple image. The expression and the pose suggest a mix of emotions from cocky to resigned. The shuttered window at a slight angle helps in this interpretation. The two handprints are mysterious: Native culture? Blood? Gang related? Who knows?

The sweat stained T-shirt implies hard work, poverty, or perhaps an "I don't give a damn" attitude. For all the exotic Guatemalan locale, the North American–style jacket suggests he isn't far removed in values and interests from any young person on a North American street.

The cowboy hat perhaps implies a rural lifestyle. I want to know the story of this Vincente. How old is he, what does he do for a living, and what were his circumstances as a child?

Being photographed by someone with a view camera is quite a different experience. The photographer typically comes out from under the dark cloth and is standing next to, but not aiming, the camera—a much more comfortable relationship with the sitter, and one that could be emulated with a tripod and any ordinary camera with cable release. It's a lot more impressive, though, when you set up a view camera—the whole leather bellows, cocking the lens, dark cloth, and time taken suggesting to the sitter that no effort is being spared, that this photographer thinks the sitter worthy of all this effort.

Of course, the photographer has to form a relationship with the sitter. One can hardly "drive by". Permission must be sought, cooperation obtained, and heaven forbid, one might even feel obliged to carry on a conversation with the subject. A wholly different experience from the usual tourist shoot.

The open shade and soft lighting reveal full detail: the dark brim of the hat perfectly frames the face. The face is further backed by the relatively dark shutters and the dark jacket against the light but fully textured wall. It is interesting that Craig has chosen to center the face, leaving the building and shutter looming over him, the figure relatively small within the photograph, perhaps implying that he is a victim of his circumstances rather than dominating them. The shoulder bag is the only element that is truly indigenous.

The tilted window matches the lean of Vincente and looks to have been real rather than a mistake created by a carelessly tilted camera, not the kind of thing 4×5 photographers are prone to let happen. It implies crude construction, function over form, and seems appropriate to the weather-beaten wall and shutters. The three handprints are nicely balanced—the two on the left just above and just below the face, the one on the right at the same level as the face, and the two main handprints are not on the same level.

On one level this is a fairly simple portrait, yet we have been able to infer a considerable amount about the person from the photograph. It may not even be that all the inferences are accurate, but as this image is not being used for a job application, an election poster, or an online dating site, it is not germane. What matters is that we find this an intriguing young man.

THE PHOTOGRAPHER'S PERSPECTIVE Little did I know in 1978 during my first visit to Guatemala that I would return nine years later to start a photographic project. The project would become an obsession, consuming most of my time and thoughts for over 15 years. I made over 20 photographic trips to Guatemala, producing over 2,000 negatives. Over the past several decades more than 100,000 people have been killed, went missing, or have been displaced in Guatemala. My admiration for the dignity of the Highland Mayan people of Guatemala, an intact indigenous population fighting for its existence, increases with each trip.

This photograph was taken in Nebaj El Quiché, a part of what is known as the Triangle Ishil, an area where much of the guerrilla activity has taken place. I was walking out of town one morning when I came upon a wall with handprints. There was no one in the street and I really wanted an interaction between a person and the wall in the photograph, so I knocked on the wooden window to see if anyone was inside. I didn't get an answer. I went around to see if there was anyone in the yard. No one was there either, and when I returned to the street the young man in the photograph was leaning up against the wall with his left arm propped on the window ledge. I asked him to please not move at all as I would like to take a photograph of him. He agreed, I quickly set up my 4×5 camera, and I took several negatives before anything changed. For me, the handprints symbolize all that had been going on in Guatemala— the disappearances and the killings. His cockiness and strong

glare were the exact match for the wall and for what I wanted to say. I purposely cut off his right hand at the bottom of the photograph because for me, he was the handprint of the present moment.

Normally I would carry a Polaroid with me so I could give the people I photographed a print, but I had run out of Polaroid film. I asked him his name and he told me it was Thomas. I said I was going to return in several months, and that I would look him up and give him a print. He said that he lived in the area. He left as quickly as he arrived and I could not help feeling that he was uncomfortable. Three months later I returned with the print. I asked several people where I could find Thomas and nobody knew him. It was only upon showing the print did people tell me that this was not Thomas but Vincente. People would still not tell me where I could find him. I was confused. Later that evening the young man came to my hotel as he had been told I was looking for him. He had done a lot of inquiring as to who I was and was reassured by people that I had photographed on other trips and given them prints too, that I was not a danger. When I asked why he had given me a different name, he replied that usually when strangers inquire about or are looking for someone, that person soon disappears.

"The photographer has to go directly to where a person exists, to enter his private theatre or his essential reality, with all of its vulnerability. He has to become one with the drama unfolding before him—and sometimes with the anguish and terror that is a part of it. Kindness is the key, and it is extraordinary that when the key is turned, much more than the simple game of appearances opens up to us. Suddenly the person and all that surrounds them take on greater meaning, as though a light were shining from within."
Hans Namuth, Los Todos Santeros

For the first several years of the project in Guatemala I was constantly asked the question "How are you able to connect and create the images in Guatemala?" At that time I couldn't answer the question and I guess that I was scared that if I answered it I would no longer have the "luck" that I was having in Guatemala. A fellow photographer and friend, Chris Purcell, joined me on a trip there in 1990, the year of the photograph of Vincente, and after the trip sent me the book of photographs by Hans Namuth as a gift. In the book Hans talked about his photographing in Guatemala and the quote above came from his writing. Upon reading it I related with what he expressed and realized that this was exactly how I approach people and my photography. It is a quote that I feel from the bottom of my heart and one that is woven into all aspects of my life.

BIOGRAPHY I was born in Edmonton, Alberta, Canada, in 1955. In 1980 I moved to live in the Canadian Rockies. For the past 30 years I have called these mountains home and I am one of the more serious and committed photographers of Canadian Rocky Mountain subjects. My work has been the subject of some 50 solo exhibitions and another 40 group exhibitions at art galleries and museums throughout the world.

For 30 years I have used a large format 4×5 camera combined with the traditional silver gelatin printing process. My interests as avid hiker, photographer, and mountain culture aficionado have coalesced to form an engaging body of work. My photography can be seen as a fusion of the historical and the contemporary.

I have been a guest instructor teaching photographic workshops in Canada, the United States, Mexico, Europe, and Africa. I have traveled extensively in mountainous areas around the world, photographing, lecturing, and giving presentations of my work. I am Curator of Photography at the Whyte Museum of the Canadian Rockies located in Banff.

Since 1995 I have worked on numerous projects around the world for the Museo Nazionale Della Montagna that include

Author's note:
I have been fortunate enough to attend one of Craig's workshops. It was a highlight of my year and a great impetus to my photography.

Canada (Rocky Mountains and Yukon), Guatemala, Italy (Valle di Susa), Uganda (Rwenzori), the United States (Alaska), and the Czech Republic (Teplice).

The mountains pose a universal paradox, an ever-present reminder of nature's power and its fragility.

My influences are Yousuf Karsh, Irving Penn, Ansel Adams, and Bruce Barnbaum.

Publications include:

Theatro Di Pietra • Kamenné Divadlo • Theatre of Stone (Nazionale Museo della Montagna, Duca Delgi Abruzzi, Club Alpino Italiano, 2009).

Agua: Imågnes de España, Water: Images of Spain (Agbar Fundacio Agbar, Museu Agbar De Les Agues, 2008).

I Popoli Della Luna • The People of the Moon, Ruwenzori 1906– 2006 (Nazionale Museo della Montagna, Duca Delgi Abruzzi, Club Alpino Italiano, 2006).

Viaggio All'Oro, L'Immaginaro Del Klondike (Nazionale Museo della Montagna, Duca Delgi Abruzzi, Club Alpino Italiano, 2005 — 2nd Edition).

Craig Richards, The Canadian Rockies (Book, Sawback Press, 1994).

And numerous other publications.

My website is located at www.craigrichardsphotography.com.

TECHNICAL I shoot with a 4×5 Linhof Technika and TRI-X film, processed in HC-110. I print on traditional silver paper.

Dancing in Bubbles

2005

GEORGE'S ANALYSIS One of the hardest parts of creative photography is to come up with an original idea. All subjects have been photographed before, and no matter how clever the idea, probably someone somewhere has already done it. That said, if we can do it in our own way, different, perhaps better, and in our own style, then it doesn't really matter whether we were first with the idea. Perhaps when serious images were made with large-format cameras with leather bellows, sitting on wooden tripods, and using film that was developed by hand, sheet by sheet, you might be first with an idea. Now, with literally millions of people photographing creatively, being first simply isn't possible or even relevant.

I don't know if Ryuijie was the first to try photographing flowers frozen in water. What I do know is that it works wonderfully well. The tonalities in the ice make a delightful and surprising backdrop for the flowers, at the same time rendering the flowers more abstract, more painterly. Lit from behind, the images are like a shadowgram, but with a lot more detail and delicacy and a full and beautiful range of tonality.

The whole idea of photographing flowers in black-and-white allows us to concentrate on form, texture, transparency, and detail, where normally the color would overwhelm all else.

The image has a sense of movement, which is odd given that everything is frozen solid. There is balance to the positions of the two buds in relation to the off-center flower; the buds being at different levels, one pointing out, the other hanging down. The lines in the ice seem to be an extension of the flower and pull the composition together.

The bubbles appear to be emanating from the drooping bud. The image is remarkably simple, the look somewhat like a woodblock print on handmade paper. Whether this has anything to do with Ryuijie's ethnicity he will have to say, but I definitely feel an Asian connection to this image.

So what we have here is a classic subject (flowers), a unique approach (freezing them in blocks of ice), and lovely tonalities in a pleasing arrangement forming a simple design. It sounds so easy. I am convinced it is anything but.

Ryuijie has been able to capture the frailty of the poppy flower in the tissue-thin petals, almost transparent and exquisitely delicate. I can't but feel that the petals are ready to blow away in the wind at any moment.

THE PHOTOGRAPHER'S PERSPECTIVE In December 2003 I began working on a new project, envisioning botanicals frozen in blocks of ice, like the small fragments of nature frozen in a piece of amber. I went shopping for materials. Within a few days I was photographing while overcoming some technical problems. By week's end I had my first prints and I was very excited.

It was soon the end of January and I had completed a dozen 16" × 20" prints. I was having a show at the Center for Photographic Art in Carmel in February and Dennis High, the director, liked what I was doing and included the *Ice Forms* in the show. The response was very encouraging and I felt I was heading in a new and exciting direction.

Through 2004 I continued my work on the *Ice Forms*, finding new materials to freeze and photograph. The prints are all split-toned silver gelatin. I wanted to make them larger than life, so I decided to use silver gelatin rather than platinum, the cost of making 20" × 24" platinum prints being prohibitive.

I did want to maintain a warm color, so I borrowed a technique from a friend, Hal Gage, a fine photographer who taught me how to create a split-toned effect using Kodak Poly-Toner

and a water bath. I am now printing most of the Ice Forms as 20" × 24" silver gelatin prints, although due to requests, I have also been making platinum prints in 4" × 5" and 10" × 12" sizes. The Ice Forms are an ongoing project, so expect new images in the future.

BIOGRAPHY I was born in Otaru, Japan, in 1950. As a young child I moved with my family to the United States and subsequently lived in many places, from Hawaii to New Hampshire and again in Japan, until my father retired from the military. Throughout my childhood, I showed a serious inclination toward the arts. This interest began to materialize during my own military service.

While stationed in Guam, I learned underwater photography while pursuing my long-time interest in scuba diving. After my tour of duty, I came back to the Monterey Peninsula

where I attended college and began a successful career in lithography. It was in Monterey that an exhibit of Jerry Uelsmann's photographs inspired me and propelled me into the practice of fine art black-and-white photography. I have steadfastly pursued my own photographic vision for over 30 years and have acquired a reputation for my platinum/palladium prints in addition to my traditional black-and-white work.

In October 2005 I returned to my first loves, the abstraction, creating panoramic visions of the natural world. This work continued for two years, resulting in 5" × 10" platinum prints of the landscapes and found abstractions. My newest series of photographs are entitled *Kanchi, The Quiet Place,* a series of platinum prints taken underwater.

Most of my influences are local photographers—Brett Weston, Wynn Bullock, and Oliver Gagliani—and some East Coast photographers that were working in the mid 1970s when I started photography: Minor White, Harry Callaghan, and Paul Caponigro. Minor White was the only one I never met. The abstraction and the perfectly printed photograph still holds a lot of magic for me.

My work has appeared in the magazines *View Camera, Photovision, Camera and Darkroom, Black & White, LensWork, Rangefinder,* and *Focus.* I have published three books—*Ryuijie: Photographs* (Fresh Silver Publishing, 1991), *Time and Place* (PHOT Photographic Publishing, 1998), and *Fragments of Time* (PHOT, 1999), along with smaller catalogs. My first portfolio, *Ryuijie: Ten Photographs,* was published in 1990; and my second portfolio, *Ryuijie: Portfolio Two Platinum/Palladium,* was published in 2002.

More information and images can be found on my website www.ryuijie.com.

TECHNICAL The ice forms are created in my freezer. The method is simple: I use an 11" × 14" stainless steel tray that I fill with water 2 to 3 inches deep. I place the botanicals in the water and press them under the surface. A little Photo Flo solution aids in breaking the surface tension of the water.

Some plants have a tendency to float, so I place the plant into a thin layer of water that freezes quickly; then, once it's frozen in place, I cover the plant with more water and freeze again.

I photograph with a 4×5 Galvin view camera and a 150mm Sinar lens. The first photographs were done on Kodak Ektapan film (no longer available). I am now using Ilford FP4 PLUS. Once the plants are frozen, I remove the ice from the tray and prop it up on an acrylic stand. I backlight the block of ice with a Bowens 4000 strobe. Using a framing card I begin searching for photographs within the ice. I have always enjoyed the practice of creating order out of chaos. The film is developed in D23 for 12 minutes. This has been my developer of choice for over 30 years.

The prints are made on 20" × 24" Ilford Multigrade IV paper. I print with a Beseler 45MCRX enlarger, 150mm EL-Nikkor lens, and an Ilford 500H variable contrast head. The paper is developed in Dektol 1–3 for 3 minutes. They are fixed and toned in Selenium then given a short wash. At the end of the wash they are toned again. To get their unique color, they are split-toned in Kodak Poly-Toner 1:32 (Poly-Toner is no longer available, so I now make a good substitute). I place the photograph in the toner for 30 seconds and then into a water bath, with no agitation. Toning can take up to 10 minutes. I then wash the print for 1 hour.

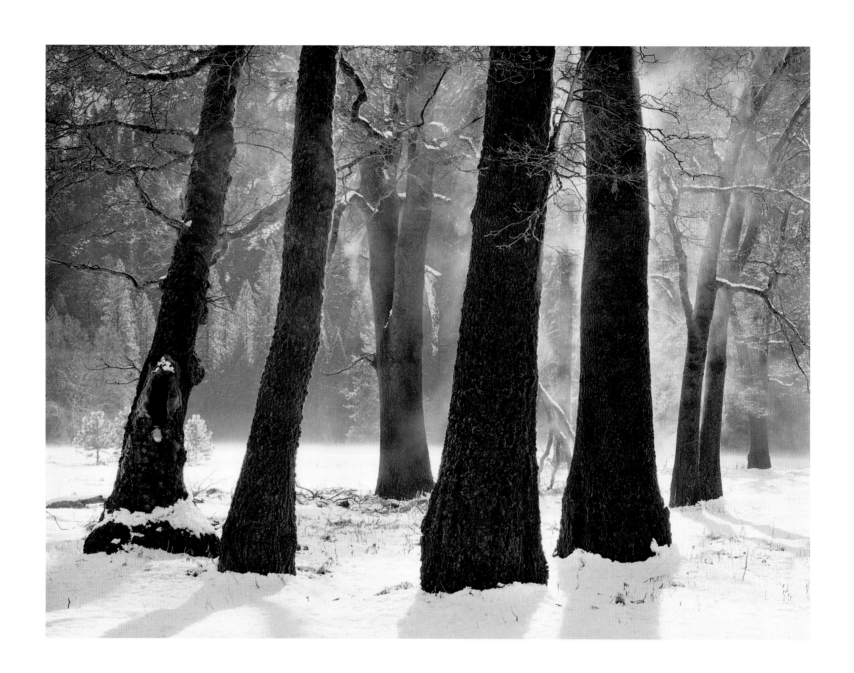

Black Oaks, Morning Mist, Yosemite Valley, California

©1984 John Sexton

GEORGE'S ANALYSIS This photograph by John Sexton is an excellent example of how photographs can work on multiple levels. At a basic level, we can talk about the attractive arrangement of two nearby trees, then a middle-ground one, then two farther trees and more trees behind that, fading with distance. The middle-ground tree in the center and the last nearby tree on the right are vertical while the others lean to the right, making a pleasing alternating arrangement. Of course, it is the mist that makes the photograph, giving the trees their distance, separating the near from the far. Unlike many photographs that show atmospheric conditions, the mist is uneven and thin and brilliant sunlight pours through.

On another level, consider the splay of the branches. Note the relative positions of the bases of the trunks. Do you think that it is coincidence that the right-hand tree exactly touches the nearby second tree from the right at its base, that there is just enough space between the two nearest trees for the sunlight to sneak through and separate the two shadows in the foreground, or that the middle tree in the distance barely overlaps the nearest tree of all? Alignments like these happen one of two ways. Either a virtual bell goes off in the mind of the photographer as they happen to stand in the perfect place and moving anywhere else wouldn't work as well or, far more commonly, the photographer worked damn hard to get to this position, moving vertically by bending knees or kneeling in the snow or standing extra tall (perhaps even bringing a step stool), by moving left and right, and by approaching and retreating from the subject. Of course, the photographer cannot do one movement at a time. The height that works best 20 feet from the

subject may not work compositionally when they're 25 feet away and the correct left/right positioning won't be the same when they crouch.

Notice the radial pattern of the shadows on the snow and how they work with the edges and bottom corners of the photograph. Consider the relation of the upper branches with the top border of the print, the angling tree on the right with the top right corner, and the branches on the top left and the light areas of the background near the upper-left corner.

The mist coming off the trees in the sun makes this scene step out of the ordinary, making this place magical—we have a photograph of air and of light. We can admire the photograph on a technical level; it has superb detail in the shadowed trunks while maintaining subtle highlights in the snow. There is detail everywhere in this photograph.

On another level this is simply a beautiful photograph, of light and shadow, solid tree trunks and ephemerally visible air. At a deeper level, we can contemplate the meanings and implications and metaphors expressed in the near solid trunks and more distant fading trees, about light and dark, shadow and sun, and by extension other opposites. We can consider how long the trees have been here and how quickly this mist is going to change and disappear.

The background forest is an even shade of gray, except for the scattered highlighted evergreens that nonetheless do not distract from the foreground scene. Often the most important thing a background can do for a photograph is to not interfere or compete with the main subject. There is texture in the foreground snow as there is in the tree bark, while in the distance the tones are less textured and the line between field of snow and background forest is blurred, even through the trees in the forest are sharp—either wind or mist blurring the detail and again simplifying the photograph.

Some of the power in a photograph like this lies in the fact that it isn't of some magnificent and exotic scenery. These trees are in Yosemite but could just as well be in a city park.

It is possible that someone standing 30 feet from the photographer might have been completely unaware of the magic of the light and the effect on the trees and the rightness in the arrangement of the picture elements.

THE PHOTOGRAPHER'S PERSPECTIVE Over the years I have often been asked, "What makes you stop and make a photograph?" This is, of course, a good question and, like most good questions, is not easy to answer.

When I decide to make a photograph, it's almost always a confluence of events. First I need to have some type of interest or relationship with the subject. Second, and of nearly equal importance to me personally, is the quality of light. Is the light working to complement the subject and create an interesting image? If the light is not appropriate, the photograph will not be successful. As Ruth Bernhard, the wonderful photographer said so many times, "A successful photograph must be an intensification of the photographer's experience when making the image."

This photograph was made in El Capitan Meadow, one of my favorite locations in Yosemite. Yosemite is a remarkable place, and I have spent a great deal of time there over the years. I love returning to the same place to see how it changes, and also how I change.

The day this image was made was a rather bleak, cold, and overcast day. I had visited a few different locations around Yosemite Valley, looking for something that attracted me. I was walking with my 4×5 view camera when the sun suddenly broke through the cloud cover about midday. As the warm sunlight struck the black oak trees, steam began to boil off of their trunks. In addition, the previous night's snowfall, which was on the branches, began to plummet to the ground. I knew from experience this situation would last only a few moments. I scrambled for a position that looked favorable to me and set up the camera. As much as a view camera can be

a contemplative and methodical tool, such was not the case with this image.

I often find I organize my photographs most effectively when I do *not* think about things. I had no opportunity for rational analysis of this subject. I had to work quickly and intuitively.

The contrast was quite high and required a reduction in development. The negative is not an easy one to print. In fact, most of the photographs I like, for one reason or another, are not easy to print.

When making this image I felt as if a number of things somehow synchronized to yield a photograph that exceeded my expectations. I think I can honestly say that I've never made a successful photograph where good fortune has not been a part of the process. As my friend and mentor Ansel Adams used to say, "The harder you work, the luckier you get."

BIOGRAPHY John Sexton was born in 1953, and resides in Carmel Valley, California. John is a photographer, printmaker, author, and workshop instructor. He has spent more than forty years refining his photographic skills to produce luminous, subtle black-and-white photographs, primarily of the natural environment.

John's most recent book is *Recollections: Three Decades of Photographs,* a retrospective volume, published in 2006 by Ventana Editions. John's previous books include *Quiet Light,* a monograph representing 15 years of his work, and *Listen to the Trees,* which were published by Bulfinch Press/Little, Brown and Company, along with *Places of Power: The Aesthetics of Technology* published by Ventana Editions.

He is Director of the John Sexton Photography Workshops program, and has conducted hundreds of workshops for other programs in the United States and abroad, emphasizing printing technique and mastery of the Zone System. Some of the other programs include: Anderson Ranch Arts Center, The Ansel Adams Gallery, Maine Photographic Workshops, The University of Wisconsin, as well as The Palm Beach Photographic Workshops.

On top of a very full schedule of photography and workshops, John provides informative and entertaining lectures to photographic and professional organizations, as well as to colleges and universities, discussing the aesthetic and technical aspects of fine black-and-white photography. He has presented lectures for, among others, George Eastman House, Center for Creative Photography at the University of Arizona, Boston University, Los Angeles County Museum of Art, Museum of Photographic Arts, and the Seattle Art Museum.

John is a consultant to Eastman Kodak Company and other photographic manufacturers. He worked as both Technical and Photographic Assistant, and then Technical Consultant, to Ansel Adams from 1979 to 1984. Following Mr. Adams' death, Sexton served as Photographic Special Projects Consultant to The Ansel Adams Publishing Rights Trust. His finely crafted large format photographs have appeared in numerous exhibitions and publications and are included in permanent collections and exhibitions throughout the world.

John received a Bachelor of Arts degree, cum laude and with departmental honors, from Chapman University, and an Associate of Arts degree in photography from Cypress College. In addition, he attended a number of photography workshops in the 1970s. He has studied with, and been influenced by, Ansel Adams, Brett Weston, Wynn Bullock, Ruth Bernhard, Paul Caponigro, and others.

My website is at www.johnsexton.com.

TECHNICAL Photographed with a Linhof master Technika 4×5, TRI-X film, 120 mm. lens, 1 second at f/45.

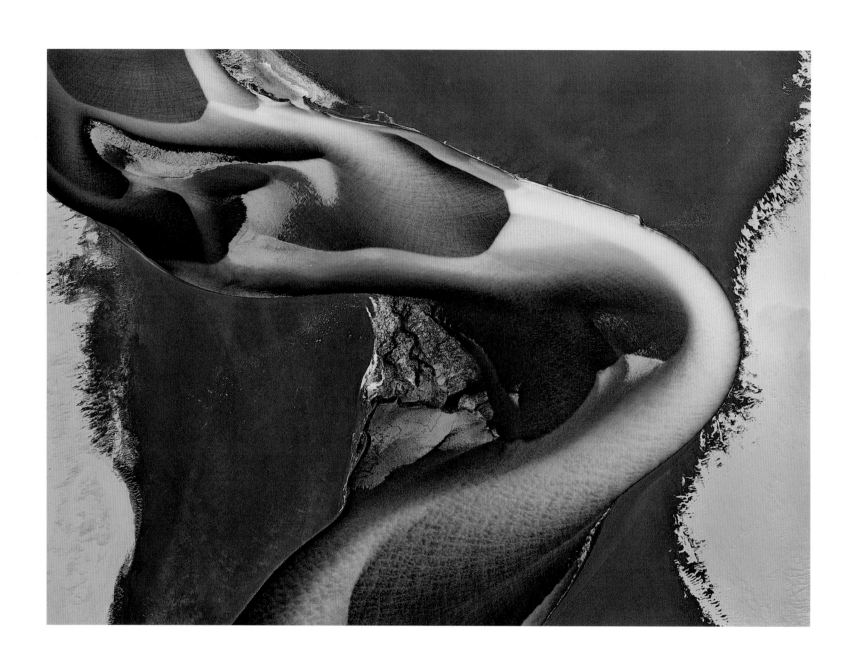

River, South Coast, Iceland

2009

GEORGE'S ANALYSIS People have been photographing from the air since the invention of the hot air balloon. Even kites have been used as a platform. When you look out from an airborne position, you can see the landscape on a grand scale—follow where glaciers have scored the land, see the entire network of channels carved by a river over millennia, and appreciate the patterns of farming and the knots of freeways. When the light is low, subtle undulations stand in sharp relief, and signs of man's ancient presence become clear, as old roads and hidden pathways suddenly become visible. Even the meandering patterns of cattle in a field become interesting. When shadows are long, they become more substantial than the objects casting them and become subject themselves.

When instead of looking out, the photographer looks downward, the landscape becomes an abstraction; fewer clues as to scale and often difficulty in even identifying what it is we are looking at make the images become a puzzle to be solved if possible, or simply wondered at if not. It is simply not a viewpoint most of us are used to seeing. Except briefly when banking sharply in a turn, even pilots seldom see this kind of perspective.

What really surprises is the incredible color that can be seen from the sky and while looking down. The subject or scale of this aerial image by Hans Strand is not immediately obvious. I happen to see an upside-down mermaid, her green scales ending in a large fin, or perhaps an upright dancer, bending backwards with arms stretched behind, flowing across the stage.

How exciting to find this flowing color form against the neutral background, the pale gray borders framing nicely on either side. The patterns, textures, and shades of the green flowing form are magnificent and would be enough to bring

one back to the image over and over. I love the flow from orange/yellow to pale green to green.

So why does this photograph capture my attention when there are many books of aerial photography on the market, and even Hans himself has dozens of lovely aerial photographs to choose from? Even if the curves didn't remind me of the female body, they are an intriguing shape. I like the way they flow from the upper-left corner to the middle of the bottom, first sweeping almost to the right middle edge. This is a shape that often works well in photographs, whether it's a stream from zero altitude or a path winding into the distance.

Photography is capable of recording fine detail, texture, and patterns in a way not found in other art form, and Hans's photograph takes full advantage of the medium, showing us incredible detail, patterns on patterns, and gradual shifting of hue and tone that makes us want to inspect the image, nose to print. I think it would be wonderful to see a really big print of this image, but perhaps it is better to let our imaginations fill in the details.

The shadings of color on what is essentially a flat plane give the image a three-dimensionality often missing from aerial photographs, the color figures standing out from the gray background with a roundness that cannot be real but significantly adds to the image.

The curved shape of the flow gives the image a great deal of energy that other shapes would not, and the study of shapes and lines as energy and dynamism in photographs would be rewarding both for photographers and lovers of photographs.

THE PHOTOGRAPHER'S PERSPECTIVE Since the year 2000, I have been visiting Iceland every summer to do aerial photography. Nowhere else on earth have I found such complex formations and colors as on this volcanic island in the middle of the Atlantic. On the south coast there is a long sandy stretch called Landeyarsandur, and here many rivers enter the Atlantic. The estuaries are often very complex deltas with extraordinary colors. The yellow/orange/red comes from natural iron oxide (rust), which is extracted from the volcanic soil. The rivers also contain a lot of silt from the glaciers of the high country, giving them a milky character. As the speed of the water drops, the iron oxide mixes with the silt and sediments on the river banks, turning them into intense orange. I have flown over Landeyarsandur many times, always finding new formations and colors. The estuaries are in constant transition due to shifting water levels and pounding storms from the North Atlantic. What you observe one day you can almost never see again. The river photographed for this image especially attracted me with its form and color. I made the composition very tight, just containing the bend of the river framed by surrounding gray sand. The photograph was taken from the open window of a high winged airplane, a Cessna 172 Skyhawk, from an altitude of about 1200 feet.

BIOGRAPHY I was born in 1955 in Marmaverken, Sweden. After a nine-year career in mechanical engineering, I decided to make a dramatic change to devote my life to landscape photography, which had long been my hobby and great passion. It was a change I have never regretted.

I have always felt drawn to the untamed and unmanipulated that one finds in nature. The wilderness is the mother of

all living things. It is always true and never trivial. Over the years I have had the entire world as my workplace, photographing everything from the vast expanses of the Arctic to steaming rainforests and dry deserts.

My work has been displayed in numerous exhibitions and published in many international photography magazines. I have received several awards for my photography, including the Hasselblad Master Award in 2008. I have published three books with landscape photographs and I am currently working on two new book projects: one on the Arctic and one on Iceland.

I live in Hägersten, a southern suburb of Stockholm, Sweden, with my wife, Carina, and daughter, Johanna. Apart from photography I have a great passion for classical music and am a lover of French wines.

I sell my photographs as limited edition fine art prints. I use both inkjet and Lightjet printers for my prints.

Early inspirations for my development as a photographer were David Muench, Eliot Porter, and Henri Cartier-Bresson.

I have a website at www.hansstrand.com.

TECHNICAL I used an 80mm standard lens on my Hasselblad H3DII-50, medium-format digital camera. Exposure was f/4.5 at 1/800 sec, ISO 200. I am very concerned to make my images authentic, and therefore I used no extra color saturation when I made the 287 MB 16-bit TIFF file.

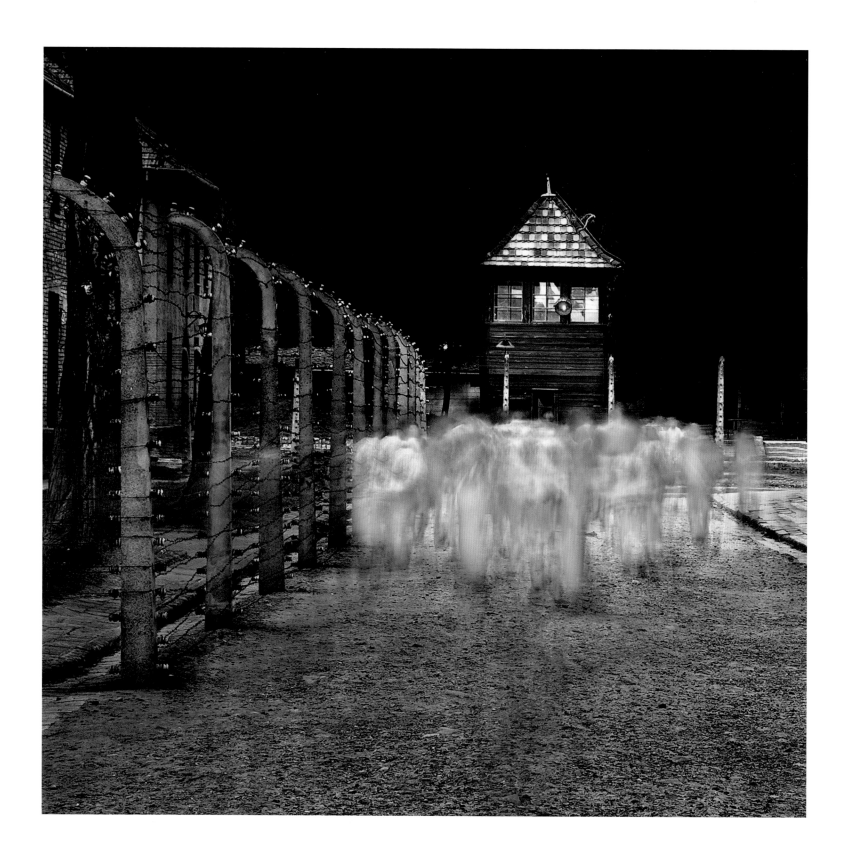

Auschwitz # 14

2008

GEORGE'S ANALYSIS How do you photograph a place of evil, a place where millions died? A simple record of the facility hardly conveys the history of the place. Images of starving inmates liberated near the end of World War II were certainly effective and helped places like this become memorials to those who suffered and those who died, yet here we are in a different century, a different millennium, and even grandparents remember little if anything of the horrors. What an effective way this is — to photograph the "ghosts" of the people who were shipped to camps like this by the trainload.

One hardly needs the image title to know that this is not a good place. Even the ghosts are not required to know that this is some sort of prison, and that with an unprotected electric fence, human life is not important to the keepers. However, we do have the title, and the ghosts remind us of the millions who never left, who died for little more than jealousy, fear, and ignorance.

It isn't entirely clear how Cole was able to record the ghost figures, but it has been remarkably effective. I feel that if I could focus just a bit better, I'd be able to see individuals, but I can't quite focus, and this reinforces the sense of loss, of waste. Even the foreground has telltale signs of prisoners, faded to almost nothing as we put the past out of mind. The black sky and dark buildings are ominous—the guard tower a symbol of evil, holding back the mass of people.

Photographs like this make us uncomfortable. In one way they are far removed from the pristine landscapes by photographers like Ansel Adams, yet those images too had a message—"This place is worth preserving"—and whether the goal is to cause you to remember, to feel guilty, or to make you sad, the message is still stronger when the usual tools of good photographs and composition prevail. Of

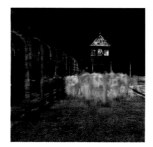

course, Ansel Adams also photographed politically sensitive subjects, photographing interned Japanese Americans at Manzanar.

The ghosts are all the more effective against the simple uncluttered ground they stand on, the fence and electric insulators shown against the dark background in a menacing way, and the guard tower with its simple black background. The overall image is dark, stark, and somber, yet the ghosts show light—perhaps symbolizing guilt and innocence, evil and good.

The tonalities of the ghosts are very effective, almost pretty, and that thought makes us even more uncomfortable, knowing that it is a totally inappropriate thought in viewing an image like this.

More often than not, a strong design and an uncluttered image will be more effective in getting one's message across.

This is a powerful and disturbing image in which technique has been used, not as an end in itself, but simply as a tool. A very effective tool.

THE PHOTOGRAPHER'S PERSPECTIVE What can be said about Auschwitz and Birkenau that hasn't already been said? What can be photographed at those sacred places that hasn't already been photographed?

As I thought about what had occurred there, I wondered how any human could do such inhumane things, and then I recalled *The Mysterious Stranger* by Mark Twain. In this story, a young boy named Seppi is talking to Satan about a man who had brutally beaten his dog. Seppi declared that this man's actions were inhumane and Satan responded, "No, it wasn't, Seppi; it was human—quite distinctly human."

I had not intended to photograph during my tour of the camps, but after being there a few minutes, I felt compelled. With every step, I wondered about the people whose feet had walked in exactly the same footsteps. I wondered if their spirits still lingered there today. And so I photographed ghosts.

For several years prior to visiting Auschwitz I had been using long exposures, but mostly with static objects. While I had developed a system that allowed me to fairly quickly compose and execute long exposures, I had never attempted it with unaware and moving objects (people) or with only 45 minutes to create a series.

My inspiration was the haunting, almost crippling realization that I was walking where many had walked—and died—before me. This got me to thinking about their spirits or ghosts—wondering if they were still there—and hence the concept was born. I had seen other photographers' works of the camps, and they always impressed me as cold and dead, treating Auschwitz like a historical museum and photographing the objects left behind.

I didn't want to portray the camps as dead but as a reminder that people lived there, died there, and perhaps were there today.

BIOGRAPHY I was born into a world of black-and-white images. Television and movies were in black-and-white, the news was in black-and-white, and the nation was still segregated into black and white. My childhood heroes were depicted in black-and-white, and these images were an extension of the world, as I knew it.

When I was 14, life changed. While living in Rochester, New York, I read the biography of George Eastman and it inspired me to purchase a Sears photo developing kit. I can still remember the magic as that first black-and-white image appeared in the developer. I was immediately liberated, no longer consigned to just look, I could now create.

I have always worked exclusively in black-and-white. For me, color records the image, but black-and-white captures the feelings that lie beneath the surface.

My recent work includes *The Ghosts of Auschwitz and Birkenau, Ukrainians, With Eyes Shut, Ceiling Lamps,* and *The*

Lone Man. I am currently working on two projects titled *Harbinger* and *The Fountainhead*.

My work has appeared in *LensWork, B&W, Black and White Photography* (U.K.), *Silvershotz, American Photo,* and *Photo Life*.

I was influenced by Edward Weston who taught me to be an artist, not a "photographer." And Alexey Titarenko (www.alexeytitarenko.com) who reminded me of how much I love the long exposure, and through his *City of Shadows* portfolio which featured people, indirectly inspired me to create the *Ghosts of Auschwitz and Birkenau* series.

TECHNICAL Several years ago I discovered the Singh-Ray Vari-ND filter, a variable neutral density filter that has made much of my work possible. It allows you to open up the filter for composition and then quickly close it down for exposure. Without it, it would have been difficult to create the Auschwitz

portfolio, and it certainly could not have been done in such a short period of time.

Creating ghosts is not as easy as it might seem, as there are a number of factors that affect the look of the ghosts such as the length of exposure, the speed and angle of the subjects, and the color of their clothing. Creating with a digital camera was critical to this project as it allowed me to see and verify as I went. Some work was then done in Photoshop, primarily dodging and burning, to create the right contrasts and mood.

Conceiving and creating this project in about an hour has given me much to think about. How can this be done when others take years, and sometimes decades, to create a portfolio? To me the lesson to be learned is that sometimes a good idea can be simple and easy to execute. Taking a lot of time doesn't necessarily mean better results; each project just takes as long as it takes.

My website is located at www.colethompsonphotography.com.

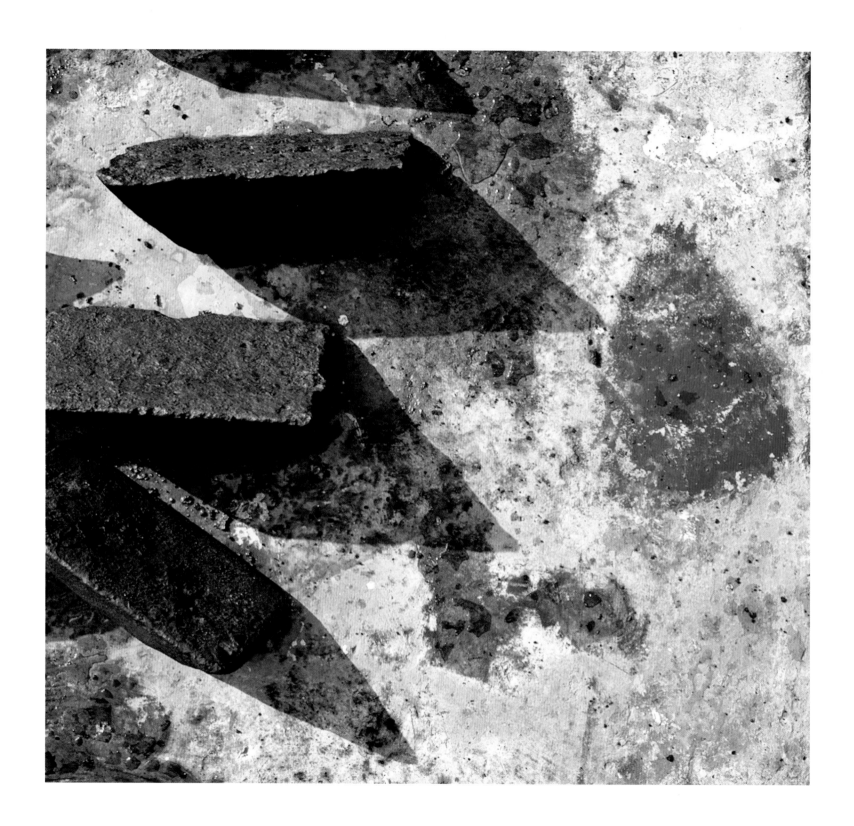

Fe²O³ # 6, Kos, Greece

1987

GEORGE'S ANALYSIS Photographing obscure details that most step over or walk past is both challenging and rewarding—in black-and-white going back more than a hundred years, and in color even more frequently since color could record the hues of rust and weathering, of worn paint and rough textures.

This photograph by George E. Todd is quite simple: three pieces of iron, four shadows, yellow ground, and a blue splotch. But notice how they are arrayed, the largest shadow just touching the blue, and the other side of the blue patch adjacent to the edge of the photograph. There is a lovely palette of colors; yellow through turquoise to blue. The ground color is varied in both tone and hue and is itself interesting. There is even a small oily puddle at the top of the photograph.

The shadows appear to be as real as the objects casting them, and as compositional elements they are arguably more important—they are larger and of more interesting shapes than the objects themselves. The iron blocks are arrayed in an arc from the top-middle to bottom-left corner, while the painted concrete faces them. In three of four corners there is an arc of color that is different from the background yellow, adding boundaries to the image so that it seems complete within the square. While the upper-left corner doesn't have a different color, the shapes pointing into the corner tend to make the background yellow itself into an interesting shape.

The iron has texture but so does the background concrete. There are no clues as to the purpose of the iron shapes or, for that matter, any obvious explanation as to the color. I thought at first this was a wall, with the shapes buried in it, until I read George's explanation.

The best way to think about a photograph like this is as a pure abstract – of a photograph made using parts of the real world but with the photographer using timing, framing and camera position to construct the image. Granted he probably didn't slide things around to make the composition, but this is a photograph of a composition rather than composition being a tool to present a subject. As such, it is important to study the relationships of the various elements that make up the photograph, remembering that in photographs, the dark shadows can be just as strong an element as the object which cast the shadow in the first place. I'll go even further and say that this can also be true of the spaces formed between the elements of the image, and between the elements and the borders or corners. These too can be important elements of the composition.

Until explained, the photograph is a mystery, the shapes and even the perspective unclear. Notice how the corner of one shadow touches both the next object and its shadow, while on either side, the shadows are a little bit separated from the next elements. That it is this same touching element that also reaches the blue splotch adds strength to the image. Along the left edge are two small dark triangles implying more of these mysterious blocks of rusty iron outside our field of view. While including too many objects could weaken the composition, especially if it adds extraneous or distracting matter, a simple implication of more is both subtle and sufficient.

The inclusion of complementary colors—yellow and blue— with the almost black objects combines and blends very nicely with the small amount of white and even smaller amount of rusty orange. There are no poster paint reds, brilliant greens, or other bright colors to distract the viewer.

In total, we have an abstract, a mystery, misleading clues, and visual elements that don't exist yet seem more substantial than the objects which cast them, all in a pleasing arrangement of attractive colors. What is there not to like?

THE PHOTOGRAPHER'S PERSPECTIVE If you are into color as I have always been, despite my lengthy sidetracking to black-and-white, then it's easy to imagine my excitement when this image came my way. It has all the brilliance and nuances of color I look for in an impressionist's painting—Monet, Sisley, et al.—which is what drew me to it, like a painter's canvas. Intuitively, I saw a totally abstract color picture in these odd lumps on a quayside in Greece. It became yet another for my $Fe^2 O^3$ (rust) collection.

But there was something else that caught my imagination: Was it ancient treasure fished up from a sunken ship of the Golden Age of Athens, perhaps? All these things went through my mind as I stepped across the scattered "pieces of eight" littering the quayside. They weren't gold, of course, but triangular sections of pig iron—boat ballast I surmised, though I wouldn't be too sure about that either. The blue spot was a gift

and just happened to be in the right place in my visualization. It was actually where fishermen had been splashing paint along the harbor edge, sprucing up their boats during the winter season. The result of their labors could have sold for millions as a concrete abstract! There were many more pieces scattered like this, and I nearly fell into the water with excitement while looking for the best arrangement. For me, it is vital that neither scene nor image be manipulated. I do not move objects to suit, rather preferring to work with what is there.

The shadows in this photograph follow my favorite graphic flow principles: composed so a viewer's eyes travel from bottom-left to top-right, scanning across the image. The result is always satisfactory. I have tested this in slide shows by turning the image back to front, asking left-handed people whether they prefer it going from right to left. They usually don't. I've also tried enlarging this image in all of the eight ways possible with a transparency; at least two of them work well, but I'll leave readers to resolve which....

BIOGRAPHY I was born 1925 in Grimsby, Yorkshire, England. I had an artistic bent from an early age and won a scholarship to study graphic design. My studies were interrupted by the war, with service in the Royal Air Force. The switch from art to engineering was not difficult—an artistic flair helps to envisage designs in 3D more easily.

After the war, I worked on missiles and the Skylark high-altitude research rocket, leading to work on the Zeiss metric camera project in Spacelab , and I worked for NASA on the Zeiss Metric Camera project from 1982–1986. The camera was one of many experiments flown in the NASA-ESA Spacelab launched on the Shuttle Columbia, November 28, 1983. During this time I used photography to document and illustrate my engineering work.

In the 1990s, I started doing some professional photography; convention groups, restaurants, wine cellars, bakeries.

My motivation has always been to express some feeling about a subject or object in an artistic way, returning to my artistic roots. I photograph in both black-and white and color, finding it quite easy to switch back and forth—someone once said that I photograph color like a black-and-white photographer. Perhaps it has something to do with the graphic forms and structure that I like to find in any motif, irrespective of color or black-and-white. I have conducted fine art black-and-white printing workshops for Hasselblad in the past.

At 85, I am still photographing with medium and large format—even with pinhole and sometimes a pocket Petri 35mm (like Rollei 35) camera. I haven't the money to try digital; I would need a decent camera, rather than some Mickey Mouse device.

My website is www.photo-todd.de.

TECHNICAL I photograph with a Hasselblad 500CX, Plaubel Makina 6×7, Gandolfi 4×5 and use all makes of film.

Author's note:
George Todd is more than a little modest. His work is currently (at the time of writing this book) included in a show, "Masters of American Landscape Photography", in Germany that also includes the following photographers: Ansel Adams, Bernice Abbott, William Clift, Alfred Eisenstaedt, Andreas Feininger, Edward Steichen, Alfred Stieglitz, Carlton Watkins, and Edward Weston. I'm surprised George T didn't faint dead on the spot—does it get any better?

He also wrote the *book Elements of Color Photography: The Making of Eighty Images* (Amphoto Books, an imprint of Watson-Guptill Publications, 2003), which is out of print, but I was able to pick up a good used copy fairly easily. This was published as a follow up on *Elements of Black & White Photography,* by the same publishers: Amphoto and Aurum Press, London.

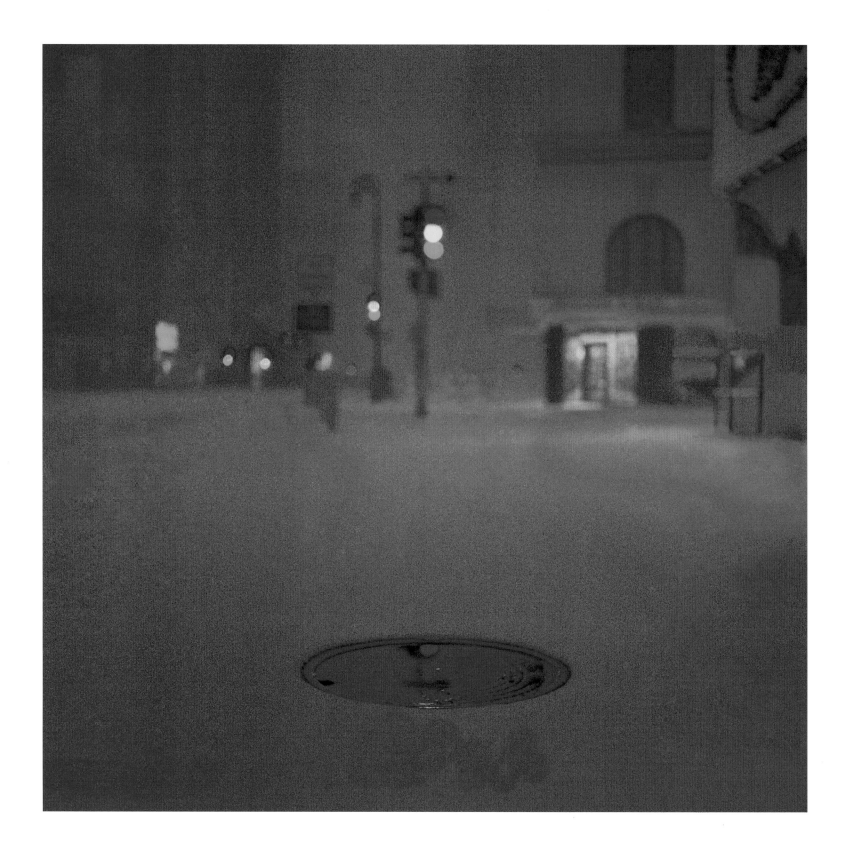

PETE TURNER

Times Square

1958

GEORGE'S ANALYSIS Pete Turner made this hallmark image in 1958. It could have been taken yesterday it looks so modern—clean in design, simple in layout, and devoid of any clues as to the era (no antique vehicles or out-of-date clothing styles). Pete famously celebrates intense colors, even occasionally adding color where it helps to create the impression he aims for.

The strong blue cast appears unreal yet totally appropriate to the image. I don't know whether Pete added it or simply took advantage of the color temperature of the light after the snowstorm to keep the blue actually recorded. Either way it is a gorgeous color. Only original prints very well made do justice to the intensity of the blue, but nonetheless it looks lovely regardless of the printing. The blue adds to the mood of the image, reinforcing the quiet that only seems to happen after a snowfall. The city is almost deserted (only photographers are wandering around). I didn't know New York City was ever this empty! The blue cast and the lack of people and vehicles make me feel very lonely looking at this photograph.

It is rewarding to contemplate the decisions that Pete had to make to create this photograph. Not only did he choose a very shallow depth of field, he deliberately focused on the foreground manhole, letting even the traffic light blur out—crucial to the success of the image. The height of the camera determined just what would be reflected in the wet manhole cover. A little lower and all three lights would have shown—perhaps too bright and too symmetrical, Pete would have lost the tiny reflections that define the left, right and nearest edge of the manhole.

The blurred background simplifies the composition and adds atmosphere to the image. Of course, it also spreads the light from the traffic lights. There is just a hint of the buildings receding in the distance.

The image isn't perfectly symmetrical, but it is close with the centered manhole and traffic light and the lines of the road and sidewalk stretching toward the middle of the image.

Look at how the four corners are handled. The two bottom corners are devoid of detail, adding emphasis to the manhole. The upper corners have almost mirror image trapezoidal shapes of buildings, helping frame the traffic light.

The lit doorway is balanced by the lights to the left of the traffic light yet they are dissimilar. The traffic light in the distance is nicely spaced between the nearer one and the street sign.

It is worth commenting on the square format. Some people like square images, while others much prefer a rectangle. There is something stable or peaceful about having the width the same as the height, the framing/cropping taking a back seat to content, as if it's one less thing to worry about. Perhaps the ultimate in this direction would be circular images—but those picture frames are so darn hard to make!

It is all too easy to forget the use of "out of focus" as a compositional tool. That Pete would use this on the most important element of the image with great effect shows considerable foresight.

THE PHOTOGRAPHER'S PERSPECTIVE It was 1958. I was 24 years old, still in the army but heading the Army Pictorial Center's color lab making C Type prints near New York City. I had the opportunity to visit my aunt on Madison Avenue. I remember getting up at dawn and photographing a huge snowstorm. Everything was quiet. It is especially visual if you are there just after the storm and there are no footprints in the snow.

At the time, the C-Type print was brand new—color in general was very expensive, but through my army duties I had the assignment to use film and make prints, and so I made repeated trips into New York to photograph.

BIOGRAPHY I am now 76, and with a 53-year history of professional and personal photography behind me, I keep very busy with a variety of photographic publications, projects, galleries, and printing. I continue to travel and photograph while doing so. I have shot for numerous magazines and corporations. I trained at Rochester Institute of Technology with classmates Paul Caponigro, Carl Chiarenza, Bruce Davidson, and Jerry Uelsmann—all dedicated black-and-white photographers. My instructors included Minor White and Ralph Hattersley. I moved to New York after my stint in the army, started a career in editorial work, and gradually shifted to more advertising assignments while also pursuing my personal work—one leading to the other and vice versa.

I like the color work of Ernst Haas and Gordon Parks.

A look at any single year from my records will give you an idea of my hectic schedule and varied projects—take 1967, when the controversial *Giraffe* was shown at the Metropolitan Museum of Art in New York. At that same time other projects included:

"Photography in the Fine Arts V", a group show at the Metropolitan Museum of Art, NYC. *Esquire Magazine* publishes "Thirty Million Miles of the Greatest Show on Earth" a landmark photo essay on the "Believe It or Not" wonders of the South Pacific and Asia, (USA) August 1967.

Popular Photography publishes "Pete Turner Right Now."

Travel to Taiwan to photograph Steve McQueen and Richard Attenborough in the movie "The Sand Pebbles" for *Look Magazine*.

Advertising for Prudential Insurance, Clairol, Autolight, and AT&T.

Work with Creed Taylor on the A&M jazz series. Photographs Wes Montgomery, Milton Nascimento and many other jazz artists.

Return to New Guinea for *Look Magazine*.

In 1986 I published my first monograph, *Pete Turner Photographs*. My second monograph, *Pete Turner African Journey*

(Graphis, 2001), is the visual diary of my adventure in Africa. My latest book, *The Color of Jazz* (Rizzoli, 2006), is a comprehensive collection of my jazz album covers.

Detailed information about my published work can be found on my website, www.peteturner.com.

TECHNICAL I like to shoot with Nikon equipment and I use Epson printers.

Times Square, 1958 was shot on 2¼ square, with negative color film that rendered the much cooler color temperature light of dawn as intensely blue. The camera was tripod mounted and the exposure was long enough to capture all three traffic lights, yellow/green/red. I'd start with the yellow light which was the shortest: it lasted only just a few seconds and that was all I needed for the correct exposure. Then I'd go on with the red and exposed it just long enough for the red. Then I'd stop and wait for the green light, still on the same frame. When the green came on, I opened the shutter again. I had a multi-exposure shutter button to make double exposure on the same frame. I used that technique on balloons, in and out of focus, and so forth. I was having a great time experimenting with color and getting the most out of this new film.

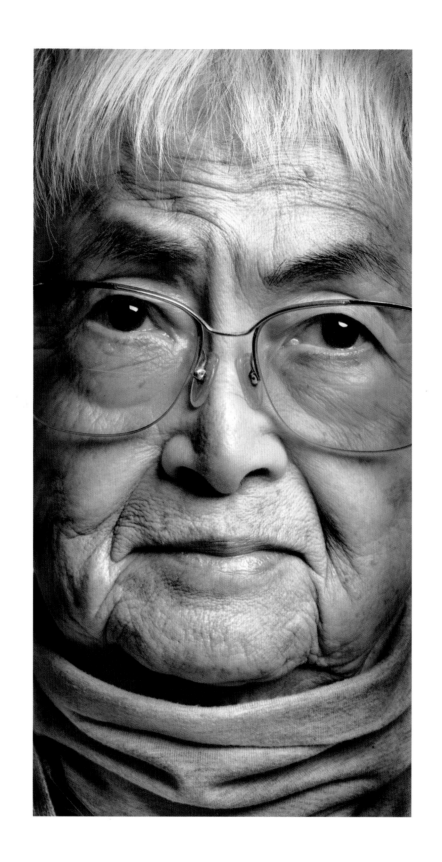

Mrs. Nishimoto

2003

GEORGE'S ANALYSIS Per Volquartz is perhaps best known for his *Instruments Of Death* series of images; sumptuous, artistic photographs of fighter planes and missiles, made with a large format camera and against plain backgrounds. The irony of showing such weapons of mass destruction as art objects is a potent message. Once led to his website however, the image which really caught my attention was a portrait. With its tall narrow format, the photograph reminds me of a totem pole, yet here is a portrait of a woman that absolutely fascinates. I would love to meet this woman and find out more about her. The eyes suggest undiminished intelligence and, frankly, a lot of us wouldn't mind looking this good at age 90.

The lighting is anything but classic portrait stuff, coming from above as it does, but looks so much more natural than typical studio lighting. One has the sense that this is the real person, not a mask the sitter puts on to portray a role they think proper.

The extremely tight cropping of the face adds emphasis to those eyes. The silver hair at the top of the image and the turtleneck collar at the bottom further frame the face. Were this some kind of still life instead of a face, the shapes and lines would still work well as a composition.

I can't quite make up my mind what Mrs. Nishimoto is thinking, and it bothers me a little—I'd like to know. Is she bemused by the situation; laughing internally at the antics of the photographer? Despite the lines in the face, there is absolutely no sense of approaching end of life, to me this appears to be a lady who is too involved in life to worry about death.

Whether it's a trick of lighting or the thoughts of the sitter, the right eyebrow appears a tad higher than the left, the brow more furrowed, adding to the

expression and further confusing me as to her thoughts. A good photograph explains, a great one makes the viewer ask questions.

Per might have chosen an image in which it is more obvious how the subject is feeling and what she is thinking, but in choosing this enigmatic expression, we are left wondering, and this uncertainty about our understanding of the image calls us back to the image again and again, hoping for clarity.

Of course, I have no idea whether any of what I have said is true about the sitter, nor for that matter what it is that the photographer thinks about the sitter. In portrait work, the viewer of the print is twice removed from the person being photographed; first by the interpretation created by the photographer in choosing that particular frame, in setting up the lighting in that way, and to be sure, in how the photographer interacts with the sitter. Once all that is set in silver, the viewer reinterprets the image. Our own experience with the elderly, whether it's our grandparents or neighbours, hugely influences our perception of the image. This personalization however is what makes portraits so powerful as works of art.

THE PHOTOGRAPHER'S PERSPECTIVE I met Mrs. Nishimoto's daughter Diane, who was working at a local photo lab. She and her parents and my wife and I went for dinner and quickly became good friends. Mrs. Nishimoto, as I knew her, had a quiet sense of humor and a mind that always was active and curious about any type of art. Yet she was in some ways confined in traditional Japanese culture. With the exception of her eyes, her facial expressions never changed much. She had a unique way of looking at you with a warmth and gentleness, which was what I wanted to show in my portrait of her.

In my photography I try to distill content to an absolute minimum, showing only what I feel is necessary, which explains the very tight framing of the face. In the case of the portrait of Mrs. Nishimoto, I did not want to just take a photograph showing her likeness. Instead, I wanted to somehow capture her soul for others to see and enjoy.

Below is a summary of Mrs. Nishimoto's biography written by her daughter Dianne.

My mother, Kay K. Nishimoto (nee Kawagoe), was born in 1913 in Los Angeles and grew up in the Los Angeles area. She went to USC and graduated from the school of pharmacy, but never used her pharmacy degree. At USC she met her future husband, Kenneth M. Nishimoto, (he graduated from the school of architecture at USC). They were married before World War II.

In 1941 Japan attacked the USA and Roosevelt made an executive order to evacuate everyone of Japanese descent from the west coast of the USA. In 1942, Kay and her husband were evacuated to the Santa Anita Assembly camp (Santa Anita Race Track in Arcadia, CA). (She was a born American citizen, but her husband Kenneth was Japanese by birth).

In 1975, my mom became a touring docent volunteer at The Gamble House in Pasadena, CA leading tours of the House. Later she took Japanese flower arranging classes that were offered to the Docents of the Gamble House as part of their training. She enjoyed going to art exhibits. In addition, my parents traveled all over the world. My mom kept up her interest in Japanese ikebana (flower arranging) by going to local shows that were offered at Nisei Week in Los Angeles and in Pasadena. She and my dad enjoyed meeting new people and keeping up with all the people that they had met over the years here and abroad.

BIOGRAPHY I started my career in the visual arts after graduating from Art Center College of Design in Los Angles in 1971. I first worked as a graphic designer and illustrator. Soon, however, I discovered large format photography, which later proved to be my main direction as a visual artist.

In the summer of 1976 I attended a photographic workshop in Yosemite. There I met Ansel Adams and Morley Baer,

who, together with the painter Lorser Feitelson, were to inspire me, laying the foundations for my creative photography. This was to become a turning point in my photographic career.

During the next decade and a half I accepted a variety of commercial assignments from many fortune 500 companies and became known for my unique photographic point of view, as well as for my printing.

My photographic images have appeared in most major magazines in the United States: this includes *Life Magazine, Time* and *Newsweek, The New Yorker, The New York Times, The Los Angeles Times,* and *The Wall Street Journal*.

Articles about my work have also appeared in many publications including *American Photographer* magazine, *Print Magazine's Casebooks (The Best of Annual Reports), Fotopozytyw* (a professional photography magazine published in Poland), *The Photographer's Companion* (the largest professional photo magazine in China), and most recently the January/February 2010 issue of *View Camera Magazine*. I have exhibited extensively in China as well as in Europe. In 2007 I had a retrospective at Denmark's Museum of Photography in Denmark.

Artists are influenced by everything in their environment—the people they meet, the books they read, and the music they listen to. Some are shaped by events; good times, or bad. Others are somehow able to listen to the inner self and reveal their thoughts, feelings, and ideas.

In my case my first inspiration was my dad, a not-so-simple furniture maker, who had great dreams—and talents as a painter. His early teachings set me on the path of visual art at an early age. However, it was not until I was in my early twenties that I discovered how powerful—and addictive—art can become.

While studying at Art Center College I had the good fortune to study under a truly great artist—Lorser Feitelson, the master of modern American hard edge painting who was famous for embracing minimalism. About that same time, I discovered the images of Ansel Adams. These two visual artists were to greatly influence the way I look at things, and subsequently, how I find my own path. Minimalism, capturing the essence of a subject, and purity of form—presented photographically—has become my personal life-long quest.

My website is located at www.pervolquartz.com.

TECHNICAL The photograph was shot on 8×10 film using a wooden Gandolfi camera. The lens was a 355mm Gold Dot Dagor. Lighting was done with a 3000 w/sec Balcar Studio Flash unit.

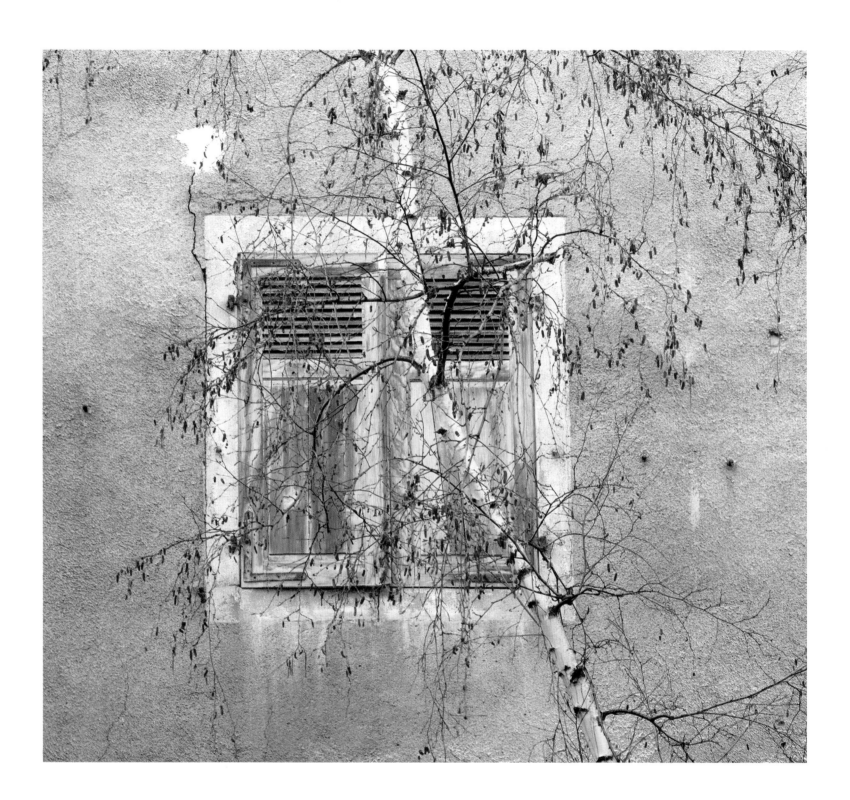

Birch and Window, Colmar, France

1986

GEORGE'S ANALYSIS One of many effective ways that great photographs work involves a relationship, usually between two ostensibly different objects. This could be an elderly man and his grandson, perhaps two similar but inanimate objects that seem to be having a conversation, or as in Charlie Waite's lovely image, a shuttered window and the tree in front of it.

The relationship is made, of course, because of the white bark of the tree with the whitewash of the window frame, and the brown of the leaves with the brown of the worn shutters. Relationships can be formed of commonalities like these or of contrasts—the delicacy of the tree against the solid wall, the diagonal, irregular, and curving lines of the tree against the rectangular window. It is hard to tell the cracks in the wall from some of the finer branches.

The wall itself is a very strong feature of the image, both for its texture and the variation in tone. The streaking under the window is that extra touch that makes the image stand out from the ordinary.

The glaring white patch repair to the wall contrasts with the subtle whites of the window frame and tree bark, putting them in perspective, emphasizing their subtlety and delicacy. This "recent" addition adds to the story of the image and balances the other elements of the composition.

We can't help but be curious about the nature of the building and who or what is behind the shutters. Why wouldn't you want to look out on this lovely tree? Shutters are a metaphor for all manner of ideas, plots, and themes that we as viewers are free to create in explaining the photograph to ourselves.

Consider the distribution of the branches of the tree—leaving open areas of wall in places and being most dense in a diagonal line from bottom-left to top-right, with a few nicely placed branches working off the corners of the image. In the upper right, they cut across the corner. In the bottom-left they reach toward either side of the corner, while in the bottom-right they reach across to the corner. In the top-left there are just a few seemingly independent branches hanging into the corner from outside the image. Although the branches lie in front of the window, they don't hide much of either window or shutters. This would be a completely different and far less successful image in midsummer when the tree would be covered in leaves. Not only would details be hidden, the "fall season of life" relationship for tree and building would be lost, the green leaves would clash with the limited palette of the scene as photographed, and the delicate tracings of the branches would be gone.

Finding something interesting to photograph is only the first step of many in making a great photograph. One of the most potent ways to make an image is to record the relationship between and among the elements of the photograph.

THE PHOTOGRAPHER'S PERSPECTIVE I was traveling through France, making images for another new book, this one to celebrate the landscape of France. The weather had been poor all day when I came across this apparently simple scene. My preference is to find elements of the landscape which relate to each other, that together make a scene, a set table piece or "arrangement", almost like designing a still life or stage scene, no doubt reflecting my experience of set design in the theatre.

I need the elements of such a scene to look cohesive, recognizing that they quite naturally seem to have a series of relationships that readily interlock with one another. If there is a narrative binding the elements of the image, then the

photograph will be successful. In the tree, wall, and shuttered window, I found several levels of relationships that made the idea of the image work for me.

I was happy that the amber tones of the leaves and shutter were not overpowering. The white weathering below the shutters gave the image a forlorn feel that added mood to the relationships in addition to the design of the image, a multilayer thread that leads to a photograph that has meaning for me

BIOGRAPHY I was born in 1949 and worked in British theatre and television for the first 10 years of my professional life. Throughout this period I became fascinated with theatrical lighting and design. Gradually the landscape and the way it can be revealed to us through light and shade stole me away from the acting profession.

Over the last 25 years, I have lectured throughout the United Kingdom, Europe, and the United States. I have held numerous one-man exhibitions in London and have exhibited twice in Tokyo.

In my photographs, I work to convey a spiritual quality of serenity and calm. In September 2005, I completed filming for a six-part television series on landscape photography. I have worked with numerous distinguished authors, including Adam Nicolson, Jan Morris, John Julius Norwich, and A. N. Wilson. The year 2003 saw the publication of my 22nd book, *In My Mind's Eye,* my first book of black-and-white photography.

It has been very important for me to share my enjoyment of photography and to help others with their photography. To this end, I have been writing about, teaching, and holding workshops on photography for many years. I am the owner and founder of Light and Land, a photographic workshop and tour company. We run photographic tours, courses, and workshops worldwide that are dedicated to inspiring photographers and improving their photography.

In 2007 I launched "Take a View," an annual nationwide photographic award to find the United Kingdom's Landscape Photographer of the Year, which ties in perfectly with my desire to share my passion and appreciation of the beauty of our surroundings through photography.

I guess my main influence is Ansel Adams for his giant technical and artistic ability. He's at the top of my list! I have also been influenced by O. Winston Link for his ingenious image construction, Eliot Porter for his color investigative eye, and Norman Parkinson for his hugely imaginative, stylistic fashion images.

Of my 28 books published so far, the following are readily available: *In My Mind's Eye* (GMC, 2003) and *Landscape: The Story of 50 Favorite Photographs* (Collins and Brown, 2005). In addition, I have co-authored several books with other photographers.

You can find more information and see my work at my website, www.charliewaite.com.

TECHNICAL I use conventional fine-grain transparency film and a Hasselblad 6×6 cm film camera. From this medium, my images are drum-scanned and I use inkjet printers to make archival pigment ink images on fine art paper. Through this process, I am able to achieve the depth and detail in the image that I demand.

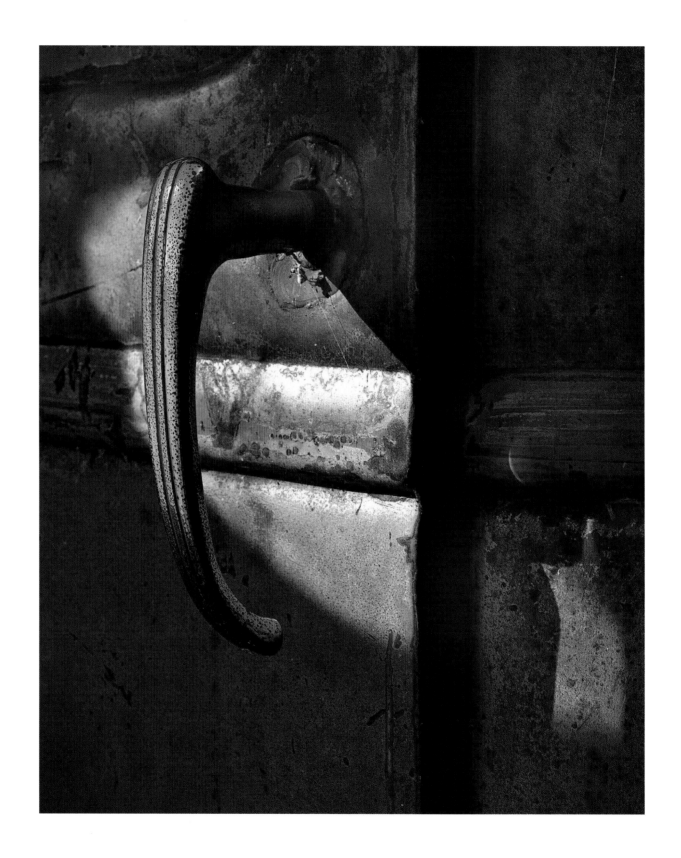

Chrome Handle
2009

GEORGE'S ANALYSIS I became aware of David Ward's work through reading *Outdoor Photography* magazine, the British publication, and was excited when David agreed to participate in this book. It wasn't easy to select a single image for the book from so many great photographs but with David's help we easily found some images, which were meaningful for me and important for him.

I was initially surprised that David would pick this non-landscape image. The others were more traditional; I particularly liked one David had made many years ago. This image of a vehicle door wasn't especially typical of his work, not even being a small part of a 'normal' landscape and not of an especially beautiful subject. Later, however, I came back to the image several times, unable to ignore it and becoming more intrigued with each viewing. Not every photograph impresses on the first viewing—it's rather like meeting someone, not making a connection, yet thinking about them and in the end becoming best friends because with time their strengths and their charms become evident. Similarly, not every novel grabs you by the end of the first page.

With each viewing, I found more to like about the image: the intense blue reflection on the top of the handle, the texture of the rusted chrome and weathered paint, the lighting and shadows.

The three sunlit areas—upper-left, middle, and lower-right—form a nice diagonal, running perpendicular to the handle. Even that little crescent of light in the right middle adds something in relation to the larger sunlit area on the right—a small accent, the final touch.

Above the blue-topped handle is a darker, faded-blue arc, acting as a visual stop for the handle. I don't suppose elements like this really do keep one's eyes

from leaving the print as has been traditionally taught in photography books, but perhaps it is more like matting for a photograph, saying, "Here it is," and isolating the important element from the rest of the world. The bottom of the handle is against the darker part of the door, and the blue at the top of the handle is framed on the right by the almost (but not quite) black of the base of the handle.

Next I noticed that the door is open. So we have what appears to be an old vehicle, with an open door. Perhaps this is a junkyard, or grandfather's farm, or perhaps it reminds one of playing hide and seek. Maybe there's something hidden behind the door, a treasure or a dark secret?

If a photograph tells you all and leaves nothing to the imagination, it may be a good photograph but there isn't a lot of reason to revisit it and even less reason to think about the image. Those images that ask as many questions as they answer tend to stay with you, but only if they can attract your attention in the first place.

THE PHOTOGRAPHER'S PERSPECTIVE A long, long time ago in a land far away, I began my photographic career as an assistant to car photographers. Almost more than any other aspect of my early development as a photographer, this gave me an appreciation of light and how it falls and (crucially for cars) is reflected from surfaces. You could say that it taught me not only how to work in a controlled way with light but also to love light. I think many photographers start from the position of loving their subject and a love of light follows. But from very early on it was always the light for me. That doesn't mean it has to be spectacular to move me, just sympathetic to the subject.

I was inspired to make this image because of the contrast between the textures and colors of this battered pickup and the beautiful and different ways the light fell on it. I noticed the way the pool of light, reflected from a mirror, skimmed across the door: the way that the pool broke as it passed the edge of the door, casting a shadow on the panel beyond; the way the light from this pool reflected into the back of the handle where it lay against the shadow. I also noticed the way the sky reflected mid-blue in the pitted chrome and the bare metal of the door behind, the way the reflected shadow of the pickup darkened the bottom of the handle, and the fact that all of these differing ways the light fell made such a humble object a thing of beauty.

And I noticed all of this subconsciously and in an instant.

Like many other of my favorite images, there was no conscious understanding of why I was making the image at the time I made it. There was simply an overwhelming desire to do so.

BIOGRAPHY I have photographed commercially a wide variety of subjects from dogs to racing cars, but my first love remains the landscape. Working with a large-format camera, I have spent the last 20 years lugging 44 pounds (20 kilos) of gear up hills at decidedly unsociable hours in search of that special moment to immortalize on film. I have traveled and photographed throughout the United Kingdom and beyond, to Canada, the Colorado Plateau, Iceland, Norway, France, and many other countries. Working on commission on walking and travel guides in the UK, I have contributed to nearly 20 books in the 1980s and early 1990s. Recent personal work concentrates more on intimate details than the wide vista.

My experience as a location photographer working in advertising, design, and publishing are now being passed on to fellow lovers of the landscape through workshops with Light & Land. My books include *Landscape Within* (Aurum Press, 2004) and *Landscape Beyond* (Aurum Press, 2008).

I have been influenced by Edward Weston, Minor White, and Ansel Adams.

You can see my work at my website www.into-the-light.com.

TECHNICAL This image was shot in Virginia City, Wyoming, and the format is 4×5. I used a Linhof Technikardan camera, Velvia 50 film, and 210mm Schneider Apo-Symmar f/5.6 lens. The shutter speed was 1 second and the aperture was f/22⅔.

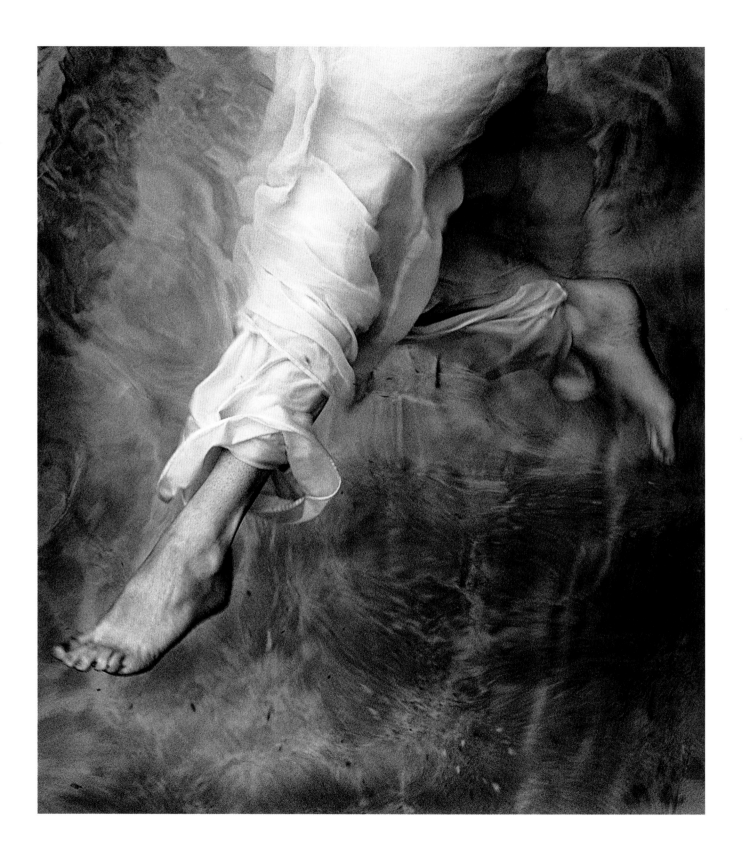

Descending Angel
1981

GEORGE'S ANALYSIS If ever an image were to illustrate the difference between admirable and wonderful, it has to be this photograph. Looking like a black-and-white photograph of an old master painting, it forces you to actually stop, check the details, and realize it is even a photograph, and a straight one at that.

The title suggests religious overtones, and certainly anyone who has seen painted ceilings in churches will recognize the connection, whether or not they are even remotely religious themselves. I wonder what someone who has never seen any frescos would think of the image; I'm sure they'd still enjoy it because on a pragmatic level, it has much to recommend it.

Whether you think of the figure as an angel, dancer, a dream, or you make a connection to the image in an entirely different way based on your life and experiences, the graceful flow of the muslin, the outstretched leg and the way the water works to soften the edges of the figure and at the same time create an interesting backdrop all combine to create wonderful.

The pose makes an interesting series of lines and shapes within the rectangle of the image, but more than that, the outstretched left foot implies action to me—not someone lying down and relaxing—and certainly the obvious interpretation is of the figure reaching down, perhaps a dancer after a leap, a figure striding forward, or, okay, an angel descending. The swirls in the water (and it isn't immediately obvious that this is in fact water) further imply action. Of course, the folds of the cloth perfectly complement the waves in the water, to a degree that is uncanny and is one of the most powerful features of the image.

I find the feet interesting—a dancer perhaps—not an inexperienced foot, or a very young one. Check the lighting on the two feet, with the bottoms of the feet

nicely defined with a dark line, reminding me of some of the nudes of Edward Weston.

Pay attention to how close the two feet approach the sides of the image, yet there is a large space under the bottom foot. It might seem obvious to crop the bottom so it matches the sides, but in so doing you'd lose the sense of some distance still to go before landing the foot. In fact, with this much space under the feet, it is implied that there may not be any impending landing at all, leaving us to interpret this as we will.

The brilliant highlights of the cloth at the top of the image are balanced by the darker tones of the water near the bottom. There are repeated diagonal lines from the water both above and below the figure toward the figure itself.

Wonderful photographs are few and far between. John tells me that getting the image was largely luck—that other images in the same series didn't remotely show the same qualities, that truly there was magic. I would argue that John was simply prepared for magic, or luck if you will. That he didn't predict or expect luck doesn't matter. We rarely know how many other failed ideas precede a wonderful image. It is the persistence as much as the readiness that we admire. And why shouldn't a photographer happily accept the luck, earned through repeated effort and the ability to translate the luck into a successful image.

THE PHOTOGRAPHER'S PERSPECTIVE *Descending Angel* was made during the morning of April 19, 1981 in a swimming pool in Menlo Park, California. The subject is my friend Christine Wells. Our intent was to relinquish all conscious control while photographing. Thus Christine did not pose; she allowed her body to flow with the moment, and I photographed only when without conscious volition my finger pressed the shutter release.

Water is an element of transformation, purification, the unconscious, birth and rebirth. To be in water is to be weightless as a spirit. The surface tension of water is an analogue for the interface between the land of the living and the realm of spirits. By photographing in this symbolically charged environment and giving up conscious control, the possibility existed that for a fraction of a second a door might open into other levels of reality that coexist with ours.

Photography is renowned for its ability to record the appearance of the physical world, but its highest potential is to simply and honestly portray that which transcends our senses. Twenty-nine years later, it's my belief that this photograph does indeed reveal a spirit being at the interface between the physical and spirit worlds.

As I stood on the diving board and looked downward into the water, I released the shutter. When I viewed the negative I was shocked, for the image was significantly different from what I had seen through the viewfinder. This photograph has not been altered in any way; it presents exactly what appeared on the film.

BIOGRAPHY I was born in 1945 in Paget, Bermuda. I first became involved with photography while serving in the United States Navy in 1966. At that time my pictures were of flight operations aboard aircraft carriers on which I served during the Vietnam War. After being discharged in 1967, I avidly pursued color street and landscape photography in the San Francisco area while employed as an electronics technician. I am completely self-taught.

The direction of my photography took a radical shift in February 1969. A profound experience while photographing a group of trees in Canyon del Puerto, California, caused me to focus exclusively on what I perceived as spiritual aspects of the world. During the 1970s and 1980s, my emphasis was on the landscape. I photographed repeatedly at locations that conveyed spiritual power, returning for more than 25 years to certain locations. Many exhibitions followed.

In 1981, I made a series of photographs of a woman underwater, which resulted in *Descending Angel*. Also, that year I left electronics and have earned a living from gallery print sales ever since. I have also performed decades of research into photographic developer chemistry, resulting in two pyrogallol formulas that are currently sold on the Photographers' Formulary website.

During the 1990s my photography concentrated on the old mining camps of Nevada. Then in 1999, my lifelong interest in shamanism led me to photograph American Indian petroglyphs, resulting in the award-winning book *Evidence of Magic*.

Early influences included Henri Cartier-Bresson, Jerry Uelsmann, and Edward Weston.

My work has appeared in the magazines *Silvershotz, LensWork, B & W Magazine, View Camera Magazine, Camera 35, Photo Techniques, and Petersen's Photographic* among others.

My website is www.johnwimberleyphotography.com.

TECHNICAL I used a Rolleiflex SL-66 camera with a Zeiss 120mm f5.6 S-Planar lens. The film was TRI-X processed in Microdol-X, and the format 6 cm x 6 cm. Prints are made on gelatin/silver paper and selenium toned. I prefer to print on papers that can produce some degree of split-toning, such as Ilford Multigrade Warmtone.

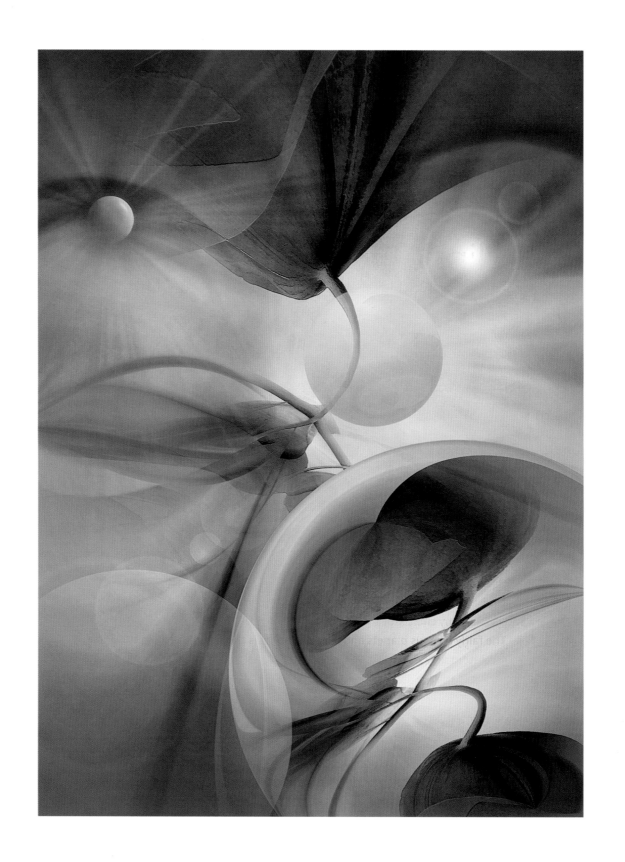

Tulips #55

2006

GEORGE'S ANALYSIS For a photographer steeped in tradition, it takes me some getting used to Huntington Witherill's *Photo Synthesis* series of manipulated flower photographs. It was not an easy choice because his traditional black-and-white landscapes are among the best and most original I have seen, his classic car series *Chariots of Desire* is exciting, and his previous plant images in black-and-white with hand-painted backgrounds seen in *LensWork* magazine were what first drew me to the photographer.

My own rather parochial tastes notwithstanding, I had been following Huntington's work in Photo Synthesis with interest, even to the point of owning another print from the series. While I find that image "prettier" and easier to relate to than the one chosen for the book, for downright intrigue, for providing a framework upon which the viewer can use their imagination, for the ability to travel within the image, and for the use of mood this photograph is special, and in the end became my choice for the book.

The fairly obvious planets and suns metaphor is there, but I also see the globe in the bottom right as being an embryo, and if you relate that back to the planetary concept, the connection to the creation of the universe comes to mind. I'm sure you will see other things in the image, and of course I have no idea what Huntington saw in it, or to be more accurate, put in it.

The risk of manipulation on this kind of scale is that the work may be considered "not photography", but what you have to ask yourself is, "Does it matter?" If the work moves us, makes us think, or induces a mood, it is art. Whether the creator of the art used acrylics or pixels isn't very important in the end. The typical modern photographers' tools of digital camera and Photoshop have been used.

The initial photograph was critical to the end result, and besides, what else are you going to call it when there is a tradition of image manipulation going back to the beginning of photography?

Compositionally the image is strong. Other images I have talked about have done things in threes. Here we have five globes, again an odd number, a prime number. There are in fact smaller and paler globes beyond that number, but in terms of image design, these five are the most important. Notice that the "moon" at top-left is slightly higher than the "sun" at the top right, that the globe in the bottom-left is lower and smaller than the one on the bottom-right.

The photographer in the field may think that they don't have the option of moving objects around, or they wouldn't even if they could. In fact, through careful positioning we do have a fair amount of control and can choose how close elements within an image are to each other and we can even determine their relative size.

For me, this arrangement simply "works." It has a rightness to it that other arrangements and sizes would not. That rightness has to do with both balance and relationships. It is more complex than simply imagining the image elements sitting balanced on a scale. A small object can nicely balance a large one through a relationship they may have with each other. That relationship can be of shape or tone, color or substance, texture or design, or perhaps nothing more than what each object implies.

The relative position of the image elements affects our interpretation of the image not only in the practical sense of trying to understand *where* things are, but also in terms of mood and message.

Within the enveloping light, there are darker forms that seem a little ominous and certainly mysterious. Tentacles reach out in ways that are suspicious. There is something about the two globes, upper-right and upper-left: It seems like the good twin is on the right, radiating light, while on the left is the evil twin, sucking the light out of the image.

Whether or not you approve of image manipulation (and to what extent), consideration of the light and form (the overall structural and metaphorical content) revealed within photographs like *Tulips #55, 2006* can provide you with inspiration, imagination, and fresh ideas that can be applied to more mainstream photographs.

THE PHOTOGRAPHER'S PERSPECTIVE Flowers are one of the most universally embraced forms of subject matter that can be explored by an artist. The sheer diversity of color, pattern, form, and line that these objects manifest cause them to adapt well to the photographic medium. As such, it would not be a stretch to suggest that *every* photographer has at one time or another photographed flowers. How then does a photographer approach this particular subject in such a way as not to impersonate a currently existing wealth of recorded expression?

The series *Photo Synthesis,* from which *Tulips #55, 2006* is derived, is intended to metaphorically depict a primordial landscape of abstracted natural forms, fantasy-based illusions, and altered visual perceptions. Within a subsection of that series, the primordial landscape suggested in this example has been further expanded to incorporate elements of the extraterrestrial.

The overall objective of this series has been to explore and demonstrate the visually related nature of *all* subject matter. The natural forms and patterns we see in a single flower can be remarkably similar (from a structural point of view) to those we perceive when viewing the universe as a whole. If one views such disparate elements from the standpoint of spatial relationships, geometric forms, and repetitive patterns, the micro becomes the macro and vice versa.

To suggest that the photographs in this series are not actually "photographs", at all, might be to state the obvious. However, one of the great things about working with a digital approach to photography is that one is no longer constrained by a 19th century definition of the word: *photograph*. With so many extraordinary possibilities for image manipulation and personalized visual interpretation, the digital approach frees the photographer to summarily redefine the very nature of a photograph.

Using a digital camera and Photoshop software, *Tulips #55, 2006* is a result of a working process more indicative of painting and sculpture, or perhaps even jazz improvisation. Within the series: *Photo Synthesis,* I have set aside most previsualized and representational aspects of conventional photography in favor of a more intuitive, symbolic, and spontaneous approach to the subject.

Whether new ground has been broken with this photography-based approach to a previously well-documented subject will be for the viewer to determine. Ultimately, it is the ongoing process of self-exploration and visual discovery that holds the key to my unwavering passion for the photographic medium.

BIOGRAPHY I was born in Syracuse, New York, in 1949, and moved to California in 1953. At the age of four I began taking piano lessons. With intentions of eventually becoming a concert pianist, I entered college as a music major in 1968 but soon became interested in the study of two-dimensional design. This shift in artistic focus eventually led to a career in fine art photography that began in 1970.

Having studied photography in the early 1970s with such notables as Ansel Adams, Wynn Bullock, Steve Crouch, and Al Weber, I have endeavored to remain faithful to my classical photographic training while progressively transitioning toward a more contemporary approach to the medium. Since 1970, my photographs have been featured in more than one hundred individual and group exhibitions in museums and galleries throughout the world.

I work in both color and black-and-white, and because I believe that growth and change are a vital and necessary part of being a successful artist, I'm not afraid to completely change and/or alter the way in which I work and I happily do so whenever inspiration affords an opportunity. I also believe that being a photographer is more about recording and expressing light than it is about depicting any particular subject matter. After all, the literal definition of the word photography is: *writing with light.* It's really *all* about the light! Thus, the overall body of my work is intentionally wide-ranging in terms of specific subject matter and includes landscapes, studies of pop art, botanical subjects, still life, urban architecture, and abstract digital imaging.

My black-and-white photographs have been the subject of two hard-cover monographs: *Orchestrating Icons* (2000) and *Botanical Dances* (2002), and I am currently working on a third book that will feature color photographs from the *Photo Synthesis* series. Additionally, some of my photographs and writings have been featured in a number of national and international magazine publications over the years.

Personal inspiration for my work has come from an eclectic variety of sources that include not only photographers like Minor White, Emmet Gowin, and Wynn Bullock, but also from classical composers like Debussy, Rachmaninov, and Mozart, and more contemporary jazz musicians like Art Tatum, Oscar Peterson, and Bill Charlap. I have also gained valuable inspiration from a number of French Impressionist painters including Cézanne, Gauguin, and Monet.

I maintain an online presence at the website www.huntingtonwitherill.com.

TECHNICAL For *Tulips # 55, 2006,* I employed a Canon EOS 5D camera and a 24–105mm, 1:4 L IS USM lens. The original digital capture was made under incandescent lighting, and the tulips themselves were positioned in front of a plain white background.

Adobe Photoshop was used to alter and restructure the photograph in ways that are unique to each individual image. Think of the sequence of editing steps in terms of jazz improvisation. Each step along the way informs the next step. Once the image is completed, limited edition archival pigment ink prints are currently produced using an Epson Stylus Pro 7800 printer employing pigment-based inks and 100% rag content fine art papers. This combination produces prints with the desired "look" and "feel" while maintaining each print's archival stability.

Recommended Photographers

Some of the photographers for the book volunteered names of other photographers they admire, like, or recommend. Use this list of photographers to expand your own horizons.

A

Michael Ackerman
Ansel Adams
Brad Anderson
Diane Arbus
Trevor Ashby
Richard Avedon

B

Banksy
Kate Breaky
Denis Brihat

C

Debbie Flemming Caffery
Reid Callanan
Paul Caponigro
Keith Carter
Henri Cartier-Bresson
Linda Connor

D

Karl DeKeyzer

E

Elliott Erwitt
Walker Evans

F

Robert Frank

James Fee
Gloria Baker Feinstein
Lee Fiedlander
Franco Fontana

G

Eberhard Grames
Andy Goldsworthy
Serkan Gûnes
Andreas Gursky
Carol Guzy

H

Tore Hagman
Robert Parke Harrison
Todd Hido
David Hockney

I

Kenrolzu

J

Tony Ray Jones

K

Sean Kernan
Josef Koudelka

L

Jan-Peter Lahall

Annie Leibovitz
Arthur Leipzig
O. Rufus Lovett
Magnus Lindbom
Bård Løken

M

Sally Mann
Robert Mapplethorpe
Mary Ellen Mark
Rania Matar
José Maria Mellado
Joel Meyerowitz
Andrea Modica
Wasif Munem
Tomas Munita

N

James Nachtwey

O

Jon Oneal

P

Luis Gonzalez Palma

R

Jim Richardson
Merg Ross

S

Sebastião Salgado
Jan Saudek
Howard Shatz
Jack Spencer
Mike and Doug Starn
Joel Sternfeld
Craig Stevens
Jock Sturges
Jean Pierre Sudre

T

Maggie Taylor
Miroslav Tichy
Alexey Titarenko
Larry Towell
Jan Töve
Jim Turner

U

Jerry Uelsmann

V

Ron Van Dongen
Bill Viola
Ami Vitali

W

Carlton Watkins

We gratefully acknowledge the many talented photographers who captured the portraits used throughout the book.

Bruce Barnbaum © by Alan Lemire

Christopher Burkett © by Page Baker

Dan Burkholder © by O. Rufus Lovett

Brigitte Carnochan © by Ginnette Vachon

Lawrence Chrismas © by George Barr

Joe Cornish © by Eddie Ephraums

Charles Cramer © by Keith Walklet

Tillman Crane © by Richard Barnett

Mitch Dobrowner © by Michael Gordon

Bengt Ekelberg © by Nora Ramboel

Carol Hicks © by Rachel Bolsover

Milan Hristev © by Lori Hristeva

George Jerkovich © by Fast Focus, Salina, KS

Kim Kauffman © by Edwin Bonnen

Michael Kenna © by Mark Silva

Brian Kosoff © by Jayni Kosoff

Michael Levin © by Hironori Nakamura

Wanye Levin © by Mary Belanger

Larry Louie © by Joanna Wong-Louie

David Maisel © by Lynn Fontana

Harald Mante © by Eva Witter-Mante

Beth Moon © by Isabel Moon

Elizabeth Opalenik © by Marty Martinez

Freeman Patterson © by Colla Swart

Craig Richards © by R.W. Sandford

Ryuijie © by Camille Lenore

John Sexton © by Anne Larsen

George E. Todd © by Jeurgen Hasenkopf

Pete Turner © by Douglas Kirkland

Per Volquartz © by Christian Volquartz